Praise for Cay Lang's *Taking the Leap*

This superb book is useful in every way for fine artists who are serious about their careers, whether they are just beginning to show their art or have been doing so for some time. I recommend it to everyone.
> —*Marian Parmenter, director, Artists' Gallery, San Francisco Museum of Modern Art*

Taking the Leap gives the truly motivated and talented artist a solid jumping off place–a platform on which to build a career.
> —*Jamie Brunson, painter and instructor, California College of Art*

Taking the Leap prepares artists for the real world of galleries and helps them learn how to discuss their work and ideas.
> —*James Harris, owner, James Harris Gallery, Seattle*

Lively and informative, *Taking the Leap* is a great way for artists to start revving up their career.
> —*Jackie Battenfield, artist and seminar director, Artist in the Marketplace (AIM), Bronx Museum of the Arts*

Taking the Leap got me back in high gear and got me thinking about who I am as an artist. It's witty, precise, and filled with important information. I refer other people to it all the time.
> —*Nancy Legge, sculptor*

Taking the Leap is the ideal handbook for emerging and mid-career artists. The art world is a fickle one, and exhibiting one's life work over the course of ten, twenty, or thirty years is an organic and unpredictable undertaking. *Taking the Leap* is a valuable guide for artists at any point in their life as an exhibiting artist.
> —*Carrie Lederer, painter and curator, Bedford Gallery, Dean Lesher Regional Center for the Arts*

Cay Lang's wise and practical advice provides information and inspiration to get serious artists headed in the right direction. It takes the art profession beyond theory.
> —*Vance Martin, art dealer, San Francisco*

You can pray for success as an artist, or you can read and use Cay Lang's book and actually do something about your future.
　　—*Michael Rosenthal, painter*

Taking the Leap is a kind of mini grad school for people just starting out or for working professionals who want to take their career to the next level.
　　—*Amy Berk, artist, publisher, and educator, UC Berkeley Extension*

Cay Lang's knowledge of the art world is grounded in the truth of her experience building a successful career as a fine artist. *Taking the Leap* is an invaluable resource for artists at any stage in their careers, from building a resume to writing a press release, and most importantly, completely demystifying the art world.
　　—*Sas Colby, artist and teacher*

Cay Lang's *Taking the Leap* strategies have guided the professional practices of artists just beginning their careers, mid-career artists who find they need a jump start to re-engage in the art world, and seasoned professionals who are handing over the business aspect of their studio practice to an assistant. Wherever you are on the journey of integrating your private studio practice with the mysteries of the art world, this book will prove to be your most valuable resource.
　　—*Susan Martin, sculptor and educator, San Francisco Art Institute*

My peers and colleagues now consider me a serious artist. *Taking the Leap* taught me how to run my business and to present myself as a professional, resulting in many more opportunities to show and sell my work.
　　—*Cynthia Lait, painter*

Learning the ins and outs of the art world is tricky. I figure that *Taking the Leap* saved me about two years of trial and error. For the serious artist, it's a great investment.
　　—*David Holmes, painter*

Cay Lang is a font of marketing information for artists. She shares this knowledge and guides artists through the art world labyrinth.
　　—*Frank Yamrus, photographer*

TAKING THE LEAP

LEAP

Building a Career as a Visual Artist

The Insider's Guide to Exhibiting and Selling Your Art

REVISED AND UPDATED

CAY LANG

CHRONICLE BOOKS
SAN FRANCISCO

Every effort has been made to obtain permissions for text and images rendered in this book. If an element has been overlooked, please alert the publisher. We are grateful to the artists, collectors, museums, galleries, and agents who granted permission to reprint the following works:

Page 1. Illustration by Richard Stine. © 1994 Richard Stine; page 23. *Back of Painting of Mount Slope.* © 1992 Edward Gorey. Reprinted by permission of Parnassus Imprints, Inc.; page 60. Drawing by R. Chast. © 1995 The New Yorker Magazine, Inc.; page 70. Calvin and Hobbes © 1992 Watterson. Dist. by Universal Press Syndicate. Reprinted with permission. All rights reserved; page 89. Drawing by Ziegler. © 1996 The New Yorker Magazine, Inc.; page 106. Drawing by Frank Cotham. © 2001 The New Yorker Magazine, Inc.; page 127. Drawing by M. Stevens. © 1984 The New Yorker Magazine, Inc.; page 148. *Masterpiece 1962.* © Roy Lichtenstein; page 164. Drawing by J. P. Rini. © 1993 The New Yorker Magazine, Inc.; page 189. Drawing by Glen Baxter. © The New Yorker Collection 2003 Glen Baxter from cartoonbank.com. All rights reserved; page 201. Illustration by Richard Stine. © 1994 Richard Stine.

ISBN-10: 0-8118-5093-5
ISBN-13: 978-0-8118-5093-3

Library of Congress has cataloged the previous edition as follows:
Lang, Cay.
 Taking the leap : building a career as a visual artist / by Cay Lang.
 224 p. 17.8 x 23.4 cm.
 Includes index.
 ISBN 0-8118-1815-2
 1. Art—Vocational guidance. I. Title.
N8350.L36 1998
702'.3—dc21 97-41038

Manufactured in the United States of America.

Cover design by Tim Belonax
Cover photograph by Grant Faint
Interior design by Amy Evans McClure
Typesetting by Donna Linden.

Distributed in Canada by Raincoast Books
9050 Shaughnessy Street
Vancouver, British Columbia V6P 6E5

10 9 8 7 6 5 4 3 2 1

Chronicle Books LLC
85 Second Street
San Francisco, California 94105

www.chroniclebooks.com

For Aaron and Sondra

Contents

Preface

As an artist just starting out, I was full of the excitement and intense terror that afflicts any traveler embarking on a journey to unknown shores where the inhabitants are rumored to be cannibals. Happily, after having lived in those once-foreign lands for many years, and after countless hours of arranging exhibitions and dealing with galleries, collectors, museums, critics, and publications, I can honestly report that although the excitement remains, the terror is gone. People are people, and art, as it turns out, is an ever-renewing spring, always fresh and clear. Gilbert and George once said, "To be with art is all I ask," and I, gratefully, agree.

When I first started exhibiting my art, straight out of art school, there were no signposts to help me find my way to becoming successful. Art schools do a great job of teaching artists about art, and a half-hearted to nonexistent job of teaching artists about the business of being an artist. I had to learn by trial and error (well, more by trial and error and error and error), and it took almost ten years before I really understood the fundamentals of how the art world worked. The art world is not all that complicated; part of the problem is that much of the interaction goes on behind closed doors and thus remains

shrouded in mystery, and part of the problem lies in the fact that each character in the story can see the plot only from his or her point of view.

As my art career unfolded, from showing in nonprofit spaces, to national gallery representation and publication in books and magazines, and eventually to visibility in international museums and galleries, I picked up more pieces of the puzzle. By 1990, I had been teaching photography to university students for some time, and every new batch of students would ask me, "How can we get our work seen and sold?" The answer was too complex for a ten-minute conversation, or even a semester's-length class, so I started the Taking the Leap program, condensing ten years of information picked up in the trenches into an intense six-month practicum.

The class was designed to be effective. I didn't want to create yet another situation where students dutifully attended a class, took great notes, and then filed them away somewhere for future use. I wanted things actually to happen for the students in a measurable way. I wanted them to experience the thrill of metamorphosis from art student to professional artist within the timeline of the class itself, and I wanted to be there to hear them come bouncing in to announce that they just sold their first piece, or got their first show, or won an award. I decided the class should meet weekly for no fewer than six months, limited the enrollment to twelve, and interviewed the students ahead of time to determine whether or not they were ready to market their work. The class turned out to be amazingly affirmative, with a high percentage of the artists going on to international art careers.

This book is designed to re-create as closely as possible the experience of the class. In a classroom situation, there is a lot of give and take: people ask questions, they get answers, people question the answers, other people question the questions. By the time we get through, everyone has a thorough understanding of the topic—not just How Things Are Done, but how the art world got that way, how it is changing, and what the options are. Creative people rarely want to follow rules, but my feeling is that if you know what is behind the rules, you can make intelligent decisions about how to use them, or change them if you like.

I am grateful for the many colleagues and friends without whose support, knowledge, and generosity this book would not have been

The object isn't to make art, it's to be in that wonderful state which makes art inevitable.

ROBERT HENRI

possible. It really does take a legion of contributors to make a book. I am especially grateful for the insider information so many busy art professionals unselfishly shared in the research and on the writing of this book: M. C. Anderson, of MC Gallery, Minneapolis; Paule Anglim, of Gallery Paule Anglim, San Francisco; Robert Brown, of the Robert Brown Gallery, Washington D.C.; Roy Boyd, of Roy Boyd Gallery, Chicago; Rosamund Felson, of Rosamund Felson Gallery, Santa Monica; Kim Foster, of the Kim Foster Gallery, New York; Gail Gibson, of G. Gibson Gallery, Seattle; Allene LaPides, of Allene LaPides Gallery, Santa Fe; Roberta Lieberman, of Zolla/Lieberman Gallery, Chicago; Benjamin Mangel, of Mangel Gallery, Philadelphia; Carolyn Miles, of Atrium Gallery, Saint Louis; Richard Nesbitt, of D.O.C.S. Gallery, New Orleans; Christine Normile, of Sherry Frumkin Gallery, Santa Monica; Janelle Reiring, of Metro Pictures, New York; Christopher Schmidt, of Schmidt/Dean Gallery, Philadelphia; Holly Solomon, of Holly Solomon Gallery, New York; Allan Stone, of Allan Stone Gallery, New York; Jeremy Stone, dealer/educator, San Francisco; and Martha Wilson, of Franklin Furnace Archive, Inc., New York.

Then there are the wonderful people whose insights have enriched the development of the program itself, whose experiences, generously shared, have added depth and color: Amy Berk, art critic; Bill Berkson, art critic for *Artforum Magazine*; Janet Bishop, curator at the San Francisco Museum of Modern Art; David Bonetti, art critic for the *San Francisco Examiner*; Frish Brandt, director of the Fraenkel Gallery; Jamie Brunson, artist and critic; Catharine Clark, of the Catharine Clark Gallery; Terri Cohn, writer/curator; Rene de Guzman, from the Yerba Buena Center for the Arts; John Delois, director of Space 743; Rene di Rosa, founder of the Di Rosa Art Preserve; Michael Floss, director of the Business Volunteers for the Arts; Marnie Gillette, director of SF Camerawork Gallery; Jo Hanson, artist; Kim Harrington, photographer; Robbin Henderson, director of the Berkeley Art Center; Jo Leggett, editor of *Photo Metro* magazine; Carrie Lederer, painter; Leah Levy, independent curator; Mark Levy, art historian; Suzy Locke, art consultant; Vance Martin, private art dealer; Lydia Matthews, art historian; Robert McDonald, independent curator; Judy Moran, curator, San Francisco Arts Commission; Douglas Nickel, associate curator of photography at the San Francisco Museum of Modern Art; Marian

Parmenter, director of the San Francisco Museum of Modern Art Rental Gallery; Stephen Pon, painter; Maria Porges, artist; Renny Pritikin, art director, Yerba Buena Center for the Arts; Harry Roche, art critic, San Francisco *Bay Guardian*; Joan Roebuck, of the Joan Roebuck Gallery; Chiori Santiago, art critic; Michael Shapiro, of the Michael Shapiro Gallery; Michaeline Stankus, art advisor; Elizabeth Sunday, photographer; Michael Schwager, director, Sonoma State University Gallery; Jason Tannen, artist; Tim Taylor, artist; Paul Tomidy, independent curator; Karen Tsujimoto, curator, Oakland Museum; Mark Van Proyen, painter and art critic; Tessa Wilcox, art consultant; and Jon Winet, artist.

In the process of assembling the book, I was afforded an excuse to re-connect with old friends I should never have lost touch with in the first place. Many thanks again to Terry Allen, Suzaan Boettger, Vanalyne Green, Rodney Harder, Ann Landi, Judy Malloy, and Yancey Richardson for their generosity and spirit.

My heartfelt thanks to all these generous people as well: Annie Barrows, Dewitt Cheng, Kate Chynoweth, Henni Cohen, David Featherstone, Julie Feinstein, Elaine Layton, Jay Schaefer, Veronica Sepe, Sacha Silva, Karen Silver, and Sarah Steinberg.

And that's all just for the first edition! For the revision, a number of amazing people came forward with their talents and expertise. Foremost among them are Tracy Rocca and Celina Cárdenas Peña. Tracy not only researched and outlined the information in the Internet chapter, but checked and rechecked the data. Celina single-handedly researched and built the extensive appendices, a major production in itself.

And still more thanks go to people who helped me along this journey with their insights and expertise: Kenneth Baker, art critic; Ben Blackwell, photographer; Jan Camp, artist and designer; Chris Eckert, Web designer; Kim Harrington, photographer; Carrie Lederer, painter; Susan Martin, sculptor; Suzanne Onodero, artist; Rachel Powers, Web designer; Alma Robinson, executive director of California Lawyers for the Arts; Michael Rosenthal, artist; Dan Sheehan, printer; Stan Stroh, sculptor; and Victoria Vargas, artist.

A big kiss for the most patient of editors, Steve Mockus, and he deserves it—I'm not the easiest writer to work with. I also want to thank Aunt Bertha, Joyce Aiken, Jackie Doumanian, Sas Colby, Bruce Lake, Frank Yamrus, and Wanda the Wondergirl, for supporting and entertaining me in real life, and just for being alive.

*I*ntroduction

or

How to Tell If You're Really an Artist, and What to Do about It

To be a successful artist, you need three things: curiosity, commitment, and good work habits. You were probably thinking I would say talent.

Talent, according to the prevailing wisdom, is a rare and unpredictable quality usually bestowed upon the lucky recipient at birth. It is commonly believed that if a person is fortunate enough to be born with talent, then everything he or she attempts will be effortless and will astound the world with its brilliance.

It's a compelling idea, but according to reports from certified geniuses like Einstein—who is reported to have said, "Genius is ten percent inspiration, ninety percent perspiration"—it is just a myth. Successful artists in any field will tell you that what appears to other people to be effortless talent is actually the result of single-minded hard work. Of course, people start out with different degrees of ability, but aptitude is only the starting point.

Let's not worry about whether you have talent. Talent is a nonissue. It can be neither measured nor defined, and agonizing over it serves no purpose other than to create both anxiety and, if you've developed a talent for worrying, an excuse for avoiding work.

Each of us, even the least complicated of us, is a vastly complex, endlessly fascinating creature, and the secret to creating art is to gain access to that creature and all that it knows. It is my suspicion that what appears to be talent is really just a doorway to a larger consciousness. As artists, we want to keep the door wide open all the time.

This brings us back to the qualities that *do* lead to success as an artist: curiosity, commitment, and good work habits. Curiosity is vital because an adventurous mind is at the center of all creative endeavors; commitment glues you to the saddle when the ride gets bumpy; and good work habits are necessary because nothing gets done by wishes alone. It's nice to have all three, but I have seen artists do very well with nothing more than meticulously applied work habits.

When I was an undergraduate art student, I was lucky enough to study with internationally acclaimed artist Terry Allen. I loved the class and worshiped the teacher, but I didn't always get my assignments in on time. One day a student asked Terry how you know if you are really an artist. Terry turned to face him and said, "An artist can't stop himself. He really has no choice about it." What an answer! I was mortified. I definitely was not an artist by Terry's definition. Even though I wanted to be an artist more than anything, I wasn't exactly clamoring to be in the studio. To be honest, I spent more time running away from making art than actually making it. Then one evening, after chastising myself for wasting yet another day, I finally understood what Terry meant. What he was really talking about was obsession. It didn't matter whether I was actually making art or not, because if I wasn't making art, I was torturing myself about not making art. *I couldn't stop myself. I didn't have a choice about it.* So my choice wasn't whether or not to be an artist, but whether to be an artist who worked or one who didn't.

Ask yourself this: Am I thinking about making art, or am I thinking about the Super Bowl, world peace, or maybe the laundry? If you find you are rarely thinking about art, then maybe being an artist wasn't your idea in the first place. It is possible you decided to be an artist because your mother noticed that you could draw great pictures of the neighbor's cat. She probably said something along the lines of, "It's a shame to waste your talent." You don't have to draw just because

The first hope of a painter who feels hopeful about painting is the hope that the painting will move, that it will live outside its frame.

GERTRUDE STEIN

Don't worry about your originality. You couldn't get rid of it even if you wanted to. It will stick with you and show up for better or worse in spite of all you or anyone else can do.

ROBERT HENRI

you can. You can do lots of things—like read a book, drive a car, hop on one foot—but you don't have to devote your life to them. Release yourself from this obligation and start enjoying the things you really want to do.

I mean it. Put this book down right now and walk away. An artist's life is not an easy one. Do not choose it unless, for you, any other choice would be unthinkable. An artist's career is a roller coaster of incredible highs and unbearable lows (followed by unbearable highs and incredible lows). The art world is fickle; the public will love you one day and ignore you the next. The need to make art will be the one constant in your life as an artist; a deep connection with the art itself is the thing that will sustain you.

Art history is a centuries-long conversation told in pictures. As each new generation enters this conversation, the artists listen to what has been said before, listen to what their inner voices tell them, and then speak, hoping to say something new. It's not easy to find something fresh to say, but what is even more difficult is to know what your own truth is and to speak it regardless of what the art world or anyone else has to say about it. Achieving that kind of authenticity is a tall order, and it is a lifetime job.

Finding your own voice means getting your hands, your eyes, your heart, and your mind in alignment within your work. If, for instance, you've learned to draw very well but you don't have a clue what to draw, then you have your hand and your eye in the work, but you now need to bring your heart and mind to it. If you have lots of great ideas that feel earthshaking in their importance but you don't know how to convey them, then it's time to develop your hand and your eye. This may seem like a simplistic formula, but it can be useful in helping you identify your strengths and weaknesses. If you need to improve your technical skills, find the best teacher you can. If you already have your skills together but you're not sure what you should be doing with them, I suggest keeping a visual diary. A visual diary, a journal of ideas and thoughts about your art, is also known as an artist's notebook. This is a time-honored tradition among artists; almost every important artist you can name kept a visual diary of some kind. It worked for da Vinci; there is no reason it can't work for you. Choose a bound book with unlined pages. It should be large enough

for making drawings comfortably, and small enough so that you are inclined to carry it with you. Make a habit of working in it daily; sketching ideas and writing down insights.

Here is an exercise for discovering your mission as an artist. Each night before you go to bed, write or sketch three ideas for your art in your journal. Don't make a big production out of this. It doesn't have to take an hour; sometimes five minutes is all you will feel like giving to it. The ideas don't have to be good ones, and you don't ever have to follow through on making them. You just have to imagine them and write them down, or make a sketch if you like. The point is to bring your attention to your work, and to notice the ideas that occur. Within a short time, a week or two, a pattern will begin to emerge. As you browse through your journal, you will notice that some of your ideas aren't so bad, some are truly stupid, and some actually seem deep and important. Pay close attention to these ideas. This is your heart speaking. It is telling you where your work wants to go. Once you begin working on a project, continue keeping the diary; the work will become clearer daily.

Knowing when you are ready to start exhibiting your art is one of the most bewildering issues an artist has to face. One problem is that we are led astray by our egos. Your ego will tell you what a genius you are and that the world needs your profound insights, and two minutes later it will turn around and announce that you are too stupid to live. I have been making art for more than fifteen years, and my ego still does this to me regularly. It is not uncommon for me to wake up in the morning, take a look at yesterday's work, and be overcome by my own blazing brilliance, only to replace that warm feeling with the deepest despair at the end of the day.

When it comes to putting your work out in the world, you will need a more reliable way to measure when you are ready. One way to gain a wider vision is to show it to people you respect and ask for their feedback. Likely candidates for this are art teachers and artists who are knowledgeable and accomplished in your area of art. If this is the first time you are showing your work to anyone, you will probably be feeling a little apprehensive about asking for feedback. Think carefully about whom you choose to ask, and show the work to several people, not just one. Don't put yourself in the position of allowing one

One's mind, once stretched by a new idea, never regains its original dimension.
OLIVER WENDELL
HOLMES, SR.

person's opinion to carry too much weight. We have all heard stories about important artists whose teachers told them they would be better off planting radishes. Thankfully, those artists ignored that advice. Remember that, in asking for feedback, you are gathering responses to help you understand the impact of your art, that is all. Ultimately your opinion is the one that counts most.

Another way to judge how your work will fit into the marketplace is to frequent art galleries and museums. The exhibitions at contemporary art galleries change every month or two. Not only will you get to see some terrific art, but you will soon get a feel for what is being shown and sold. If you live in a major city, make a habit of seeing these shows regularly. If you don't live in a major city, make special plans to visit one; it will be well worth the effort.

Art is either plagiarism or revolution.
PAUL GAUGUIN

Some artists complete three paintings and start exhibiting right away. I think this is a mistake. You need time to develop your craft. You need time to find your voice. These things should occur in the privacy of your studio, not in the public forum. If the art world is confronted with underdeveloped work, it won't be interested in returning for a second look. Also, it is necessary for an artist to be free from public response, both good and bad, while the artwork is still in its formative stage. It is easy to ruin a promising body of work by exposing it to public scrutiny; you will either gain so much praise you won't need to finish the work, or so much criticism that it destroys your creative impulse.

In order to market your art, you need a body of work to market. A body of work is a series of pieces that holds together in some way, that seems to have something in common. Usually each piece employs the same medium, like oil paint, but a body of work must be more specific than that. The art must be united thematically or stylistically, and usually both. A body of work can't just be the same painting repeated with minor variations; it should show an in-depth exploration of a single idea, or related ideas. It should engage the viewer in that exploration, and each piece in the series should expand the viewer's understanding of the ideas the artist is pursuing.

Once you have found your voice and developed a cohesive body of work, in order to establish a career as a successful visual artist, you must have a clear understanding of how the art world works—who

the important people are, what their backgrounds are likely to be, what their prejudices are, what their days are like, where their skills and interests lie, what their bottom lines are, which institutions and galleries are available to artists, how to approach them, and on and on. If you don't want to take the time to learn all this information about the marketplace, you will need to hire someone who does. Or you can be like Blanche DuBois and rely on the kindness of strangers. Hers was actually not a bad plan for artists of former generations, when the world was a kinder, slower place and there were fewer artists. Today the art world, like the rest of the Western world, is experiencing the aftershock of frequent economic and political changes; the waters are in turmoil, castles are tumbling, and there are still quite a few sharks near the shores. As an artist, you need to know what to expect and how to deal with it.

This book is designed for use by artists at all levels of their careers: artists just getting out of school ready to fast-forward to success and fame; midcareer artists who want to accelerate the progression of their careers; and once-active artists returning to the art world after an absence. Each category of artist will want to use the book in a different way.

If you are entering the art world for the first time, or if you are returning after a prolonged absence, read the chapters in sequence. Beginners should read them in sequence because they won't want to miss any of the information; returnees because the art world has changed a lot in the last few years. The organization of the chapters is designed to follow a natural progression of activities, each chapter building on the last. Reading the chapters in order will provide a fundamental understanding of the world you will be entering, as well as demonstrate the activities you will be undertaking, in an organized and easy-to-follow manner.

If you are a seasoned artist, use your intuition about which parts are appropriate for you. You already know some of the information, and other ideas will be quite new to you. Chapter one might be a good place to start, since it examines a wider range of exhibition possibilities than is normally associated with the art world; then maybe chapter four, which discusses career strategies in detail. Once you have your plan in mind, look at the earlier chapters to fine-tune your

The creative habit is like a drug. The particular obsession changes, but the excitement, the thrill of your creation lasts.
HENRY MOORE

promotional materials. Chapter two will professionalize your artist's packet, and chapter three is good for helping you focus on your choices. Chapter five discusses gallery relationships and negotiations; chapter six provides tips for organizing your workspace and streamlining tasks. In chapter seven, you will find step-by-step directions for every aspect of staging your own exhibition, and in chapter eight secrets to effective networking. Chapter nine will help you build a distinctive artist's Web site. Chapter ten will teach you how to get, and keep, the media's attention. Take a look at chapter eleven, as well, since it addresses problems specific to the midcareer artist.

The big secret for all readers is to *use* the information as you learn it. Maybe you can't act on everything immediately (unless you have unlimited time, a trust fund, and an office of secretaries at your disposal), but make a point of starting to integrate some of what you are learning into the way you live now. Don't wait until you win the jackpot; you may be waiting a long time. Start living your life as an artist now. All big goals begin with little steps. And don't forget, choosing to be an artist is a good and generous act. The world needs its artists, whether it knows it or not.

Art happens—no hovel is safe from it, no prince may depend upon it, the vastest intelligence cannot bring it about.

JAMES McNEILL
WHISTLER

A World of Possibilities

Richard Stine © 1994

In the art world, the hottest issue today is guaranteed to be old news by next week. Art may be eternal, but the attention span of the art world is roughly the blink of an eye. In your lifetime as an artist, you will see dozens of art movements come and go, hundreds of galleries spring up and disappear, and governments at all levels alter their policies regarding the arts. Entire mechanisms for support of the arts will collapse and then be replaced by something new, and painting will be declared dead at least once every five years. If you take all of this as a given, riding the ups and downs of your career will feel like an unfolding adventure rather than a series of unexpected jolts.

What doesn't change, however, is the impulse to create. Artists will always make art; we can't help ourselves. Imagination is inherent in the human species. This ability to wonder "what if?" is what makes us different from the rest of the animals on the planet. Blessed with a creative intelligence, and our amazing opposable thumb, human beings were born to be artists.

In Europe, before the mid-eighteenth century, artists made their living by fulfilling commissions for the church or the king. There was no great division between the kind of art they created as work and what they did as art. Today, there are no great patrons existing to support the arts on such a scale. This lack of support brings with it a lack of external control. With the end of the patronage system, artists began to turn their attention to subjects other than the glorification of the king or the church.

> *If I didn't start painting, I would have raised chickens.*
> GRANDMA MOSES

The concept of art-for-art's-sake is fairly new. This is what the art critic Thomas Crow calls "freely conceived art" and what contemporary critic Bill Berkson christened "art that nobody asked for." Art today can be seen as a response to both the breakdown of the royal and clerical patronage system and the democratization of Western culture. Over the past two centuries, artists began to make art on their own cognizance; nobody was supplying them with subject matter. At the same time, salons began to be organized to exhibit this new work to the general public and art became available to the shopkeeper as well as the aristocrat.

No one knew what to make of an art that was no longer defined by the exterior restrictions of religion and class. How did one know if the art was any good, or even what it was about? Hence the birth of the art critic (an expert to help people figure out what to think), the gallery system (with its experts to help people spend their money), and the art market (all those experts who participate in the buying and selling of art).

The gallery system has become the principle means by which artists reach the public. Traditionally the gallery system has worked this way: The artist labors in a garret and, at some point, if lucky and talented, is discovered by a gallery. The artwork is then consigned to the gallery to be displayed and sold. (Notice that the work is *consigned*

to the gallery, not sold to it—an important distinction indicating that the gallery, not the artist, is setting the rules here.) If the work is purchased, the artist receives a percentage of the selling price; if it isn't, the gallery holds it for a while and eventually either sells it or returns it to the artist.

This doesn't sound like a terrific deal for the artists, and certainly no other kind of manufacturer would consent to so one-sided an arrangement; but artists do not define themselves as manufacturers. They are seekers on a quest. As any hopeful before the divine, an artist only wishes to be found worthy (and, one hopes, to gain wealth and fame in the bargain). Acceptance by a gallery conveys worth and brings the art to the attention of critics and collectors. Since the gallery makes all the career decisions, the artist is free to do what he or she wants to do most, make art. The problem with the gallery system is that it is modeled on a parent-child relationship, with the artist (as child) relinquishing control over personal affairs to the gallery. If the gallery is a wise, affectionate, and savvy parent, this arrangement can be beneficial for both parties. But how many of us feel our parents did a perfect job? And, more to the point, why should a stranger be any better?

The traditional gallery system does have its attractions, however. Let us say you were accepted by the perfect gallery in the 1960s; what could you expect? You could expect the gallery to mount a yearly solo exhibition of your work, handle all the advertising and publicity for your show, and constantly court the art critics, museum curators, and especially the art collectors. The gallery would arrange for the framing and hanging of the show. It would negotiate with clients to get the best prices for your work. Between shows, it would keep your art on hand and unfurl it proudly for prospective collectors throughout the year. It would secure the payment from your sales, subtract a percentage as commission (it used to be as low as 10 percent in Van Gogh's day, but has been increasing steadily over the years so that now the standard is 50 percent, edging toward 60 percent), and promptly deliver the rest to you. If you were experiencing hard times, the gallery would remain steadfastly by your side. It would advance you money when you needed it and say "there there" when you were having trouble sleeping.

The true work of art is but a shadow of the divine perfection.
MICHELANGELO

Leo Castelli was the epitome of this kind of dealer. Stories abound of his generosity and support for the artists he represented. If he mounted a show of an artist's new work and nothing sold, he would either buy the art himself or advance the artist money against future sales because he *believed* in the value of the work. Castelli was in it for the long term, and most of the artists he represented—Jasper Johns, Robert Rauschenberg, and Roy Lichtenstein, to name a few—have become household names.

Examples such as this are wonderful, but they have filled today's artists with unrealistic expectations when they search for a gallery to handle their own art. Times have changed. The yearly solo show is a thing of the past, and shows are now scheduled two to three years in advance. Galleries still arrange the publicity for their exhibitions (design and print announcements, write press releases, contact critics), but increasingly they are asking the artist to share in these costs. In the current economy it is common practice for galleries to offer discounts to important collectors, art consultants, and other dealers and museums (usually around 20 percent). In the past, the galleries absorbed these costs, now they ask the artist to share them. Framing the art is now often the artist's responsibility, as are all or part of the shipping costs. The gallery staff labor enthusiastically for the artist while the exhibition is installed, but once it is down, most of their energy is occupied by the next artist's show. Although the standard gallery-artist split has been fifty-fifty for quite a while, I have recently begun hearing rumors of galleries asking for sixty-forty, in their favor. In fairness to the galleries, the economic ups and downs of recent years have been very difficult for them. The galleries that survived did so by tightening their belts, giving discounts on artwork, decreasing their staff, and increasing their artist base.

A quick chronology of changes in the art world occurring just in my short lifetime might help you acquire a larger worldview. In the 1970s, when I entered the scene, the art world was proceeding just as it had for a century or so, with artists making art, critics discussing it, curators looking for historical links, and galleries selling it to a small group of people who cared passionately about being a part of it all. Some artists and galleries did well, others didn't; no one became outrageously rich, but everyone was in it for the love of art and there was a balance to the whole mechanism.

I don't believe in art.
I believe in artists.
MARCEL DUCHAMP

In the 1980s, art became fashionable, and suddenly everyone with money to play with and an eye for a quick buck started buying art. Prices soared. Auction houses astounded everyone by commanding higher prices with every sale. Contemporary art was selling almost as fast as it was being made, and no price seemed too high. International magazines and newspapers reported record sales daily, and more new art lovers joined the fray. Universities expanded their art departments, and enrollments multiplied.

In the 1990s, the economy collapsed, the entire country went into a recession, and artists were left with art that no one would buy. Artists who had become accustomed to a life of international jet setting suddenly found themselves working menial jobs just to pay rent. You would be surprised at the list of talented and famous artists who found themselves in this situation. The mistake they made was in thinking that they were on an ever-ascending staircase, rather than a roller coaster, which can (and will) swoop down as well as up.

It is not clear that intelligence has any long-term survival value.
STEPHEN HAWKING

Suddenly the art was priced too high, and everyone was reducing spending; collecting art was no longer the cool thing to do. The art schools, however, continued to pour out hopeful young artists, many of them filled with expectations of wealth and fame, but now there was no longer a system in balance to support them. There were too many artists, not enough galleries, and not enough collectors.

As you can imagine, the art world looked pretty bleak as the 1990s progressed. Many galleries could no longer afford the high rents they had been paying. At the height of the recession, an article in the *New York Times* reported that as many as thirty art galleries a month were closing in New York City alone. This seems an exaggeration, but there is no doubt that the face of the art world was changing dramatically.

Since then, the art world has bounced back, but not with the kind of stability it once took for granted. Depending on whom you are talking to: Everything Is Bountiful, or the Cupboard Is Bare. Both groups are telling the truth, because both things are happening. From non-profit and commercial galleries and organizations you will hear reports from both ends of the spectrum: some are doing well beyond their wildest dreams, while others are closing down.

Many factors contribute to this situation, not the least of which is the Internet. With access to the Internet, you can find collectors,

audiences, and supporters without ever walking into a gallery. For the first time in history, you can do away with the middleman, if you choose to.

As an artist, you will need to make decisions about whether or not to pursue representation by a commercial gallery. The answer will be based on your ultimate goals. Nowadays, most successful artists work both inside and outside the gallery system. If you are determined to make it in the Big Time—that is, to gain international recognition for making a significant contribution to art history and to have your art sold to important museums and private collectors—then eventually you will need to enter the gallery system. There is no doubt that representation by a respected gallery significantly adds to an artist's status. In addition, the gallery often has access to influential collectors and art professionals who are difficult for an artist to reach alone. But each gallery approaches these things differently, with varying levels of expertise and commitment. It is not uncommon for a gallery to take on a new artist, put out a little effort, and eventually consign the work to a drawer in the back room, where it is occasionally pulled out to show to clients. At that point, the only advantage of being in the gallery is for the status, a dubious advantage at best.

If you care more about sales than recognition, there are many options open to you. Galleries, of course, are one way to go, but you can also market your art yourself via the Internet or by putting on your own exhibitions. You can sell your art through art consultants, poster and greeting card companies, open studios, and even mail order.

To help you decide how best to get your work seen by the public, it might be useful to look at the structure of the art world, specifically how the pieces fit together and how each part functions.

All art has this characteristic: It unites people.
LEO TOLSTOY

The Exhibition Spaces

Established exhibition spaces fall into seven categories: museums, nonprofit galleries, alternative spaces, commercial galleries, university galleries, artist co-ops, and online galleries. I have also added an eighth category, called *nontraditional venues,* which is a catch-all for everything else. Each type of exhibition space has a different focus, although there is often some overlapping of functions.

Art World Ladder of Success

Type of Exhibition Space	Status Indicators	Publicity Indicators
World-Class Museums		Favorable Review in the *New York Times*
High-Profile New York Galleries	Shiny Floors, Art Hung Sparsely, Stylish Staff	Not So Good Review in the *New York Times*
National Museums		
High-Profile Galleries Not in New York		Feature Article in a Glossy Art Magazine
High-Profile Alternative Spaces		Reviews in Glossy Art Magazines
Medium to Small Museums		Reviews in National Newspapers
Most Commercial Galleries	White Walls, Art Installed Carefully	Reviews in Regional Art Magazines
University Galleries		Reviews in Local Newspapers
Low-Profile Galleries	Boutique Atmosphere, Many Kinds of Art, Haphazardly Displayed	
Restaurants, Hotels, Retail Stores, Cafés, Beauty Parlors	Primary Activity Is Eating or Grooming	Calendar Listings in Local Newspapers
Your Home	Work Hung in Bathroom	Your Roommate Likes It

Museums. As keepers of culture that collect and preserve art and hold it in trust for future generations, museums perceive their role in the art world to be historical. The names of many museums reflect a specific focus, like the Museum of Modern Art or the Jewish Museum. Since the emphasis of a museum is on art history, it will generally be reluctant to show work by emerging artists. In order to obtain a show in a museum, it is necessary to gain a reputation for your art first through another venue, such as a commercial or nonprofit gallery, or a media-attracting public event. Museums are dependent upon memberships, grants, and major donors for their financial support. Museums do not sell art, except through adjunct galleries that are usually organized as art rental galleries. Museum rental galleries exhibit art by local artists rather than work from their permanent collections.

Nonprofit galleries. Nonprofit art galleries are similar to museums, but they tend to be smaller and lack permanent collections. Instead of a historical focus, they usually emphasize contemporary art. Like museums, they are supported by memberships and grants. There are several kinds of nonprofit spaces: municipal nonprofit spaces, nonprofit spaces focused around a specific medium or issue, and alternative spaces.

Municipal nonprofit spaces are usually created under the auspices of a city or county government. They may be run by city employees and be funded directly by the city, or they may be administered by an adjunct group that raises the funds for the gallery by using the city's nonprofit status as an umbrella. Most American towns and cities have at least one municipal nonprofit gallery. You can usually recognize them by the words *Art Center* or *Cultural Center* associated with the name of a city, as in the Berkeley Art Center and the Chicago Cultural Center. These galleries tend to focus on art by local artists, which makes them ideal candidates for emerging artists. Because a government organization is involved, municipal galleries tend to favor artwork that does not disturb the status quo.

Issue-focused and medium-specific spaces are created by groups of people with an interest in a specific kind of art. The International Center of Photography and the Drawing Center, both in New York City, and the Photographic Resource Center in Boston are examples of galleries established around a specific medium. Examples of issue-

The universe is full of magical things patiently waiting for our wits to grow sharper.
EDEN PHILLPOTTS

oriented spaces are The Sacred Circle Gallery in Seattle, which exhibits Native American art; the Art Research Center in Kansas City, which focuses on art and science; and the Yerba Buena Center for the Arts in San Francisco, which emphasizes cultural diversity.

Alternative spaces. Alternative art spaces tend to show work that is on the cutting edge. This type of gallery first appeared in the art world in the 1970s, during the heyday of performance art, conceptual art, and mail art—all the art forms that are now called *new genres*. Artists were fed up with the commercial emphasis of the art world. They wanted a place to show experimental art that wasn't influenced by its ability to sell, so they rented buildings and inaugurated their own galleries. Many of the early alternative spaces have not survived into the New Millennium, but an amazing number of the best ones are still with us, and new ones are being born daily. Today's alternative art space is usually an artist-run nonprofit space with a small staff and most of the work performed by passionate volunteers. Budgets for alternative spaces are usually small. If your art falls into the new genre category, alternative spaces are perfect for you; if you happen to be a traditional painter, probably not. Things move slowly at alternative spaces. Exhibition schedules are often decided by committee, and the staff is always overworked and underpaid, so be patient. Shows change regularly and are usually accompanied by announcements and receptions, just like uptown. Some of the better-known alternative spaces include the Clocktower Gallery and the Kitchen in New York, LACE (Los Angeles Contemporary Exhibitions) in Los Angeles, and The Capp Street Project in San Francisco.

Many a man fails as an original thinker simply because his memory is too good.
FRIEDRICH NIETZSCHE

Commercial galleries. The business of selling art falls to commercial galleries. They bring the latest art-world discoveries to the people who will buy them, mostly the wealthy. This means they must maintain a look of wealth themselves. To hang the art, they have to rent large spaces in high-rent neighborhoods, then decorate and maintain those spaces to pristine perfection. Most gallery owners do not have art history backgrounds, just a love of art. Many of them once planned to be artists, but got sidetracked along the way. Quite a few of the most successful gallery owners come from wealthy backgrounds; this gives

them access to the right people, which is good for the artists who are with them. Sometimes running the gallery is just a hobby, which is not so good for the artists. If a gallery owner isn't rolling in money, he or she is going to have to work very hard to succeed.

When a commercial gallery considers an artist's work, money is always the bottom line. The expenses are just too high for an owner to behave otherwise. That is not to say that galleries don't occasionally take work they know will be difficult to sell. They do, but they have to balance it carefully with more accessible work in order to keep the doors open.

When investigating galleries to handle your work, bear in mind that galleries are as individual as the people who own them. Each gallery has a specific focus. Determine what it is before you contact the gallery. If you are not sure how to do this, examine chapter four for some pointers. Don't waste your time bringing feathered jewelry to a gallery that handles only vintage photographs. Edith Caldwell, who owns a contemporary realism gallery in San Francisco, reports that every day she receives slides from artists whose work holds no relationship to the realistic paintings her gallery is known for. Not only does this waste a gallery director's time, it tends to put him or her in a bad mood for the next artist who comes along.

Commercial galleries vary widely in terms of status in the art world. You can usually discern the status of a gallery the moment you walk in, even without looking at the art. In general, the whiter and emptier the walls, and the shinier the floors, the more "important" the gallery is. To make it easier to recognize the kind of gallery you are in, I have divided contemporary art galleries into four distinct groups: the New York model, young and hot, boutique-style, and the disreputable gallery.

The New York model is the one I described above. The walls are white and freshly painted; the floor shines. It holds mostly one-person shows, and the exhibits change every month. The gallery designs and prints announcements for each new show and hosts an opening reception. The high-profile galleries get reviewed in the newspapers. Check out the outfits of the gallery staff. Do their clothes look expensive, with just a touch of insouciance? You are probably in a New York–style gallery.

Even if you're on the right track—you'll get run over if you just sit there.

ARTHUR GODFREY

Young and hot galleries follow the style of the New York model, but with a smaller budget. The director and the artists are usually newly out of art school, and they make up for limited funds with a nonchalant attitude and imaginative events. Exhibits change monthly, the gallery space is usually in a trendy but dilapidated part of town, and they often get reviewed. If your work fits into this category (and you fit into the twenty-something age bracket), hooking up with a young and hot gallery could be just the right thing for your career. You and the gallery can ascend the success ladder together.

Boutique-style galleries can be recognized by a wide range of artistic styles and mediums packed into one space. In a boutique-style gallery, it is not unusual to see watercolor paintings by one artist displayed next to oil paintings by another, with a jewelry display case next to a ceramic sculpture. There are no regularly changing exhibitions here; the gallery director will hang a piece for a while and change it when the spirit moves. Boutique-style galleries hold no receptions and rarely get reviewed. Showing your work in this kind of gallery is not going to help you become famous, but you may sell some work.

Disreputable galleries are the ones to watch out for. They are often located in high-traffic tourist districts, such as Fisherman's Wharf in San Francisco. Not all galleries in tourist areas fall into this category, but a tourist area is a perfect location for a disreputable gallery because most of the people who walk in don't have any knowledge of contemporary art. These galleries snag unwary customers by promising them that the work they are buying is an investment that has surged in value. Often, the real reason the value of the work has increased is that after selling the first piece by that artist, the gallery has doubled the price on the second. The gallery operators trap unwary artists into signing ironclad contracts that basically put the artists into a type of forced servitude. I have heard of contracts that not only require an artist to complete a certain number of paintings a week, but dictate subject matter and style. A gallery contract can be a good thing (we will talk about them in Chapter five), but never sign one without careful scrutiny. If possible, show it to a

> *The reasonable man adapts himself to the world; the unreasonable one persists in trying to adapt the world to himself. Therefore all progress depends on the unreasonable man.*
>
> GEORGE BERNARD SHAW

lawyer. If you don't have access to a lawyer, check out the appendices in this book for some leads, or call your state art council for a referral.

University galleries. There are often several different kinds of gallery spaces on university and college campuses, and they are wonderful places for emerging artists to show their work. The big universities usually have a museum (which is commonly reserved for showing established artists), but there is often gallery space available in the art department, the design department, or the student union, and sometimes in campus hallways. At least one of these spaces may be available for off-campus artists. The shows are often curated by a teacher, who is willing to look at work by lesser-known artists. Although these shows rarely have receptions or announcements, they do carry the prestige of the university, which is a nice thing to add to your résumé. If you have a show at a university, your work will be seen by hundreds of students; while they often make an attentive and inquisitive audience, you probably won't sell any work.

Artist co-ops. Artist co-ops are the art world's equivalent of the literary world's vanity press. They flourished in the 1970s, the same time as alternative spaces. A group of artists would get together, find a space, share the cost of the rent and the work duties and, in exchange, each artist would get a yearly show. This is a great way to gain hands-on experience in running a gallery, and if you're the kind of artist who works best with a deadline looming ahead of you, co-ops are good for helping you get some work done. You will meet some nice people, but don't expect the co-op to assist your career much. Since everyone knows the artists pay to exhibit there, the shows usually are not reviewed. Each co-op is organized a little differently, but the ones that set aside a part of their gallery space for nonmember shows tend to be taken more seriously. If you live in a city with an active art community, consider other exhibition options first; but if you reside in a small town, a co-op gallery can help create fellowship among artists and establish a support system for art.

Online galleries. These come in many forms. Some are basically online versions of real-life galleries, while others exist in cyberspace only. As

I have walked this earth for 30 years, and, out of gratitude, want to leave some souvenir.

VINCENT VAN GOGH

with all galleries, the quality and exposure varies from site to site. Each artist needs to get his or her work online in some form; we will discuss the options in more detail in chapter nine.

Nontraditional venues. This is the term I use for anything that doesn't fit into the categories listed above. A nontraditional venue can be any place that isn't customarily considered an exhibition space, such as a restaurant, a bank, a one-night gallery, a hotel room, a corporate building, a storefront window, a coffee shop, a hospital, a hair salon, a nightclub, a shopping bag, a shopping cart, a Web site, or a public-access television show. The possibilities are as endless as your imagination. Creating or discovering a new place to show art is a great way to be involved in your community. Art shown in a café is art that is participating in the culture, rather than being isolated from it. This adds vitality to the community. The disadvantage is that there is no gallery staff to attend to details like opening receptions, show announcements, press releases, and sales. You will have to take responsibility for those things yourself. The advantage is that you gain control over those elements; and if the event is conducted with panache, you may attract more public attention than you would with an ordinary gallery show.

Who the Players Are

The artist. That's you. I don't need to say much about the artist except to remind you that, as the artist, *you are central* to the whole mechanism. Without the artist, there is no art world.

The curator. An art curator may work at a museum, nonprofit gallery, or alternative art space, or have a freelance career. The curator's job is to recognize trends in art-making and create themes for exhibitions based on what he or she sees and thinks. Curators select the work, oversee the hanging of the show, and write about the work for a catalog, if there is one. They are often expected to raise the money for the show, as well. They are paid by the institution for which they work.

Curators at museums usually have a background in art history; the more prestigious the museum, the more extensive the curator's art history credentials will be. They work long hours for amazingly low

pay. It is not unusual for a curator to devote well over forty hours a week overseeing installation of shows, writing catalogs, applying for grants, maintaining a permanent collection, and going to committee meetings. On top of all their other duties, they are expected to attend evening social functions such as exhibition receptions and fund-raising dinners, sometimes several times a week. Most of the curators I have met care passionately about art. When they look at art, it is from the point of view of art history, and the questions and issues they raise will reflect that. When they look at art by lesser known artists, they are doing so to acquaint themselves with new work being done in their area in order to generate new ideas for shows. They are not interested in what they call derivative art—art that mimics another artist's work. From the point of view of art history, there is already one Matisse; we don't need thirty more. Curators will be most interested in art that breaks boundaries or that makes them see things in a new way.

An art school is a place where about three people work with feverish energy and everybody else idles to a degree that I should have conceived unattainable by human nature.

G. K. CHESTERTON

Curators for nonprofit and alternative art spaces work just as hard and get paid even less. Often they are artists themselves, juggling creative and curatorial careers at the same time. Since the curatorial focus at nonprofit spaces is usually on contemporary art, rather than its historical precedents, these curators will be interested in a wider range of work. They still have to stay within the defined focus of their gallery, however, so determine that your art fits before approaching them.

The art dealer. The role of the art dealer is to sell artwork, so the art dealer can usually be found in a commercial art gallery, although some private dealers do not maintain a public space. Sometimes the terms *dealer* and *gallery* are used interchangeably. It is the dealer's job to do whatever is possible to advance the artist's career so that the value of the work continues to grow. Dealers, who usually represent fifteen to thirty artists, spend a lot of time on the phone trying to bring in curators, collectors, and critics to see the work they carry. They

plan career strategies, store artwork, and arrange exhibitions. In exchange, they usually expect exclusive rights to the sale of your art within their immediate geographic area. Beware of any dealer who asks for worldwide rights unless that dealer has unusually extensive art-world connections. Even then, I'd think twice. How can one dealer be everywhere at once? Sometimes, in a large city like New York, an artist will have two galleries, one uptown and one downtown. This arrangement should be done with the full knowledge and agreement of all parties concerned. Art dealers are fond of calling the artist-dealer relationship a marriage, which basically means they need to feel they can trust you to treat them fairly and honestly. You should expect the same in return. The standard artist-dealer relationship is fifty-fifty on any sales made by the gallery, although I am hearing tales of galleries asking for 60 percent. This can go the other way, too; if an artist is very well known, and the gallery expects an increase in business by taking on that artist, the gallery sometimes offers to reduce its commission to 40 percent.

The art consultant. The art consultant does not belong to a gallery. He or she is hired by collectors or corporations to help them acquire a collection of art. The difference between an art consultant and an art dealer is that while an art dealer shepherds the careers of a number of artists, art consultants have no such allegiances. Their job is to oversee the creation of an art collection based on the client's interests and needs. For instance, the client may be a trucking company with an urge to fill all twenty-three offices with pictures of trucks. The art consultant's job is to find a selection of images of trucks for the client to choose from. The art consultant rarely keeps inventory in stock, but likes to have a varied collection of slides on hand. Most art consultants don't maintain a gallery space and expect no exclusive rights. They generally are paid a fee by the client but also expect a discount from the artist, anywhere from 20 to 50 percent. If they buy work through an art dealer, they will expect the dealer to give them a discount (usually 20 percent), which the dealer may or may not require the artist to share.

> *The annual output of all American art schools is probably around 35,000 graduates.*
> ROBERT HUGHES

When you send your slides to an art consultant, don't expect an immediate response. Sometimes the slides are kept up to a year before anything happens. Then again, you might receive a phone call within a week announcing ten pieces have just sold. This happens most often in booming economic times; but working with a good art consultant is still a great way to sell art. Since art consultants sell mainly to corporations and the work is hung in public buildings such as hospitals, hotels, and corporate work spaces, they will be looking for art that doesn't offend anyone. If you are making paintings of copulating crayfish, the art consultant is not for you.

The agent. I get at least one phone call a week from some young artist asking if I can recommend a good agent. Unfortunately, I never can. There are lots of agents in the commercial art world, as in the literary world, but not in the fine art world. That is probably because art dealers have traditionally done the work of an agent, which is to manage the artist's career. With the decrease in responsibility on the part of the galleries, the idea of an agent has become more and more attractive to artists. There is obviously a need. But a problem arises with how they are to be paid. Some agents want to be paid a set monthly fee by the artist; while this makes sense for the agents, most artists don't have the money to pay them. Others try a percentage system (say 15 percent, like literary agents), but the problem is that almost everyone else in the art world—like galleries and art consultants—expects a percentage as well, and they are not always happy to share. Most agents I know end up becoming private dealers or move on to some other role in the art world. The one or two successful artist agents I have known were already well connected in the art world and were careful to take on only a handful of well-established artists.

The art collector. There can never be enough of the rare breed known as the art collector. Although the stereotype is the wealthy socialite, anyone can become a collector. All one really needs is a love of art. Vance Martin, a private art dealer in San Francisco, once told me that his real job is to be an educator, to help collectors develop their eye. A

new collector will come to him wanting to buy a piece by some well-known artist, such as Ansel Adams. The dealer will help the collector buy the piece, and then he will show him other work, work by artists who may not be so obviously in the public eye. The more the collector sees and has a chance to talk about art, the more sophisticated his way of seeing becomes. He eventually ends up with a collection that is uniquely his own.

Your first collectors will be your family and friends. Don't shy away from this; every artist started this way. See it as a first step on your way to a healthy career. When a friend asks to buy a piece of your art, your first impulse will probably be to say, "Oh no. Here, I'll just give it to you." Fight that impulse. If your friends want to buy your work, let them. They want to show their support for you. They want to be part of it all. In years to come, they can say they "knew you when" and brag about how much more the work is worth today.

No statue has ever been put up to a critic.
JEAN SIBELIUS

The critic. Every art critic I have ever met has held a definite opinion about the role of art criticism. No two definitions have ever been alike. I have come to the conclusion that the job of an art critic is to have an opinion. It is better if it is an informed opinion, but this gets confusing since all of them believe that theirs *is* an informed opinion. Since there is no way to measure this, and really no criteria for becoming a critic, the question becomes moot. All it takes to become a critic is to write a review that someone is willing to print, which is surprisingly easy. Some critics have art history backgrounds, some have writing backgrounds, and many of them are also artists. Most express a very definite set of ethics (such as a taboo against writing reviews of their friends' work, or accepting gifts from artists) but, as with everything, the definitions of what is ethical vary widely. Critics get paid almost nothing for their work, so, just like artists, most of them hold a second job as well. It takes a lot of courage to be an art critic and to put yourself on the line in print, particularly since the rewards are dubious. If you are outspoken you tend to make enemies, and the friendships you make among artists are always suspect. On the other hand, you tend to get invited to all the best parties.

I have forced myself to contradict myself in order to avoid conforming to my own taste.
MARCEL DUCHAMP

The World Is Your Gallery

Think of the whole world, real and virtual, as your gallery space, and start from there. There are many more ways of being an artist than just sitting back and waiting for some gallery to welcome you onto its hallowed walls. Not only is it exciting to be taking your career into your own hands, but it often turns out to be an effective strategy. Innovation is a great way to attract the attention of the art world. Why not let it come to you?

Some Examples of People Who Found Creative Ways to Exist as Artists

Reverend Howard Finster. Reverend Finster started painting at the age of sixty, and continued to paint and preach until his death at age eighty-four. He was in the process of repairing and painting a bicycle when he spied a face in a smudge of paint on the tip of his finger and heard the voice of God. God spoke unto him: "Paint five thousand sacred works of art." So he did. His paintings are bright and fresh and filled with words, and when he finishes a painting he paints the can the paint came in, the rag he wiped the canvas with, and anything else in sight. Originally, Finster just wanted to decorate his little garden (which he calls "Paradise Garden" and the *Washington Post* called "God's Little Junkyard") with the word of God, but the word has spread. The garden now covers three acres and includes elaborately painted buildings, trees, and objects, as well as a gift shop run by his family. "I'm not out trying to make money or to be a big artist. I'm trying to get the world straightened out." The wonderful part is that, in the process, he has become a big artist, and his works are in demand at top galleries and museums around the world.

The Guerrilla Girls. As the self-proclaimed "Conscience of the Art World," the Guerrilla Girls is a band of anonymous artists fighting for the elimination of sexism and racism in the art community. Established in the mid-eighties in response to the shocking lack of women in the Museum of Modern Art's blockbuster exhibit *International Survey of Contemporary Painting and Sculpture,* the Guerrilla Girls decided

to fight back by plastering New York with posters that pointed out the statistical discrepancies. The posters were savvy, sarcastic, and compelling. They named names and printed statistics with their sources, so they could not be easily dismissed. The posters have become such collector's items that new "releases" don't remain on the walls very long. The members maintain their anonymity by appearing in public wearing gorilla masks with miniskirts and high heels. Their mailing address is a post office box, and their phone is answered by a mechanized answering machine. They feel anonymity is important for keeping attention focused on the issues, instead of on personalities. This serves to make them even more intriguing to the media. Through their efforts they keep important cultural issues alive and have a lot of fun doing it. They have appeared at symposia, on television, and in glossy magazines. You can download their amazing posters for free from their Web site (www.guerrillagirls.com), or support them by buying their books and prints.

Genius is the capacity for productive reaction against one's training.
BERNARD BERENSON

*The Art*O*Mat.* Artist Clark Whittington saw a use for those old unused cigarette machines. Why not refurbish them to sell art? He filled a machine with art objects of his own making, and people purchased tokens for $5, which they then inserted into the machine for a piece of art. It turned out to be a great success, so Clark invited other artists to participate as well. The result is a fleet of Art*O*Mats in museums and galleries across the country. To find out more about the project, visit the Web site, www.artomat.org.

J. S. G. Boggs. J. S. G. Boggs is an artist who literally makes money. He draws detailed renderings of currency from around the world in color, one side only, but changes minute details to phrases like "The Bank of Boggs" or "J. S. G. Boggs, Secretary of the Measury." Boggs refuses to sell his art; he will only spend it. When he dines at a restaurant, he offers to pay for the meal with one of his creations, making it clear to the waiter that he made it himself, that he is offering to pay with art, not money. If the waiter accepts it as equal to money, Boggs expects change in return. If the check was $17.50 and he gave the waiter a twenty-dollar Boggs's

I am for art that is political-erotical-mystical, that does something other than sit on its ass in a museum.
CLAES OLDENBURG

Bill, he will expect to receive $2.50 in change. An interesting conversation then ensues, usually involving the manager at some point, and eventually they come to an agreement. A surprising number of people accept his proposal. Boggs says the ratio is about one in ten. When he has completed a successful transaction, he saves the change and the receipt and carefully documents the time and place. He sells the receipt and change to art collectors who then try to track down and purchase Boggs's drawn money from the person who originally received it, creating yet another transaction around the work. He has traveled throughout the world and bought large items, like a motorcycle, with Boggs's Bills. In England and Australia, he's been arrested for counterfeiting, and he is in trouble with the U.S. Secret Service. Every time he gets arrested, the work goes up in value.

The Taxicab Gallery. Thai artist and taxi driver, Navin Rawanchaikul, decided to open a gallery in the backseat of his Bangkok taxicab. Using the cab as the location for a series of conceptual installation pieces by a diverse group of artists, he changes the shows monthly as if he were running a more traditional gallery. Most of the people who enter his taxi are just looking for a ride, but they end up with an unforgettable experience. In response to the increasing interest in the taxi-gallery, Rawanchaikul has printed a detailed schedule of expected daily stops, which he distributes with the disclaimer "times approximate."

Keith Haring. This late New York artist began his career by drawing with chalk on subway walls. Ordinarily, the panels that line the New York subways are filled with ads. One day Keith Haring noticed an empty panel at the Times Square Station and decided to fill it with a drawing. Before long, he was making a drawing in the subway every morning on his way to work. His images became so popular and so many people thanked him for making them that, according to the biography by John Gruen, he "found it difficult to stop. It became a rewarding experience to draw and see the drawings being appreciated. The number of people passing one of these drawings in a week was phenomenal."

I don't want life to imitate art.
I want life to be art.
CARRIE FISHER

The subway drawings had the added effect of launching Haring's very successful art career. By his untimely death in 1990 at the age of thirty-one, Haring's art had moved from the New York subways to the most prestigious galleries and museums in the world. He did not limit his work to the gallery system, however. A champion of art for all people, he also transferred his images to watches, T-shirts, and give-away buttons. Whenever he would arrive in a new city to install a museum show, he would schedule time to create a mural with local children as well. His work has universal appeal and can be found all over the world.

Christo and Jeanne-Claude. Renowned for large scale projects that involve wrapping buildings or locations in yards of fabric, Christo and Jeanne-Claude create completely self-financed site-specific environmental art. They and their teams have wrapped a huge government building and a bridge, and they surrounded eleven entire islands in fabric. This is artwork on a grand scale. The creation of each piece involves not just the design, fabrication, and installation of the art, but also years of negotiations with the people who own the property, or use the building, to gain the necessary permissions. They must consider local zoning restrictions and the environmental impact of the project each time they approach a new location.

Then there is the difficulty of financing their work. Obviously, art of this kind is meant to be experienced, rather than owned. You can't exactly carry a wrapped building home and hang it in your living room. The projects are supported in several ways. Christo makes lots of preliminary drawings and collages of a proposed project that they sell themselves rather than through an art dealer. They also sell smaller wrapped sculptures and works they created in association with earlier projects that have increased in value over the years. When a project is complete and dismantled, they recycle the materials, returning them for use elsewhere.

Do you see yourself here? In these examples, the common thread of authenticity and creativity is a combination that can't be beat. No

Success is the child of audacity.
BENJAMIN DISRAELI

matter how cynical the world becomes, genuine work will always find its audience, but you may have to help it along by stepping outside your studio. I am reminded of my dear friend Rachel, one of life's originals, who had grown weary of waiting for true love to appear. One day she announced, "I finally figured it out: my white knight can't get his horse into the elevator." She decided to go out and meet him halfway. Not a bad plan.

Creating Your Artist's Packet

Edward Gorey © 1992

In order to approach any of the different kinds of exhibition spaces described in the previous chapter, you will need to assemble an artist's packet. The artist's packet is the basic business tool of the art world; it is the way we make First Contact. A typical artist's packet will include a CD or a sheet of photos or slides of the artist's work, a list of past exhibitions called an artist bio, a written statement about the work, a cover letter, reprints of reviews or articles about the art if you have

them, exhibition announcements with color images of your art, and a self-addressed stamped envelope (SASE) large enough for the return of your materials, all placed lovingly inside a 9" x 12" or 10" x 13" envelope. It is a good idea to include a stiff piece of cardboard to protect your materials from the exuberance of the post office.

When a gallery receives a packet from an artist, the first thing the staff person notices is whether or not the information is presented in a clear and professional manner. This is a signal that the artwork can be expected to be professional as well. If the packet is thrown together in a sloppy or confusing manner, if the art samples are of poor quality, if only part of the materials are there, or if the cover letter is insulting, too personal, or too demanding, the gallery will probably send everything back without further consideration.

Put yourself in the gallery director's place. Every week you receive hundreds of slides from hungry young artists who all want *you* to change their lives. You probably enjoy looking at art, that's why you took this job; but you are already working a fifty-hour week and still not getting everything done. You didn't ask to receive these art samples. You probably already know lots of artists who are clamoring for your attention, not to mention the artists whose work you have seen elsewhere and would like to pursue. But those unsolicited packets arrive every day; and when you open them, you wonder why you bothered.

According to reports from gallery owners, at least two-thirds of the unsolicited packets they receive do not even approximate the type of art they handle, questions of quality aside. If the artists who sent the art samples had invested the time to find out about the gallery, they would have known this. A gallery that features abstract painting will not be interested in ceramic sculpture or handmade jewelry. Sending inappropriate art samples not only wastes everyone's time (including yours), but insults the dealer. Galleries, like artists, develop a certain style and voice. They become known for the kind of art they show, which in turn is a reflection of the gallery owners' interests. To expect them to change their style to accommodate your needs is inappropriate and futile.

Another complaint I hear from galleries is that they receive poor quality slides that are too dark, too light, or not clearly labeled. If they

have to strain to see the work, they aren't going to bother. It's easier just to slip the slides into their SASE and send them home.

When I ask gallery owners how many artists they eventually take on who make first contact through unsolicited packets, the answer is invariably "very few." This is because only a very small number of the packets galleries receive are both appropriate and clearly presented. Assuming those hurdles are crossed, a gallery owner who likes an artist's work must then decide if the work is of sufficiently high quality to be considered for the gallery. The owner will then want to meet the artist to be certain that he or she is a person the staff feels they can work with, someone who will be willing and able to meet commitments, someone personable enough to invest time and money in.

When you consider all that, it is a miracle any artist ever gets picked up by a gallery at all. And yet they do, all the time. My own experience, and that of my students, is that approximately 10 percent of the unsolicited art samples you send out will result in some form of positive response, if they are well presented and appropriately targeted.

The first step in receiving that response is to create an impressive artist's packet. As an artist you should give as much attention to the preparation and presentation of your artist's packet as you do to your art. The packet will stand for you. It should be clear and concise, look professional, and inspire the recipient to want to see more of your art.

I will be an artist or nothing!
EUGENE O'NEILL

Looking Closely at the Artist's Packet

The cover letter. The cover letter is simply a general greeting. Keep it short and direct, avoiding the impulse to embellish it with unnecessary details. When a gallery receives a packet containing a CD or slides, it already knows why they were sent. Obviously the sender wants a show, gallery representation, sales, or, preferably, all of the above. The gallery staff members don't have the time or interest in reading a long letter. When they open the packet, they will glance at the cover letter and then move on to looking at the art samples, which is what you want them to do anyway.

Here are a couple of sample letters, which I gladly offer for you to copy in whole or in part. The first letter is simple and direct, perfect

January 6, 2006

Mr. B. R. Fingers, Director of Exhibitions
International Museum of Candy Wrappers
900 Fifth Avenue
New York, NY 10007

Dear Mr. Fingers:

I am writing to introduce you to my work. Enclosed is a current bio, a sheet of slides of silver gelatin prints from my "Deep Chocolate" series, a statement about the work, and a review from a recent exhibition.

If you are interested in seeing the work, I would be happy to send additional materials or arrange a studio visit at your convenience.

Thank you for considering my work.

Sincerely,

John Smith

Enc.: slides
 bio
 statement
 review
 SASE

January 6, 2006

Mr. B. R. Fingers, Director of Exhibitions
International Museum of Candy Wrappers
900 Fifth Avenue
New York, NY 10007

Dear Mr. Fingers:

Jacqueline Onassis suggested that you would be interested in seeing my work. Enclosed are photographic materials representing a selection of recent photographs from my "Deep Chocolate" series. As you will note from my résumé, the work is exhibited regularly in galleries and museums worldwide and has been featured in numerous international publications.

The photographs from the "Deep Chocolate" series are 20" x 24" color prints available in an edition of ten. If you are interested in the work, I would be happy to send additional materials, or actual prints, for you to look at.

Thank you for considering my work. I look forward to hearing from you.

Sincerely,

John Smith

Enc.: CD
 bio
 statement
 review
 SASE

for sending art samples to a gallery when you don't have a recommendation. The second is slightly longer, but even though it contains more information about the work, it is still succinct and businesslike.

Writing your bio. A typical artist's bio is a one- or two-page list of exhibitions and related activities. Headings may include solo exhibitions, group exhibitions, publications, collections, commissions, awards, education, birth place and date (personally, I skip the birth date), and anything else you feel is pertinent. The rule of thumb is to list the most important information first (usually solo exhibitions). Within each category, list the most recent activity first, working your way back in time. Each listing should include the name and location of the show (just the town, you don't need the street address), the title of the show if there was one, and the show dates (month and year). Don't leave out any of this information. When art professionals review your bio, they are looking to see where you have shown your work and when. There should be enough information in the bio for them to follow up on it if they want to.

If your bio looks like the example on the facing page, put away this book; you don't need it, you are doing just fine. If not, file this bio away in your mind under "Something to Shoot For." I include it as an example of what a bio should look like for a professional artist who has an active and successful career.

If your career isn't quite as active as the one above, you will need to modify the standard form to fit your exhibition record. By definition, an artist at the beginning of his or her career will have participated in very few shows. There is no shame in that. As your career progresses, you will be able to fill in more and more of the blanks.

Artists' careers vary. Often an artist will participate in one or two exhibitions, usually affiliated with his or her school, or maybe a juried show or two, but nothing more. Another common pattern is to experience a flurry of interest from galleries, curators, and critics for several years, and then fade from the public eye. Other artists have a show every once in a while, but no steady activity.

> *When I am working on a problem,*
> *I never think about beauty. I think*
> *only how to solve the problem. But when*
> *I've finished, if the solution isn't*
> *beautiful, I know it's wrong.*
> BUCKMINSTER FULLER

<div align="center">

Your name

address • phone • e-mail • fax

</div>

Selected Solo Exhibitions	Venice Biennale Internazionale, Venice, Summer 2005. Documenta, Kassel, Germany, Summer 2004. Whitney Biennial, Whitney Museum of Art, New York, May 2004. Pace Wildenstein Gallery, New York, October 2003. Tate Gallery, London, May 2003. Margo Leavin Gallery, Los Angeles, May 2002.
Selected Group Exhibitions	Museum of Modern Art, "New Acquisitions," New York, January 2005. Centre National d'Art Georges Pompidou, Paris, September 2005. Royal Ontario Museum, "Wild Visions," Toronto, July 2004. Museum of Contemporary Art, Los Angeles, March 2003. Corcoran Gallery of Art, Washington, D.C., January 2003. Institute of Contemporary Art, Boston, November 2002.
Selected Publications and Reviews	*ArtNews* magazine, cover article, February 2004. *New York Times,* "Biennial's Best Kept Secrets," May 5, 2003. *Artforum* magazine, article, "Hot Stars on the Rise," April 2003. *Los Angeles Times,* "Artist of the Year at Margo Leavin," May 2, 2002.
Grants and Awards	MacArthur Fellowship, 2004. Guggenheim Artist Fellowship, 2003. National Endowment for the Arts, Artist Fellowship, 2002. MacDowell Colony Artist in Residence, 2001.
Education	Master of Fine Arts, San Francisco Art Institute, 1996. Bachelor of Arts, University of Houston, 1994.
Born	Dallas, Texas; January 1, 1973.
Represented by	Pace Wildenstein Gallery, 32 East 57th St., New York 10022 Margo Leavin Gallery, 812 N. Robertson, Los Angeles 90069

Traditionally, the point of the artist's bio is to highlight your exhibition record. Your career should look vigorous and professional. It should indicate that you take a responsible and dedicated attitude toward your art, that you are committed for the long term, and that your art is vital and in demand. If your exhibition record is sketchy or nonexistent, then you will need to examine the other areas of your life that can attest to your commitment. This is where those highly developed creative skills come in. What is it about you that is unique and interesting? If you can't think of anything, then I suggest the following exercise. I call it "Rediscovering Your Accomplishments."

Create a chart on paper or on your computer with the following column headings: month and year, residence, job, artwork, classes, travel, hobbies, other. Under the *month and year* heading, write the current month and year, then work your way across the chart, filling in the information for each column. When you have finished, return to the month and year column, writing in last month's date and filling in the columns with the activities that were going on in your life then. Keep working backward in time, from month to month, year to year. It won't be long before you realize how many wonderful things you have done in your life. You will be amazed at the lifetime of riches you have to draw upon. Now all that remains is for you to put this together in a form that makes people want to see your work.

The one thing to say about art and life is that art is art and life is life, that art is not life and that life is not art.

AD REINHARDT

One of my former students, Tom Mallonee, has generously allowed me to reprint a bio from early in his career, in which he created a format based on his experiences (see page 32). At the time, Tom had rarely exhibited his photographs, but he was a committed artist and he wanted to emphasize this. Although Tom had no formal degree in art, he had studied with a number of well-known photographers in a workshop format. He decided to emphasize this. The format of his bio is unusual, but it shows a serious commitment to photography.

Another way artists with a sparse exhibition record can improve their bio is to add a category called "Bodies of Work." Here you can list the art you have made at different times in your life, with one or two

Month & year	Residence	Job	Artwork	Classes	Travel	Hobbies	Other
March 2006	Aspen, CO	Ski instructor	Ice sculpture of wild birds	Welding at J.C.	——	Bird-watching	Still reading *War and Peace*
February 2006	Aspen, CO	Ski instructor	Ice sculpture	——	——	Started bird-watching	Still reading *War and Peace*
January 2006	Moved to Aspen	Looking	Started ice sculpture	——	——	Obsessing over not having a job	Reading *War and Peace* again
December 2004	Who knows?	Thinking	Sketches on beach	Quit school	Cancun	Waterskiing	Reading Batman comics
November 2004	Kansas City	Coffeehouse	Drawing from models at school	——	——	——	Reading *War and Peace*
October 2004	Kansas City	Coffeehouse	Drawing from models at school	Chemistry, beginning drawing	——	——	Reading *War and Peace*
September 2004	Kansas City	Coffeehouse	Taking drawing class	School starts: chemistry major	——	——	Reading *War and Peace*

Tom Mallonee

Born	Presque Isle, Maine, February 19, 1953
Selected Exhibitions	Bucci's, Emeryville, California, February 1992
	Stevenson College, University of California at Santa Cruz, Santa Cruz, California, January 1985
	Lost and Found, Santa Cruz, California, September 1981
Education	Self taught

The Friends of Photography, Ansel Adams Workshop, 1991
Studied under— Morley Baer
 Ruth Bernard
 Marilyn Bridges
 William Christenberry
 John Sexton

The Friends of Photography, Ansel Adams Workshop, 1982
Studied under— Ansel Adams
 Roy DeCarava
 Olivia Parker
 Arthur Ollman
 John Sexton
 Don Worth

The Friends of Photography, Landscape Workshop, 1981
Studied under— Linda Connor
 Wanda Hammerbeck
 Ted Orland
 John Sexton

Publications	Waterscape Series, 16-page catalog for CMS Collaborative, Fountain Consultants, 1988
Affiliations	The Friends of Photography, San Francisco, California. Member, 1979–Present

sentences describing the materials and/or the content. Maybe you spent a summer in Barcelona sketching buildings designed by the architect Antonio Gaudí and then put the drawings away in a drawer. This is a perfect thing to list under "Bodies of Work." Be sure to give the work a title, "The Gaudí Series" for instance, and mention where and when you did the work. Your listing might read: "The Gaudí Series: Twenty pen-and-ink sketches of the buildings of Antonio Gaudí, Barcelona, Summer 1994."

Jeanne Herbert, another former student, started out as a travel agent. At the time she was composing her first bio, she hadn't exhibited her work anywhere other than in student galleries. She had traveled a lot, mostly to Africa, taking photographs of people in remote villages and tribes, and she would hang her photos informally on the walls of the travel agency where she worked. To create her first bio, she listed her student shows under the category "Selected Exhibitions" and added the shows she had hung at the travel agency, giving them titles and dates (see page 34). She then created a "Bodies of Work" category and listed each set of photographs she had made on her travels, writing a description next to it. Her next category was "Travel," which showed her wide range of experience, followed by "Education," in which she included receiving her pilot's license along with more conventional educational experiences. The result is a bio that may not follow the standard exhibition format but nevertheless conveys a vital and committed creative life.

Following is a truly creative bio by well-known video artist Vanalyne Green (see page 35). It was written as a joking attempt to attain a teaching position. It may not have had any serious intent, but it was the highlight of the College Art Association Conference in 1982, where I came across it.

Pay attention to the parts of your life that either add to your cachet as an artist or appear to be in conflict with it. Both can be used to your advantage. Perhaps you have a habit of taking photographs of your hotel room whenever you go on vacation. This can be described as a body of work. Or maybe you have a job as a police officer. Don't try to hide these things; this is the stuff that makes you interesting. Suddenly you become mythological: The Cop Who Taught Himself to

Try not to become a man of success but rather try to become a man of value.
ALBERT EINSTEIN

JEANNE HERBERT PHOTOGRAPHY

SELECTED EXHIBITIONS

And/Or, John F. Kennedy University, Orinda, California, January 1992

Portraits of Côte d'Ivoire, Blue World Travel, San Francisco, 1991

Mali, On the Road to Timbuktu, Blue World Travel, San Francisco, 1990

Photographing People, U.C. Berkeley Extension Gallery, San Francisco, May 1989

BODIES OF WORK

Life in a Longhouse, Black & White Photographs, 1991.
 Documentary portraiture of Iban families on the Upper Skrang River, Sarawak, Borneo.

Portraits of Irian Jaya, Black & White and Color Photographs, 1991.
 Documentary portraiture of Asmat and Dani peoples of Irian Jaya.

Barbershops, Color Photographs, 1989–1991.
 From Africa to Oceania, barbers and their places of work.

Chez Bonne Idée, Color Photographs, 1990.
 A study of small businesses in West Africa and the influence of urban art on their shop signs and displays.

Life with the Mbenzele, Black & White and Color Photographs, 1990.
 A study of life in an Mbenzele Pygmy hunting camp in northern Congo.

Portraits of Côte d'Ivoire, Color Photographs, 1990.
 Portraits of Baoule, Senufo, and Fulani peoples in Côte d'Ivoire, West Africa.

The Omo, Color Photographs of Southwestern Ethiopia along the Omo River, 1989.

Mali: On the Road to Timbuktu, Color Photographs, 1988.
 A voyage up the Niger River by pirogue and overland to Timbuktu.

TRAVEL

USA, Canada, Mexico, Europe. Africa: Zimbabwe, Zambia, Botswana, Zaire, Congo, Kenya, Tanzania, Ethiopia, Morocco, Egypt, Mali, Côte d'Ivoire. Asia, Middle East, India, Indonesia, Malaysia, North and South Pacific Islands, Caribbean, South America. Residency: Morocco 1969–1970.

EDUCATION

U.C. Berkeley Extension, Berkeley, California. Associate of Arts, Fine Art Photography, 1991.

Parsons School of Design, New York. Documentary Photography Program in West Africa, 1990.

Honolulu Flying Academy, Honolulu, Hawaii. Private Pilot License, 1972.

Denver University, Denver, Colorado, 1969.

VANALYNE GREEN
New York, NY

CAREER OBJECTIVE: TENURE IN MY LIFETIME

Born: Ft. Knox, KY 1948
B.F.A. California Institute of Arts, Valencia, CA 1973
Graduate work, Feminist Studio Workshop, Los Angeles, CA 1974

Tuition scholarships, California State University, Fresno, CA 1968–1972
CAPS Grant in Multimedia 1982

SUMMARY OF PERFORMANCES 1982:

- Carolee Schneemann's opening. Stood still with no one to talk to for 10 minutes, pretending to be actively engaged with the work.

- Went to political artist's party. Socialized and danced with men as if they looked at women's bodies objectively.

- Went to art opening. When told by woman from New Museum that she had heard of my work, feigned an aura of blasé normality.

- Went to my Group Show opening. Realizing there was absolutely no one there who could do anything for me, continued to smile, act energetic and interested. This, even though snubbed by Brooklyn woman in smart cotton print dress, whose work was priced entirely too high.

PUBLICATIONS:

By the artist: Ten. Five strictly self-promotional, one authentic attempt at critical thinking and four reproductions of work.

About the artist: Twenty. Four reviews to be used over and over again. Four honorable mentions. Some to impress on a résumé and one that must not ever be seen or mentioned.

References available upon request.

Paint in Order to Cope with the Stress in His Daily Life. Find a way to get this into the bio. Later, when you have participated in more exhibitions, you can move to a more traditional résumé. At either stage, though, when you add information about yourself that doesn't conform to the basic information usually found in an artist's bio, do it sparingly, and only if it relates to the art itself. Gallery owners don't want to plow through your life history to find out the facts.

Don't even consider lying on your bio. It's not a good idea, and you will probably get caught. Chances are that the day you add a fake solo exhibition at the Metropolitan Museum of Art in New York to your résumé, will be the exact day you hand your bio to the curator's best friend in Toledo, Ohio. The art world may appear vast on the outside, but it is really a tiny little town. You will find that everyone knows everyone else and they do talk.

The artist's statement. Unless you have skills as a writer, you probably would rather not write an artist's statement. You are probably hoping that you can get away with saying that the work stands for itself. In the 1950s an artist was expected to say things like that, but now it just won't fly. Not because it isn't true—a work of art is still, and always will be, a unique experience that defies description. But describing the work is not the point of the artist statement; the purpose of the statement is to make the viewer want to know more about the work.

The artist's statement will be used in a number of ways, including to point the viewer to the concerns you consider to be important in the work, to set a tone for viewing the work, and to help publicists, curators, and critics write about the work. The value of this last cannot be underestimated. A magazine will often decide to write an article simply because the artist's statement arouses their interest. If astounding artwork reaches them that just happens to be accompanied by an interesting statement, particularly if the statement doesn't need much rewriting, it is a combination too good to resist.

The artist's statement should be short. One page is the standard length, but you could go as long as two. For your first draft, plan to write more than you intend to keep so that later you can edit out the parts that feel embarrassing. The easiest course of action is to think

of someone specific in your life and pretend that you are speaking to this person about your art. Speak as honestly and straightforwardly as you can. No one expects you to be a brilliant writer. You simply need to convey the thoughts and concerns underlying your art that interest you the most, to give the reader insight for looking at the work.

Keep the information as specific as possible. There are certain experiences common to almost every artist that, although they may be powerful and profound for each individual, come across as ordinary to the viewer. For example, almost every artist I know, particularly painters, describe the creative experience as one in which they never know what will happen before they do it, as a series of surprises becoming manifest. You can write this if you want, but then edit it out. It may be true, but it is not specific enough to generate interest in your art.

Writing is easy: all you do is sit staring at a blank sheet of paper until the drops of blood form on your forehead.

GENE FOWLER

Be wary of overblown phrases and big ideas, loftily expressed. If your work is about the big issues, and most art is—after all, who wants to devote their life to small ideas?—you need to find a way to speak of these things with feeling, but without pomposity. Be especially careful of using the royal *We*, which speaks for other people. The minute you say, "We all need love," there will be someone who says "What does this guy mean? I don't need love. How dare he say I need love."

Another pitfall in statement writing is to turn the statement into a list of the things you like. "I like to paint flowers." Who cares? We can tell by looking at the painting that you like to paint flowers. (Unless, of course, the painting is of an ambulance. In that case you might be able to get away with it.) What we want to know is why. Did you have a profound childhood experience with a flower, were you impressed by another flower-painting artist, did you read about painting flowers in a book, did a flower save your life? These are things that could grab our interest.

Some artists work intuitively; others work analytically. If you are one of those who thinks of a project ahead of time, works out the logistics, and then creates the art, you will have a fairly easy time writing your statement. All you have to do is describe the whys and the

hows of the project. If you are an artist who goes into the studio and works until you like what you see, however, it may be more difficult to put the experience into words.

I suggest keeping a visual diary with you in the studio as you work. As ideas and phrases come to you, write them down, in part or in whole. Don't worry about your writing style, just get the thoughts down. Your work wants you to understand it; spend time with it, and it will speak to you. Later you can use the ideas as sources for your statement.

One other important use of your statement is to assist you in crystallizing your thoughts about the work. Clarifying your ideas will accelerate your growth as an artist, and you will find yourself grateful when the time comes to discuss your work with curators and critics. You will be able to tell them decisively and intelligently what your work is about.

After you have written your statement, give it to another artist to read; you can read theirs in return. Then try to imagine the other artist's statement applied to your art, and vice versa. If any part of your statement can be applied to his or her work, the statement is not specific enough.

Here are a couple of examples of successful statements. I am including the statement I use for my Flower Series, which, after several rewrites, finally says what I want it to say. There are also statements from two other artists, Carrie Lederer and Susan Martin (see pages 40–41), whose writing styles are completely different. Carrie Lederer is a prolific painter whose work is both intellectual and emotional, which is reflected in her statement. Susan Martin is a sculptor. Her work, and the way she describes her work, is much more spare. Each of these writing styles appealed to different editors, and each artist received positive responses to them. Use these statements only as starting points. Your statement should be a reflection of you, not written to a formula.

Stationery. Each of the components of your packet—your statement, your bio, and the cover letter—will need to be printed on a piece of paper with your name, address, and phone number on it. Thankfully, it is a simple matter to create such stationery yourself on a computer.

There is a right physical size for every idea.

HENRY MOORE

To create the photographs for the Flower Series, I regularly visit the San Francisco Flower Mart to retrieve the flowers merchants throw away. I find it interesting that these flowers, whose worth in our culture is based upon their youth and beauty, are no longer considered to be of value. I collect the flowers from the trash bins and bring them back to the studio to photograph. Working more like a painter or a sculptor than a photographer, I use the flowers as raw material, sometimes painting or reconstructing the flowers themselves. I am particularly interested in the range of responses the flowers exhibit when faced with death. I have found their actions to be as broad and varied as any human response to trauma.

When they are young, all tulips, for example, look essentially the same. But as they grow older, they begin to develop individual personalities. As they start to fade, they may give up and drop over immediately, or actively resist by pushing outward, or try to hang on by wrapping their petals around each other in what appears to be an embrace. It is this last action that most intrigues me. Flowers seem particularly sensitive to each other's presence and appear to create a community when cut and placed in a bowl. They seem to be drawn to some flowers and repelled by others, and will rearrange themselves according to these affinities and resistances. As the series has evolved, it has begun to touch on this pronounced sensitivity to community.

The work has also extended into the area of portraiture. With each batch from the Flower Mart, one or two flowers stand out for their individuality. I try to remain attuned to their changes and to make images that allow them the clearest possible voice. The photographs, then, can be seen in one sense as metaphors for the human condition, and in another, as portraits of another species.

All photographs are shot with a Hassleblad camera and are printed full-frame, the black edge of the negative being an integral part of the image. The intention is for the photograph to stand as a document, as a moment in space and time. The photographs are printed 20" x 24", in editions of 25, on Ektacolor-Plus paper.

CARRIE LEDERER

About the Garden in Chaos series:

These paintings relate to one subject—the origins of life and especially of our lives as human beings. The paintings depict turbulent gardens informed by nature's riotous beauty, or the deep space of our universe filled with a Byzantine intricacy of stars, snowflakes, and snowmen.

Looking closely at these two worlds—a garden and the universe—I can see that my work highlights the order beneath the confusion found in both.

The science of fractals and patterns of chaos are critically important to my exploration of both worlds, each of which seems at first to be only a tangle of order/disorder, or violence/beauty. A fractal is a complex geometric figure made up of patterns that repeat—each time on a smaller scale, each smaller version being referred to as a "self-similar" form. I am drawn to nature's intrinsic ability to reproduce pattern—as a source of imagery and also as a working process for my own art.

Fractals basically tell the story of the wild transformations in nature that take place on a daily basis; they give order to what seems to be a chaotic world of energy and change. The paintings are a response to these natural wonderments.

My daily, up-close encounter with nature is the fifty-foot journey through our family garden, from home to the studio. I'm continually captured by nature's lunatic exuberance—a spectacle of complexity—beautiful, simple, seemingly haphazard.

SUSAN MARTIN

Epiphanies: Artist Statement

Plywood bridges nature and culture. I use laminated pieces of plywood in my work to create a three-dimensional object, usually a cube, that mediates the space between the floor and the pedestal or shelf on which objects rest. Aesthetically, I am engaged by the idea of cutting into the sheet of plywood to reveal its interior and also by the crosshatching pattern created by the multiple horizontal layers of wood grain.

Objects found (the film canisters in a photographer's studio, the poppy seeds in Monet's garden, the dried roses in the flower mart, toothpicks in a grocery store, the WOMEN/MEN sign in Tap Plastics) can trigger for me what James Joyce called epiphanies: the sudden "revelation of the whatness of a thing—the moment in which the soul of the commonest object seems to us radiant."

The materials I use are simple: plaster, wax, steel, wood, plastic, cardboard. I find plaster and wax compelling because they are transformative: liquid/solid; warm/cool; soft/hard.

Each sculpture provides a glimpse into many things, including my aesthetic preferences, sensual pleasures, childhood memories, and/or art historical prejudices.

If you don't want to design it yourself, you can hire a graphic designer to do it for you, but it will cost more. Your stationery should look professional. Make it simple and direct. The point of the stationery is for the recipient to be able to contact you. You want people to think you are a brilliant artist, but be cautious in trying to convey this with your stationery. Avoid adding too many flourishes or using your images on your stationery, because if the stationery draws too much attention, the viewer will judge you by your stationery, rather than your art. Unless you are looking for a job as a designer, this can be death to your art career. On the other hand, if you can find a way to add a subtle touch of individuality, so much the better. It's a delicate balance, and if you're not sure, go with the simplest, most direct approach. The art will shine that much more.

> *Experience is not what happens to you; it is what you do with what happens to you.*
>
> ALDOUS HUXLEY

A self-addressed, stamped envelope. This is what is called a SASE. Whenever you mail slides to anyone, include a SASE or the slides will not be returned. This expensive mistake can also cause unnecessary anxiety as the months go by and you haven't received any responses for your efforts. Galleries receive mounds of unsolicited packets every day, and they can't afford to spend time or money returning them all. So stack the odds in your favor. In every packet, enclose a 9½" x 12½" envelope addressed to yourself, with enough stamps for return postage attached. In the upper left-hand corner, write the return address of the person you sent the slides to originally. I do this because occasionally someone returns my slides without a letter of any kind. I think that is extremely rude, but it happens; if you have several sets of slides out, it becomes difficult to determine who has returned them. Writing the gallery's return address on the SASE saves you this irritation.

Reviews and show announcements from previous exhibitions. These are optional. The point of adding reviews to the packet is to show the person receiving it that your work is already being critically acclaimed. If you don't have any reviews yet, or if the only review you have describes your work in less than respectful terms, don't include it.

Everyone gets a bad review from time to time, even the most successful artists, but it is a good idea not to advertise it.

Visual images. Artwork can be represented visually in your packet in several forms. The traditional approach is to include a sheet of slides (up to twenty images). This is your best approach with most older established galleries, since they are used to working this way. Younger galleries often prefer receiving a CD (compact disk) of your artwork, which they can pop into a computer and review. In general, slides are the old technology, CDs (or DVDs) are the new technology. If you send a CD rather than slides, always include some physical image of your art, a computer printout or show announcement; something that can be seen without the aid of computers. Contact galleries in advance to find out how they prefer to view work. You will find they have strong opinions about this, and you will want to please them.

Whether sending slides or CDs (or some other technology that has yet to be invented), if you have any doubts about the quality of a particular image, leave it out. An art professional who looks at your work and likes the first image thinks, "This is great. What else can this artist do?" If the next image is not so good, is the response, "The second one must have been a mistake"? No. It is, "With one good piece, and then a bad one, this artist must not be able to tell the difference." If you don't have twenty pieces you feel strongly about, just include ten. If you are sending slides, include only one sheet of slides, even if you have lots of work. If you are sending a CD, you don't have to limit yourself to twenty, but the same principle applies. Send only those images you have no doubts about, and keep the number of images small, no more than can be viewed in just a few minutes. The point is to get the gallery's attention, so choose the images carefully until every one of them is a killer. Anyone who wants to see more will ask.

If you are an artist who works in several mediums or in more than one style, you have an additional dilemma. Each slide sheet or CD should contain images from only one type of work, so you will need to put together slides and CDs for each body of work you wish to promote. In addition, you will have to decide which body of work to send to each recipient. Mixing different kinds of work is one of the first

> *A photograph is a secret about a secret.*
>
> DIANE ARBUS

marks of the dilettante and is the kiss of death to your proposal. A gallery wants to know what it is getting when it gives an artist a show. It wants to have a sense of who the artist is and what the work is about, and, being concerned about the bottom line, it wants to have something consistent to market.

When in doubt, send your most recent work; it is probably your strongest anyway. Never send very old work. Gallery owners are interested in what you are doing now, not what you did five years ago. If all you have is old work, I would suggest getting into the studio and working, setting a goal of having enough strong new pieces to be ready in six months or a year.

A note about CDs. A CD can, and should, hold much more than just images of your art. Include your bio, statement, reviews of your art, and contact information, at the bare minimum. Everything on the CD should be easily accessible and the procedure obvious. If you are a designer, or are willing to learn what it takes to be one, you can add animation, sounds, movies, and so on, but it's not necessary, and unless done well, can distract from your art.

You can make your CD yourself or hire a professional to do it. The same skills needed to design a good Web site (see chapter nine) will serve you well in designing your CD or DVD. In fact, if your Web site is built cleanly and concisely, it can just be downloaded to a CD.

When planning your artist CD, make sure you create packaging to go with it. Nothing looks sloppier than a CD marked with a felt-tip marker. You can buy labels specifically made for use on CDs at any large office supply store and design how they will look on your computer. Why not use one of your images, or part of one of your images, in the design? Include your name and contact info, so if the CD gets separated from your other materials, you can be found.

You will need a protective case for the CD, which can be bought at any office supply store as well. There are many kinds to choose from, but I like the see-through plastic book cover style. You can design a cover to go with the CD, and slip it in. The cover should include your contact info and any special instructions for viewing the CD for Mac and PC users. The idea is to present yourself professionally, while making it easy for people to view the work.

Artist's Packet Checklist

____ One or two show announcements with pictures (optional)

____ A short, sweet cover letter

____ One exhibition bio

____ One artist's statement, specifically written to accompany the enclosed images

____ Copies of favorable reviews of your art (optional)

____ One sheet of perfect slides (or a CD) of your art

____ One or more printouts of your artwork

____ A 9½" x 12½" self-addressed, stamped envelope (SASE) for the return trip

____ A piece of cardboard to protect the packet (placed inside the SASE)

____ A 10" x 13" envelope to put it all in

____ Enough postage to get it there

Printouts of your art. Take care that the quality of your physical printouts represents your work well. To do this, you will need a medium-to-high-quality computer printer, good paper, some knowledge of a photo-imaging program like Photoshop, and lots of time. It's a little work, but the great thing is that you will have total control over the output, and your work will look stunning.

A Word About the Quality of Your Photographs

This is not a place to skimp. I know that spending money on a camera, accessories, and supplies, and particularly on hiring a professional photographer, can become an expensive proposition, but consider the situation. You have put hours (days, weeks, months, years) into creating your art, and now you are trying to get across the power of the work in a tiny flat image. Focus, lighting, composition,

and image quality are all important, and if any one aspect is missing, you've lost your audience.

Good photographs of artwork should contain the following components:

- Artwork should be photographed on an absolutely neutral background. No trees, buildings, dogs, or posing artists should be visible in the image unless they are an integral part of the art.
- Photographs should be properly exposed. White areas should be white, black areas should be black. There should be details visible in the image wherever there are details in the art.
- Lighting should be even across the surface of the image (especially if it is a flat piece). No area should reflect glare from the light source or have shadows falling across it.

If you can afford it, hire a professional photographer to shoot your photographs. If not, keep your lighting setup simple and meter the exposures carefully. Pay attention to the details, and allow time for reshoots.

Hiring a professional photographer. It is not uncommon for photo students to decide to pick up extra cash by shooting artwork. I am sure they think the job is an easy one, and on the surface it looks easy; but photographing art is a specialized practice. It requires a thorough knowledge of the way light reflects on different surfaces, the ability to recognize when small changes in exposure are necessary, and an eye for exact color rendition. Just because a photographer is a professional does not mean he or she knows what to do when it comes to photographing art. I suggest telephoning galleries you respect in your geographic area to ask for names of photographers they recommend. They will probably be able to give you several names. Curators at the local museums will have some leads, too. The nice thing about using museums and galleries as information sources (apart from the opportunity to do some networking) is that they are often on a tight budget and have already sought out the best and cheapest photographers in your area. Regardless of whom you choose to work with, be sure it is someone who is willing to work with you until you are satisfied with the results.

Every authentic work of art is a gift offered to the future.

ALBERT CAMUS

When working with a professional photographer, you will find that most of his or her time is spent in setting up the lights and camera and tweaking them for optimum results. Therefore, it is to your advantage to know ahead of time just what you need.

Shooting your own photos. If you have a technological bent, you might consider learning to shoot your artwork yourself. There will be an initial monetary outlay for equipment, but you won't have to pay repeated photographer's fees. And since no one cares about your art more than you do, you will eventually get very good images. There are several good books dedicated to teaching you how to do this, but here is a reliable basic plan.

The film versus digital controversy. The first thing photographer Ben Blackwell said to me when I told him I was writing about this topic was, "I don't envy you." He was referring to the fact that photography is changing so fast that the minute I write this, it's already old news.

But here's how things stand right now. Film is the old technology; it still works great, but film-processing labs are becoming scarce. I doubt that they will disappear altogether, however, because serious photographic artists who use film will continue to keep them alive.

Digital is the new technology. In some areas of photography it is as good or better than film. Digital cameras are the choice of photographers whose main use is reproduction in digitally produced end products such as Web images, CDs, magazines, and printed cards and posters. Photographers whose end products are slides or continuous-tone prints, generally still choose film.

Basic Equipment List:
- *Camera:* If you are using a film camera, choose a 35 mm single-lens reflex camera body with manual exposure capabilities and interchangeable lenses. (Those lightweight travel cameras and fancy automatic cameras with zoom lenses will not work for these purposes.)

 If you decide to go digital, choosing a camera becomes more complicated, and not just because the technology is changing. You

can use almost any midrange to high-end digital camera to shoot artwork but, in general, the better the camera, the easier it will be for you to get a good result in the end. Most digital cameras are made for shooting vacation pictures, not artwork, so they tend to render the three-dimensional world fairly accurately, but flat images, such as paintings and drawings, have a tendency to look distorted at the edges.

Fortunately, imaging software can straighten those edges out for you. That's the good news. In fact, it's more than good news; it's miraculous! Never again does a photographer have to settle for a less than perfect image, because now almost everything can be corrected on the computer. But there is a downside. It takes time and patience to learn Photoshop, and it takes time and patience to use it. Not just that; technology has changed our expectations. As an art professional, you are expected to settle for nothing less than perfection, since perfection can now be achieved.

If you can afford a digital single lens reflex (SLR) camera with interchangeable lenses, that is your best bet, but regardless, when looking for a digital camera make sure the one you choose includes the following features:

- the ability to turn off the flash feature (flash often creates glare)
- a white-balance setting (for getting the colors right)
- an auto-bracketing setting (for making exposures for different uses)
- the ability to save images as TIFF (Tagged Image File Format) or RAW files (necessary for producing high-quality images)
- the ability to accept a polarizing filter on the lens (for reducing glare)
- a cable-release socket (to reduce camera shake)
- a tripod socket (for precision shooting)

The tripod socket is essential, and unfortunately, not all digital cameras have one. To take good pictures of your artwork, you absolutely must use a tripod.

I'm sure you don't need to be told to read the instruction manual thoroughly to acquaint yourself with the use of these features.

- *Lens:* If you buy a camera with interchangeable lenses (film or digital), don't buy the normal lens that ordinarily comes with the cam-

era unless you will be photographing sculpture. For flat artwork, you will want a 55 mm or 105 mm macro lens. This has the added advantage of being useful for close-ups as well. The best way to choose a lens is to go into a camera store and try several of them. Attach one to the camera, then look through the viewfinder at an object roughly the size of your biggest artwork. Focus so that the object exactly fills the frame, and then notice how far away you are standing from it. Will the room in which you plan to work be large enough? If not, change to a lower-millimeter lens, one with a shorter focal length.

If the digital camera comes with a fixed zoom lens, adjust the lens to its longest optical setting, the telephoto end of the lens, and look through the camera to a poster or other rectangle on the wall. Are the edges perfectly straight when the image fills the lens? If not, then you will have to correct every picture you take in imaging software on your computer. Many zoom lenses are sold with two different zoom settings, the optical zoom and the digital zoom. Never use the digital zoom: it will result in poor-quality images. When testing the zoom in the store, turn off the digital zoom feature. Tell the salesperson you want a camera with no edge distortion (flat-field) for shooting artwork.

> *Go on working, freely and furiously, and you will make progress.*
>
> PAUL GAUGUIN

- *Tripod:* Look for a tripod sturdy enough to hold the camera; one that will not be easily knocked over. Try lengthening and shortening the legs a few times. Is it easy to adjust? Put some weight on it. Do the clamps hold?
- *Cable release:* The purpose of the cable release is to eliminate camera shake, particularly when you are using long exposures. Any cable release that fits your camera will do (and they're cheap, too).
- *Tungsten or quartz lights:* Before you buy any lights, I would urge you to go into a full-service photo supply store and have the clerk show you the different levels of lighting available. Tungsten lights are the least expensive. They will do the job, but tungsten lightbulbs wear out quickly and change color with use, so always buy two at once, and change them both at the same time. Quartz lights are ideal, but they cost more. They don't overheat, the color balance is consistent, and they are easy to use. Do not let the salesperson talk you

into buying a strobe unit. Strobes are fun, but they are difficult to use for photographing art. Because the flash lasts for only a fraction of a second, you can't see the way the light falls on the subject. You will find it difficult to identify problem areas. Some strobes come with modeling lights that are used while setting up a shot, but these are not strong enough to give really detailed information.

If you choose to work with tungsten lights, you will want to get two lights with reflectors. The cheapest approach is to buy a couple of basic 12" clip-on lights at the hardware store. Be sure that they come with a ceramic, rather than a plastic base. The lamps will get hot, and plastic bases can melt and create a fire hazard. You will need a stand for each light (available at photo supply stores) and two 500-watt (3200-degree tungsten) lightbulbs.

- *Gray card:* A gray card is exactly that, a piece of cardboard painted evenly with a perfect middle-gray tone. It will assist you in determining the best exposure when you use either the light meter in your camera or a separate reflectance meter. If you are using an incident-light meter, you won't need a gray card.
- *Small level:* I mean a really tiny one. This is for placing on your camera and the artwork to check whether or not they are level. You can buy a level at photo supply stores or sometimes at hardware stores. Buying one is a worthwhile investment and can save many headaches from trying to figure out why the picture doesn't look straight.
- *Film:* You can use any color slide film that is balanced for tungsten lights. Be careful not to buy daylight film, or your pictures will turn out orange. Films have either the word *color* or the word *chrome* at the end of the name. Ektachrome and Ektacolor are two examples. Avoid the color films. They are for making color prints, not color slides. Choose a chrome film that has a slow film speed (the number behind the name, as in Ektachrome 100). The lower the number, the slower the speed. You want a slow film because it has a higher tonal range, less contrast, and finer grain. A slow film requires a longer exposure time, but this does not matter since you will be using a tripod anyway; unless you make kinetic sculpture, your art won't be moving much.

- *Digital memory cards:* Every digital camera comes with some sort of memory storage device. They all have different names depending on the make of the camera and come in different sizes. Buy the largest memory card made for your camera. You will be saving your images in the highest resolution your camera allows, so you will need the space. Memory cards can be used repeatedly, so if you fill them up, you can download the images to your computer and then use them again.

- *Light meter:* If your camera has a light meter in it, and most SLRs do, you won't need to buy a light meter. If your camera doesn't have one, buying a hand-held meter is a must. Hand-held meters come in two types, reflectance and incident. The reflectance meter measures the light as it reflects off the object. The meter inside your camera is a reflectance meter. An incident meter is held near the object to be photographed and measures the light that falls on it. Either will work. I usually use an incident meter, because then I don't need a gray card.

- *Polarizing filters for the lights:* Polarizing filters are not absolutely necessary, but I think they make the difference between mediocre and really good photographs of your artwork. You will need two, since polarizing filters are placed over each light. They cut down on glare, so your colors appear richer and you have fewer hot spots. They work especially well with oil paintings, photographs, and art under glass. Choose a size larger than your reflectors. The 18" size, in a cardboard mount, is a good choice.

- *Stands for the filters:* The filters need to be kept an inch or two away from the lights so that the filters don't melt. Any cheap photo stand will do the job. You will also need spring clamps (or clothespins) to clip the filters to the stands.

- *Polarizing filter for the camera:* There is no point in having polarizing filters for the lights if you don't get one for your lens as well. You will adjust the filters in relation to each other.

Basic Photographic Procedure:

1. Hang your artwork on a wall. Choose a neutral-colored wall, white or black. I usually hang a big piece of black fabric on the wall

All great truths begin as blasphemies.

GEORGE BERNARD SHAW

behind the art. A black background is less glaring when the finished slides are projected and, in most cases, shows the art to advantage, unless the art is very dark to begin with.

2. If you are using a film camera, load the film; if your camera is digital, insert a storage chip. Put the camera on a tripod. Attach the cable release.

 If you are using a digital camera, now is the time to mark the settings. Always save to the highest-quality image your camera allows. That will be either a TIFF file or a RAW file, but never a JPEG. You may use the file later in a JPEG or minimal file format, but for your archives, you need the best you can get. If your camera has a RAW file option, choose that; it saves the same data as a TIFF but uses less storage space. If not, save the image as a TIFF. Turn off the flash feature and turn on the white-balance feature. If your camera has an attached zoom lens, move it to the telephoto or macro setting. Use the close-up setting as applicable.

3. Look through your camera's viewfinder to make sure that your artwork fits inside the frame of the camera viewer. Line up the center of the camera lens to the exact center of the artwork. Then use the level on both pieces to make certain that each one is level to the floor. This will avoid the artwork appearing trapezoidal in the slide.

4. Set up the lights on their stands on either side of the artwork. The center of each light should be at a 45-degree angle to the opposite vertical edge of the art. The idea is to cross the light beams of the two lights, in order to create an even field of light across the surface of the art. The lights should be placed at least as far away from the artwork as the camera is, but not so far that light strikes the camera itself. This lighting setup is designed for flat surfaces, such as paintings, drawings, or photographs. For sculptural surfaces, start with one light only, placing it slightly to the side of the camera and slightly higher. Notice how the light falls on the object. Adjust the light until it shows the art to its best advantage. Then add other lights as needed. Lighting sculpture can be tricky. It takes patience and attention to detail. There are many good books on the subject.

5. Place the polarizing filters in front of the lights—far enough away not to burn them—and follow the instructions on the filters on which way is up. The filters will cut down on the amount of light

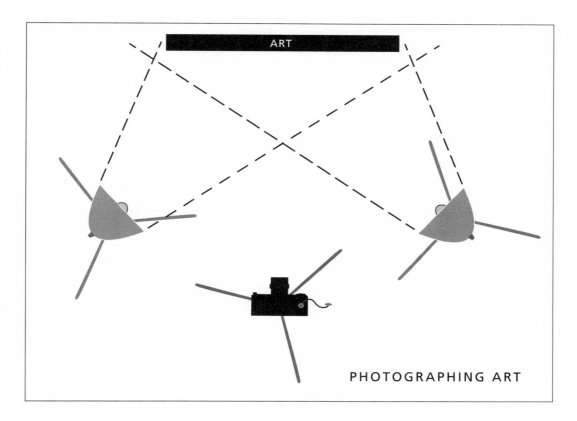

ART

PHOTOGRAPHING ART

that reaches the artwork, but since the camera is on a tripod you can make up for it by using a slow shutter speed.

6. Put the polarizing filter on your camera. Look through the viewfinder and turn the outer ring on the filter; you will see a dramatic difference in the way your artwork looks. Turn the ring until all the hotspots have disappeared and the color intensity is at its best.

7. Next you will need to check the exposure. If you are using the light meter in your camera, you will need to remove the camera temporarily from the tripod to do this; if you are using a hand-held reflectance meter, the camera can stay where it is. Hold up a gray card and your camera (or hand-held light meter) in the center and at all four corners of the artwork, taking a light reading in each spot. Hold the gray card directly in front of the art and parallel to it, and aim the light meter at the card, not at the art. Comparing the readings will tell you if the light is falling evenly over the entire art piece. If all the readings are the same, don't move anything. If not, change the

Content is a glimpse.

WILLEM DE KOONING

angle or position of the lights—*one at a time* (or you'll go crazy)—until you get a balanced reading. If you have an incident meter, you don't need the gray card. Be careful not to stand between the lights and the art when you are taking meter readings.

8. If you are using the meter inside the camera, the exposure indicated should be correct. I usually set my shutter speed at one second and then adjust the aperture ring on the lens (the f-stop) as the meter suggests. If you use a hand-held meter, subtract one-and-one-half stops from the exposure reading to compensate for the polarizing filter on the lens.

9. It is always a good idea to bracket exposures to be sure you get a good result. Bracketing exposures is a photographic term meaning to hedge your bets by taking several different exposures of the same thing. It's easy to do. Shoot your first exposure at the proper reading (for instance, f-5.6 at one second). Then shoot another at a half-stop overexposed (between f-4 and f-5.6), and a third shot at a half-stop underexposed (between f-5.6 and f-8). Keep the shutter speed the same throughout the procedure. If you have a digital camera with automatic bracketing capability, read the manual and engage the feature. By bracketing, you are bound to get one of your exposures right.

10. Hints to make it easier: Try to cut down on the variables so that, if anything goes wrong, it will be easy to trace. If you always use a one-second shutter speed, you will have maximum latitude in choosing your f-stop. If you use a film camera, decide on a film, and then stick with it until you know it well. Always use the same processing lab so that you can develop a relationship with the staff. Use the same lighting setup each time. Once you've found the perfect lighting setup, mark the spots on the floor with tape so you'll know exactly where to put the lights next time. If you can, leave the lights set up for a few days so that you can reshoot if you need to.

11. Good luck!

Everyone is in the best seat.
JOHN CAGE

Right about now you are probably thinking that it would be easier just to photograph your art outdoors on a nice day. I don't recommend it. It certainly saves a lot of money and trouble fooling around with lights, but it is almost impossible to control the sun and the sky. You

may get lucky the first time, but outside it is impossible to have predictably repeatable results.

If you are determined to try the outdoors route, here are some hints. Use a digital rather than a film camera; the digital camera is more forgiving than film when it comes to variable lighting. Engage the white-balance feature in the camera. Photograph the art in even shade, rather than direct sun, and keep an eye out for sun dapples. Try shooting with and without the polarizing filter on the camera. The filter can reduce unwanted hot spots and specular highlights on the art.

If you are shooting slides with a film camera. Shoot a minimum of three to five perfect slides of each image. If you are bracketing your exposures, this means that only a third of your slides will be any good, so plan ahead. Make one good set to send off for duplication and another to put aside for giving slide lectures; the third set should never ever leave your house. A couple of extra sets of slides are not a bad idea in case of a catastrophe. Keep one set at a friend's house or in a safe-deposit box.

Duplicate slides are never as good as the originals, so if you can afford to do so, make more than three sets when you shoot. If you do have to get duplicates made, shop around. Prices and quality can vary dramatically. Duplicates should always be made from originals. Never duplicate other duplicates, or you will lose information in the details and the contrast will become unacceptable. A few companies I have worked with happily are included in the appendices. I am sure there are many more. Always choose a lab that is willing to work with you until you are pleased with the results.

If you are shooting slides with a digital camera. Borrow someone's film camera instead. As I write this book, digital cameras are getting better and better, but they still don't make very good slides yet (unless you have invested a fortune in a super-high-end model). If you still want to shoot slides with a digital camera, do your research: the new perfect digital slide camera may have just hit the market.

Labeling slides. Label each slide with your name, the title of the piece, the year (with copyright symbol), the work's medium and size, and an

> *Let your workings remain a mystery. Just show people the results.*
>
> TAO TE CHING

arrow showing which way is up. It is a good idea to put your contact information on the slide as well, in case it gets separated from the accompanying paperwork. This is a lot of information to crowd onto such a small space, but it can be done by printing with very small type onto self-stick labels made especially for slides. Several companies make them, and they can be found in stationery stores. Be sure to get the kind presented on $8\frac{1}{2}$" x 11" backing, so that they will fit your computer's printer.

Unhappily, although the information required on every slide is standard, the placement of it isn't. It seems as though every grant or competition wants the information written in a different order. It is a good idea to leave a few slides unlabeled for these contingencies.

Transferring your art to the computer. If you are using a digital camera, simply upload the images to your computer, following the instructions that came with the camera. If you are using a film camera, you can scan the images onto the computer yourself, or ask your photo lab or service bureau to develop the film onto a CD or other storage device that can then be uploaded to your computer. The latter is often an excellent choice, since most photo labs use high-quality drum scanners, which are beyond the pocketbook of most individuals.

Using a home scanner to scan slides. To scan slides, you will need to invest in a high-quality slide scanner adapter for your flatbed scanner or purchase a scanner made specifically for scanning slides. Since scanning a slide of an artwork puts another step into the process, you will want to get the best-quality scanner possible. If you are not sure which scanner to buy, ask the people behind the counter in the best photo supply store in your town (clerks at mega discount computer stores may not have the expertise). Ask more than one person; staff may disagree, and the resulting discussion should give you some solid answers. You can also compare scanners online, but pay attention: make sure the Web site doesn't have a vested interest in your decision.

Using a home scanner to scan artwork. If you have a medium- to high-range flatbed scanner, you can scan your original artwork (if it is small

enough) directly on the glass, eliminating the need for a camera altogether. (Why didn't I tell you this before?!) The image will likely need some adjustment in imaging software, but the quality should be quite high. Don't try scanning a photographic print of a painting or sculpture, however: you won't be happy with the results. But scanning a photograph, which is in itself the artwork, can work well. The general rule of thumb is, the more steps there are between the original work of art and its reproduction, the lower the quality. If the photograph is a reproduction of a piece of art, results can be sketchy. If the photograph is the piece of art, a direct scan will look fine.

Whether you are working with a photo lab or doing the scans yourself, make your scans at a resolution of 300 dpi (dots per inch) or *higher.* You will need these scans for a number of different purposes, each requiring a different dpi. For printing announcements, 300 dpi works well; if you are using the image on the Web, you need only 72 dpi. It's always better to make your scan at a high resolution, then cut it down as needed rather than the other way around. If you scan at 300 dpi, then cut it down to 72: the computer will combine dots to make the lower-resolution image. If you scan at 72, then upsize it to 300: the computer has to *invent* the dots in between (see *About interpolation* below). Your image will end up an approximation of what it should be.

I probably don't need to say this again, but I will. The numbers I just gave you are standard practice right now, the year 2006. Technology is moving at warp speed, so always check with your photo lab or service bureau to make sure any technical details I give you are still the case.

About interpolation. Understanding interpolation can greatly improve the quality of your digital images. When a digital camera or scanner takes a picture, it translates the information into dots. The higher the resolution, the more dots, the more information the device captures. But the device, camera or scanner, can capture only as much as it was designed to do. When you ask it to do more, it will interpolate, or invent information. That is not good, and you want to avoid it as much as possible. When using your digital camera, always be sure the zoom is set to optical zoom (real) rather than digital zoom

(interpolated). When using your scanner, read the instructions to know when the scanner is recording real information or making up its own. On my scanner, noninterpolated dpi are indicated by an underline on the number; check to see how your scanner communicates this information.

Working with your images on the computer. This requires learning about imaging software, which is the name for any computer program in which you can view and manipulate photographic images. Most computers come with a basic imaging program already installed, and this should be enough for most purposes. You will be using the software to open image files, adjust the colors, and crop or resize the picture. Some common imaging programs currently in use include Photoshop, Photo Deluxe, Coral Draw, Paintshop Pro, MGI photo suite, and iphoto.

Basic computer adjustments for each image. Open an image in your imaging software. Crop it to the size and shape you want. If the edges are crooked, straighten them out. Adjust the color to get it as close as possible to the original artwork: this means adjusting contrast, brightness, hue, and saturation until it meets your standards. When you are finished, use Save As rather than Save so that your original untouched file remains intact in case you need it.

Assembling Your Packet

The packet should be put together with the cover letter on top, followed by your artist's bio, your statement and optional reviews, a sheet of slides, and finally the SASE and cardboard stiffener. If you are including a color announcement and/or a CD, put it on the top of the stack. The idea is to give the recipient a packet that is easy to deal with and shows your work to advantage.

My favorite method for arranging a packet requires that you buy two sizes of envelopes. Use a 9½" x 12½" envelope for your SASE, address and stamp it, and then cut a piece of stiff cardboard to place inside it. Paper-clip your other materials to the outside of the SASE,

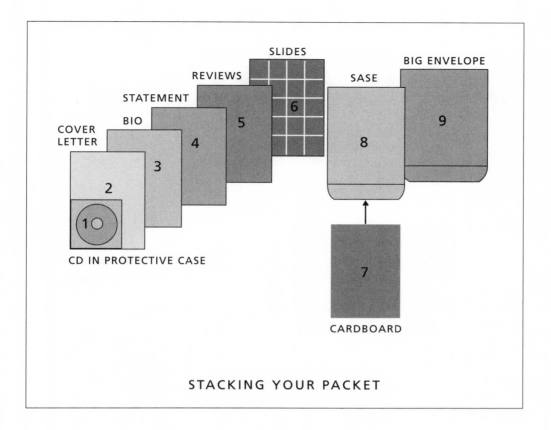

COVER LETTER
BIO
STATEMENT
REVIEWS
SLIDES
SASE
BIG ENVELOPE

1 · 2 · 3 · 4 · 5 · 6 · 7 · 8 · 9

CD IN PROTECTIVE CASE

CARDBOARD

STACKING YOUR PACKET

with the cover letter on top. Put all of this inside a larger envelope—10" x 13" is a good size. The cardboard protects the materials in transit both ways, and if you place the cardboard inside the return envelope yourself, it makes it easier for the recipient to return everything intact.

The first time you mail an artist's packet, you will be amazed at how much work it took. Creating and organizing the materials is time-consuming and not nearly as enjoyable as making art. There will probably be several points at which you almost quit; but if you hang in there and complete it, putting together future packets will be a snap.

Now you just have to decide where to send them.

Choosing Your Own Life

You have much more control over your life as an artist than many people will have you believe. Traditionally, artists have been encouraged to behave passively concerning their careers, to accept gratefully whatever offers or opportunities happened to come their way and, if there were none, to accept that as well. This tiresome "if you are any good, you will be rewarded" mentality preys on an artist's insecurity about his or her art and offers salvation only through a "fairy gallery owner."

Changing that scenario is not difficult, but before you jump into the art market, let's talk about setting goals. The first and best thing you can do for yourself is to gain some clarity about what you really want. Then you can set about obtaining it.

In planning for the future, your greatest enemy will be the inner voice that tells you it can't be done. As artist and curator Tim Taylor describes it, "We are taught to rehearse the negative." Instead of thinking your goals are impossible, train yourself to ask not "Can I do this?" but "How can I do this?"

Personal insecurities aside, a lot of the ideas we hold about artists come from attitudes embedded in the culture itself. People who are not artists are fond of describing artists as "flaky." They say that we have no head for business and can't function in the real world. They assume we have to suffer for our art, and put the words *starving* and *artist* together so often that even we believe it is our destiny.

In the seventeen years I have worked with artists, I have found that not only are these concepts wrong, they are monumentally wrong. If artists don't function well in the business world, it is not because they can't but because, for the most part, it holds little interest for them. Artists would rather be making art. When an artist decides to turn his or her attention to business, the results can be amazing. Artists are first and foremost creative people, and creativity applied in any arena transcends whatever apparent limitations there are. Creativity, by definition, changes everything.

As artists, we have been taught to be wary of the business world, and this caution is not without foundation. The business world is not renowned for its concern with the quality of life, questioning the status quo, or any of the deeper issues. The business world is primarily concerned with the bottom line; other issues are considered second, if at all. In order to enter the business world, you will need to learn how it functions. Here are a few guidelines to help you maintain your integrity while learning to negotiate in the realm of business.

I have offended God and mankind because my
work didn't reach the quality it should have.
LEONARDO DA VINCI

▬▬ Guidelines for Entering the Business World

Make the art first, then find the market for it. It is standard practice in the business world to conduct a market survey before launching a new product. This practice may be brilliant if you manufacture baby diapers and need to discover whether your new style works before you invest in producing a million of them. But the efficacy and power of art cannot be measured; certainly not by any survey.

Encountering art is a private experience, specific to the viewer. Since no two viewers are alike, it is impossible to concoct a formula guaranteed to succeed. As an artist, you have to start from yourself—what you know and what you think—and from that make the truest art you can. Then begin searching for your audience, the people who can hear what you are saying. If you make authentic art, art that is meaningful to you, it will speak to someone else.

> *Better to write for yourself and have no public, than to write for the public and have no self.*
> CYRIL CONNOLLY

Don't try to second-guess the market. If you do, one of two things will happen. Either you will guess wrong and end up making art that nobody wants (and you're probably not very interested in either), or you will guess right and spend your life making art you don't want to make while dreaming of the day when you can make your own art again.

The point of being an artist is to make your own art, art that speaks about the things you want to say in the way you want them said. Any business decisions that lead you away from this are the wrong ones.

Assessing your art in terms of the marketplace. Before you enter the marketplace, you will need to take an honest look at your art. Put your emotional attachment aside and look at the work as others see it. One obvious element to examine is quality. Does the work live up to your standards in terms of its concept and the execution of that concept? Most artists are never completely satisfied with the quality of their work. In their eyes, there is always something that can be improved. Taking that into consideration, does your art live up to the ideals you have set for it? Is it at least as well-made as other works of the same

genre that are selling in galleries? If it is almost there but not quite, get back to work. Don't let your art leave the studio until you are 97 percent happy with it (the other 3 percent can be attributed to intrinsic artist dissatisfaction).

Let's assume you are happy with the quality of your work. The next thing you need to consider is where your art fits in the marketplace. Who is your audience?

In the first chapter, I suggested that you think of art history as a centuries-long conversation. Each generation of artists comes along, listens to what has been said before, and then adds something new. You might also think of it as an extended cocktail party; and just like any cocktail party, if you jump in and say something that somebody else has already said, you will probably be ignored.

Who attends this party? Museum curators, art historians, critics, high-profile gallery owners. These people want to see art that is cutting edge, art that surprises them, art that takes the culture's knowledge of itself in a new direction, or art that moves an old direction in a new way.

If this is the kind of art you make, if these are your goals, too, then this is the market you should aim for. If your work is truly saying something new, then don't be shy about sending your work to the well-known galleries, the world-class museums, and the most demanding critics. If your art isn't saying something new, don't waste your time trying to get these people to pay attention to you.

> *A life spent making mistakes is not only more honorable, but more useful than a life spent doing nothing.*
> GEORGE BERNARD SHAW

Most art isn't about breaking new ground. Many artists create for the love of the materials; the thrill of putting paint to canvas; the joy of capturing a moment, person, or place in every detail; or the challenge of pushing oneself to master techniques used by the great artists of antiquity. Museum curators and art historians may call this derivative art because it is covering ground already attended to by earlier artists, but for the artists making it, it is as fresh and true as any art can be.

Maybe you are making beautiful paintings in the style of Monet, or exploring the beauty of nature, the human figure, personal growth, or

spirituality in a manner that is not new to the art world but is authentic to you. Maybe your focus is on painstaking craftsmanship. These are all worthy of your attention, and there are markets for all of them. There are thousands of galleries, as well as local museums and nonprofit spaces, that specialize in each of these genres. Much of this kind of art can be sold through art consultants as well as online venues.

Making strategic choices. The quickest way to reach success is to narrow your list of goals, just for the short term. I know you want *everything*, but which part of everything do you want first? Do you want to get your work seen or do you want it to be sold? Do you want gallery representation? Do you want to show in nonprofit spaces? University galleries? Is gaining notoriety important? The choices you make in these areas will determine where and how you approach your market.

How I Learned to Set Goals

Several years ago I took a class at UCLA called the Psychology of Success. I had finished art school and was supposed to be building a body of artwork, but I couldn't seem to make myself work. I would start a piece and not finish it. I would buy a new set of art materials and use them once. I wanted to be an artist more than anything; I agonized every day over my inability to get anything done. Then I noticed the Psychology of Success class in the UCLA Extension catalog.

I don't know the key to success, but the key to failure is trying to please everybody.
BILL COSBY

The class was in one of those big circular auditoriums with the professor standing in a glow of light in the front. There must have been five hundred people there, or so it seemed at the time. On the first day, the teacher passed around a box of 3" x 5" cards and asked all of us to write our goals on a card. When my turn came I thought, okay, no more thinking small for me, I'm going to think big. So I wrote: "I want to be really famous."

We returned the cards, and the teacher shuffled through them, plucked one out, and held it high. She announced with authority, "This person is doomed to failure."

You probably know what's coming, but I didn't. I thought, "Oh, that poor person!" Then she read *my* card aloud to the whole class. I

could have kept my anonymity, but I was so appalled that I whined loudly enough for everyone to hear, "Some people are famous. Why can't it be me?" The teacher asked the class if they knew why my goal could never be achieved. Fortunately, for my ego, only one person knew the answer.

The answer is: Because you can't figure out the first step! It's fine to want to be famous, but famous for what? Baseball? Piano playing? Inventing a new adhesive? I had neglected to state my area of interest. Also, what did I mean by *really* famous? How much is really? How would I measure it? A solo show in a museum? Which museum? My own TV show? A breakfast cereal named after me? Dinner in my honor at the White House?

I find it rather easy to portray a businessman. Being bland, rather cruel, and incompetent comes naturally to me.

JOHN CLEESE

So when you sit down to set your goals, make them specific. The more precise they are, the more obvious the first step will be to you. If you want to be a respected painter, the first step obviously is to paint. Think about what you mean by respected. Whose respect do you want? What do you want to have achieved to merit this respect? The more specific the questions, the more obvious the answers, and the easier it will be to achieve goals.

I learned many amazing things in that class. The teacher described an experiment in which they placed a rat at one end of a chute and its food at the other, and then measured how fast the rat ran to the food. The scientists discovered that no matter how long the chute was, no matter how far the rat had already run, it always found an extra burst of energy the minute the goal was in sight. The teacher described this as an adrenaline rush.

Have you ever noticed that when you have twenty phone calls to make, you can put them off indefinitely? And yet, once you make the first call, the others seem to follow with ease. This is the best part of an adrenaline rush, the overflow of energy that automatically propels you on to the next task. You can use this phenomenon to your advantage.

It is good and right to set big goals for your life's plan; all successful people have them. But exceptionally successful people make sure

their days are filled with lots of little goals as well. Every time they complete a goal, they experience the extra boost of energy that comes with achievement. Every time you achieve another goal, you feel good about how much you have accomplished; and that is so much more enjoyable than feeling bad about how much you haven't done.

Say you want to become really buff; you want your whole body to become a solid mass of muscle. Obviously, the first step is to set up an exercise program. Let's assume it's a big job—you're thirty pounds overweight and not exactly in shape. You decide to go to the gym and work out two hours a day, seven days a week for the next three years. This is just setting yourself up for failure. Who can go to the gym every day for three years? You are bound to let yourself down. It is not that your goal is too big, but the steps are. The best way to set up a daily goal is to ask yourself what you can realistically do, given your lifestyle and circumstances, and then cut that number in half. You will get a lot more out of yourself, and feel a lot better doing it.

So you have been meaning to go for a run before work in the morning, but you can't seem to get started. Change the goal. Instead of setting a goal of running every morning, decide you just have to get into your running clothes. Once you put on the outfit, you will often find that you might as well take a short run. But on days when you don't, on days when you just get into the outfit and take it right off again, congratulate yourself. You achieved your goal; running was a bonus.

You can use this same kind of thinking for your art career. Maybe you want to paint a masterpiece to rival Picasso's *Guernica*. There's a nice big goal! First of all, how do you measure a masterpiece? You can't. If you can't be sure you are creating a masterpiece, what can you be sure of? You can be fairly certain that you are making a painting. And you can be fairly certain that making a painting is how Picasso started.

If you are a painter, set a goal to be in the studio painting a certain number of hours per week. Watch yourself the first week to see if you are meeting your goal. If you are not, don't scold yourself for being a shiftless sloth with the backbone of boiled pasta. Change the goal to one you *can* meet. Decide that all you have to do is be in the studio;

you don't have to actually paint anything if you don't feel like it. All you have to do is be there. Eventually you will pick up a brush, out of boredom if nothing else. Do whatever it takes to reach the point where you start to develop a regular pattern, no matter how elementary. Before long, the thrill of the work will carry the momentum for you.

In my classes, the students set their own goals for studio time. Some work for as little as one hour a week, others as many as forty-five hours a week (those are the ones with the trust funds). It doesn't matter what goal is set, as long as it is reachable for the artist who set it. After two weeks, we reassess the goals. If an artist is easily reaching or surpassing his or her goal, we leave it as it is. If the artist really had to stretch to make it, or simply couldn't, we cut it in half. There is no shame in setting a small goal. Each of us has different responsibilities, different demands on our time. Instead of growing angry over your circumstances, or making yourself *wrong*, accept the cards you were dealt and start from there. Even with just an hour a week, if it is honored every week, an amazing amount can be accomplished.

When bankers get together for dinner, they discuss art. When artists get together for dinner, they discuss money.

OSCAR WILDE

One of my students, a young lawyer, hated her fifty-hour-a-week job. All she wanted to do was paint. Her job was so demanding that she only had one day off a week, and that was usually consumed by necessary chores like laundry and grocery shopping. She decided to carve two hours out of that day for painting. Some weeks she was able to do more, but she always stuck to her two-hour minimum. After a couple of years, she was able to build a body of work and to begin exhibiting and selling her paintings. Then she reduced her hours at the office, and recently she quit her job altogether. I've never seen anyone happier. It all started with making a commitment to her art that she could actually keep, and then building from there.

To help you define your goals as an artist, I have included a one-page questionnaire, a self-contract, for your use. Don't agonize over filling it out; you probably already know most of the answers. The idea is to clarify your goals, not to create an excuse to avoid them. If you don't know what your

Putting off an easy thing makes it hard, and putting off a hard thing makes it impossible.

GEORGE LORIMER

five-year goal is, write whatever comes to mind. You can always change it later on.

Now that you know what you want, you are ready to devise a strategy.

Name: _____ Date:_____

The purpose of this contract is to help you analyze and clarify your objectives and to set goals. Try to be as specific as possible about what you want.

What is success to you? Possibilities include, but are not limited to: creating a new body of work, completing a body of work already begun, finding a new direction as an artist, having a solo show, having a university exhibition (or nonprofit space, or gallery, or museum show), selling work, getting published in a magazine or book, getting a grant, funding a special project, working with art consultants, finding a dealer, getting a gallery in Europe, having five shows a year, ten shows a year, a show at the Whitney, your own TV show, etc.

Not all of these things are possible at the beginning of an artist's career. It depends upon a number of factors: how resolved your art is, how much and where you have shown already, how much time and money you have to devote to your art, and how lucky you get. But don't let that deter you. Set the goals you really want. Setting a goal is always the first step toward getting there.

1. *What is my lifetime goal as an artist?* List everything you can think of here. Be as specific as possible.

2. *What is my five-year goal as an artist?* Where would you like to be in five years? Cut down on your lifetime-goal list a bit. Choose the goals you most want to achieve. State them as specifically as possible.

3. *What do I plan to accomplish during the next six months?* Here is where you plan where your energies will go during the immediate time period.

4. *How much time do I plan to devote to my goals each week?* Don't skip this question. It is crucial. Decide how much time you can give to your career as an artist. Decide when you can work on it and where.

*P*lanning a *S*trategy

CALVIN AND HOBBES Bill Watterson

Once you have a body of work completed (or a body of work that is nearing completion) and you have made a few decisions regarding your career objectives, you can start developing a strategy. A good business strategy is one that provides a clear route for reaching your goals, involves the smallest amount of anxiety on your part, and includes lots of small achievements along the way so it feels more like fun than work.

The first thing to remember is that all roads lead somewhere; the second is that you can never be certain just where they are going to lead. An artist may have a show in an uptown gallery and another in a small café. Logic would dictate that the gallery show would be the one to launch the career, and usually that is the case, but not always. I've

seen many careers suddenly skyrocket because an influential curator or collector found the art in some offbeat place, and I've heard just as many stories of art languishing unsold in gallery back rooms. For myself, even though my art has been represented by reputable galleries in cities such as New York, London, Paris, Los Angeles, and Houston, it was a café show in Emeryville, California, that led to my work being included in two important collections. The owner of the café was a friend, but when she invited me to show my work, I replied that I was much too important an artist for such a lowly venue. She told me to get off it and bring her some art. So I did. As it happened, two curators had dinner at the café that evening, one from a major museum and the other in charge of a world-class private collection. They saw the work, liked it, and asked me to send them slides.

No formula is guaranteed to work. Since there is no way to do something exactly right, it follows that there is also no way to do it exactly wrong. The only thing you can do wrong is to do nothing at all. Any strategy you choose will take you in the direction of your goal. Some directions will move faster, and some will travel only so far and then stop, requiring that you devise an alternate plan; others will start to lead one way and suddenly veer toward another route. Just stay on that pony, keeping the goal in mind, and you will get there.

I heard a wonderful quote on the radio. I wish I knew who said it. I was driving along listening to music when I changed the channel and heard a man say, "One day I discovered that although two wrongs may not make a right, three left turns do." Since I was driving, I decided to test it out. It works; three left turns *do* make a right. So keep the goal in mind, and you will eventually reach it.

Once I make up my mind, I'm full of indecision.
OSCAR LEVANT

Some Common Strategies

Let's consider some possible strategies and where you can reasonably expect them to lead.

Entering juried shows. Most artists begin their careers by entering competitions. The terms *competition* and *juried show* are used interchangeably in the art world. The artist submits slides of his or her art

Juror Tells All!
By Cay Lang

I have sat as a juror for a number of competitions, and here is what it is like from the other side. Usually the job involves spending one, often two, and sometimes more days sitting on folding chairs in the dark looking at slides with the other jurors. A juror is usually paid a small stipend as a token for the time invested, but it is nowhere near an hourly wage. The reason a juror agrees to spend several days looking at slides is not for the money, but because he or she feels a commitment to helping the larger art community. The jurors arrive on the agreed-upon date, are introduced to each other, make small talk for a few minutes, maybe eat a donut or a bagel, and then everyone gets down to work.

Before jurying day, each prospective artist has been assigned a number to prevent the jurors from being influenced by the artist's name, and his or her slides have been placed in carousels, ready for projection. If, as in the case with the NEA, the artist was instructed to submit ten slides, there will be five projectors sitting in a row, so that the work of each artist can be viewed as a body, in two sets of five.

The jurors are instructed to vote on the work as it comes up, by number. As they look at the slides, they write their vote on the form in front of them. Often the slides are projected for only a few seconds, and unless one of the jurors asks a question, this brief look is all the jurors get. Even at that speed, it can take hours to view all the slides.

Slides are the great equalizer. If the slides are improperly exposed, even by a tiny fraction, the work will look gray or white or black on the screen, instead of the colors that were originally intended. If the juror has been looking at slides for even just a couple of hours, his or her eyes will not be able to adjust quickly to allow for this deviant information. Since they are viewing so much art, most jurors will tend to dismiss bad slides, turning their attention to the next artist instead.

The problem with slides is that all art is altered by the slide film itself. Art with strong graphic components and rich colors will look even more striking. Images with subtle colors, delicate shadings, or light pencil lines will tend to look muddy or washed-out. Film exaggerates some things and misses others entirely. If the work is conceptual or narrative in nature, or kinetic, or is composed of a lot of text, you will have difficulty trying to capture these details in a tiny slide. Always project your slides yourself before sending them to a competition. Any problems will become apparent immediately.

All the slides are projected to the same size on the wall. This means that a painting thirty feet long will appear the same size as one that measures six inches. If scale is important in your work, you need to make special note of that in the accompanying paperwork. Do not stand next to the artwork; the jurors will look at you instead of the art.

The jurors work like this for three or four hours, looking and voting, looking and voting. They take a short lunch break and then return to view slides for another four hours. By the end of the day, the jurors have seen more art than they can possibly absorb. To be fair to the organizers of juried shows, most try to be fair to each contestant and show the artists' work in a good light, and they try to create a pleasant experience for the jurors. But the truth is, with hundreds, sometimes thousands of artists applying, there really is no other way to do it.

along with an entrance fee, and a jury decides whether or not to accept the work into the show. If the artist is accepted, he or she will be asked to frame and ship the work. The work will then be exhibited in a group show. Such exhibitions are good for adding entries to your bio, and, who knows, you might win some prize money. You can find juried shows listed in the back of magazines like *Artweek, New Art Examiner,* and *ArtCalendar,* among others.

Entering competitions can become costly. The entrance fees add up, as do framing and shipping costs. And although it is always advantageous to add another exhibition to your bio, juried shows hold the lowest rung on the ladder of art-world status. Enter a few for the experience, if you like, but start planning some more active tactics for launching your career.

You should know how juried shows work. The sponsors collect money from lots of artists, reject most of them, and select a few for inclusion in the exhibition. A small part of the money collected sometimes goes to prizes for a small number of artists, and the bulk of the money goes to the organizers of the show. Sometimes the money goes to support a worthwhile organization, such as a nonprofit art space; but sometimes a juried show is just a scam. It is often difficult to tell the two apart. Just because a juried show is advertised nationally is no guarantee that it is legitimate; sometimes the splashiest shows are the dishonest ones. *ArtCalendar* magazine often prints articles exposing the most obvious scams, but it can't catch them all.

> *Destiny is what you are supposed to do in life. Fate is what kicks you in the ass to make you do it.*
>
> HENRY MILLER

If you decide to enter a juried show, choose carefully. Examine the list of jurors. Are they people you know and respect? What are their credentials? If they are curators, critics, or gallery owners, then entering the competition might be a way to bring your work to their attention. Be aware that they will be looking at hundreds of artworks in a very brief time, so they won't be able to focus on any one artist.

Notice the location of the exhibition. Will the art be exhibited in a museum or someone's garage? One of the reasons for entering a juried show is to strengthen your résumé. If the exhibition will be held at a location that won't enrich your bio, then it is probably not worth it.

You should also consider the cost of a juried show. Look at similar juried-show listings. Is the entry fee about the same? At the time of this writing, five to twenty-five dollars a slide is about standard. If the sponsor is asking very much more, the show could be a questionable investment.

Finding a commercial gallery to represent you. The traditional path for entering the art world is to find a gallery to handle your work. This can have many advantages, as we discussed in earlier chapters; but today's artist needs to be much more savvy than his or her predecessors, both in the strategy for finding the gallery, and in working with it once a relationship is established. For one thing, there are many more artists than there are galleries to handle them. Also, the economic climate is more difficult than it was ten years ago, forcing the galleries to pay close attention to their bottom lines.

> *There is only one success...to be able to spend your life in your own way, and not to give others absurd maddening claims upon it.*
>
> CHRISTOPHER MORLEY

The standard strategy for finding a gallery is to blanket the art world with your packet, hoping by the sheer numbers to get a bite or two. I asked gallery owners across the country what it is like to be on the receiving end of these truckloads of artists' packets. Their experiences were almost identical in every case. Here's what they told me:

- Most of the packets they receive are from artists who haven't a clue what the gallery is about or from artists who have never seen the space, never heard of the artists the gallery represents, and never attended an opening.
- Much of the material they receive is put together without care or concern: the images are poor, the labels are nonexistent or incomplete, or the written material is full of extraneous information, such as how much the artist loved a third-grade teacher.
- Artists send materials without bothering to inquire about the gallery's facilities for handling them. As one New York dealer pointed out, galleries are ill prepared to take care of material that does not belong to them, so each gallery has its own solution for

looking at slides. Artists will send CDs and DVDs to galleries that have no facilities for looking at them, or drop off large portfolios at galleries where space is at a premium, when, with a simple phone call, they could have devised a more effective plan.

- In spite of the difficulties, most gallery owners consider viewing artists' work an integral part of their job. When art floats across a dealer's desk that is both appropriate for the gallery and presented professionally, it stands out from the multitudes.

It is no wonder that galleries rarely take on artists from unsolicited materials, but I know that the system works when properly applied because it worked for me with several very good galleries early in my career, and because I see it work every year for many of my students. The secret is to choose the recipients of your materials carefully, create beautifully presented promotional packets, and behave in a thoroughly professional manner.

I asked the gallery owners where they get most of their artists, if not from packets. Those answers, too, were instructive. At the top of the list were individuals recommended by artists they represent. As one dealer put it, "If Roy Lichtenstein calls me and says 'there's this young artist and I think she's talented,' don't you think I'm going to pay attention? Of course I am." Gallery owners trust their artists because the artists know what the gallery's program is and the gallery owner knows that the artists wouldn't recommend anyone they would be embarrassed showing with. Gallery owners also listen to recommendations from respected curators and art dealers in other cities with whom they have worked in the past.

Art dealers are always looking; they like to keep an eye on the hottest art-world developments. When they travel, they look at art. In their own town, they look at art. They make a point of seeing shows at all the local noncommercial art spaces. They keep an eye on the artists handled by their competitors as well, although most are quick to say they would never steal an artist from another dealer. They read the art magazines and the newspapers for reviews about artists. And most of them have a long list of dream artists they would like to handle.

Established galleries already have a stable of artists they have invested time and money in, and each gallery can handle only so many

artists. The older the gallery is, the less likely it will be interested in unknown artists. As a gallery grows, its focus becomes more definite, and the energies of the staff are directed toward artists whose careers they are already committed to. Younger galleries are more open to taking on emerging artists.

I asked the gallery owners for the best strategies for finding gallery representation, and they listed the following. Suggestion number one was universally to make astounding art. After that, they said:

- Create your own energy. Taking your destiny into your own hands is the key. Really interesting art scenes are created when a group of like-minded artists get together and hang their art wherever they can.
- Become involved in your local (or regional) art community. Go to galleries, attend openings, and meet the people there. If there is a particular gallery you feel would be right for your work, make a point of demonstrating your interest by going to the openings and taking the opportunity to get to know the artists and the dealer.
- Be professional. Make sure everything about your presentation is absolutely top-notch, research a gallery before you approach it, and treat the gallery staff with consideration and respect.

Starting locally. Traditional art-world thinking demands that you start locally. The idea is to build your career by gaining acceptance in your hometown first; as your acceptance grows, so will your career, in an ever-increasing spiral. While this has been the default strategy of artists for centuries, beware, because sometimes you can dead-end at the local level. There are a number of reasons for this. Sometimes an artist's work speaks to a wider or different audience than the one found in his or her immediate geographical location, but the artist who only tries showing the work in that one spot may never become aware of that fact. Also, being a homegrown artist may have a detrimental, rather than a positive, effect. Local artists are a dime a dozen, no matter where you live. It is notoriously difficult to convince people who have grown up with you that you may be a genius. No one ever believes that they could actually know one.

On the other hand, you can usually find a gallery in every town that specializes in local artists. These galleries have a mission to support

I have the feeling that I've seen everything, but failed to notice the elephants.
ANTON CHEKHOV

local art; they like to be able to work directly with artists on a daily basis, and they believe in the talent that surrounds them. For the emotional support, and the chance at some sales, a local gallery of this kind could be a good first move. If the gallery also has connections with galleries in other cities, it could be a great first move.

Showing in cafés and other non–art-world spaces. This can be a wonderful way to get started. When you show in a neighborhood café, your friends and acquaintances often get to see your work for the first time. Viewing the art on the walls can be their motivation for buying the work, so you may make your first sales. Cafés are less forbidding than galleries and can create dialogue and interaction around the work. A show in a café usually won't directly advance your career, but you never know who will see it. It could be one of those left turns that leads to the right. Be prepared to do all the work yourself, from hanging the show, to publicity, to putting on a reception, to dealing with sales and insurance. Many café-style venues do not take a percentage of sales, so if you sell anything the money is all yours. Of course, they don't have any salespeople pushing the work either, so you deserve it.

Café shows can be a good experience and worth doing a few times, but just like juried shows, they can be a dead-end for your career. Do them for the fun of it and to connect with your neighborhood, but make some steps in other directions as well.

Moving to New York. What about moving directly to New York? When I was a student in art school, I was repeatedly told that if I were truly serious about becoming an artist, I would move to New York. I was willing to tear myself away from California, but my life conspired against it and I became an artist without the benefit of the Manhattan experience. Because the cost of living in California was low, I was able to travel; and before long, I began exhibiting my art all over the world, including New York.

Some of my school friends did move to New York. A few of them were able to launch successful art careers, but most are still waiting. I actually got my first show in an uptown gallery before any of my New York friends did. In Manhattan, every other cabby, waiter, bartender, or salesperson is an aspiring artist, actor, playwright, or novelist, so

> *I think perhaps there would be more anxiety in my work if I lived in New York.*
> ED RUSCHA

the competition is very steep. In addition, the cost of living is high. If you move to New York, you will be spending more for food, housing, and even art supplies. Many aspiring artists move to New York without a job, a place to live, or money in the bank. This generally results in their finding one of the low-paying jobs above, working long hours, and squeezing in time to make art. If you are young, healthy, determined, energetic, and adventurous, or if you happen to have a nice fat trust fund, go for it.

The truth is, New York is still the hub of the art world. In New York, art movements come and go so fast that the rest of the world rarely even hears about them. There is a cornucopia of art events to choose from; lots of chances to talk and think about art and many opportunities to network. The artistic stimulation alone can be worth making the choice. The stakes are high in New York, but if you are one of the few who make it big, you can make it very big, indeed. Most of the art magazines are located there, as well as several world-class newspapers, so the chance for media attention is much higher than anywhere else. New York also houses more museums, more galleries, and more art collectors. The rich and famous are everywhere; you could become one of them. Just remember, the very poor are everywhere, too.

All the really good ideas I ever had came to me while I was milking a cow.
GRANT WOOD

Jim Pomeroy used to tell a story about John Baldessari at the early part of his career. I don't know if the story is true, but I love it anyway. Pomeroy said that even though John Baldessari lived in Los Angeles, he would fly to New York every couple of months for the art gallery openings. People in New York thought he lived there. They would see him and say, "Hey John, I haven't seen you around for a while. Where have you been?" And he would answer, "Just working in my studio." He neglected to tell them that the studio was in L.A.

Targeting a large American city. One effective plan is to target a city with an active arts community, devising your strategy from home. Choose any city with a large number of galleries, museums, and non-profit spaces. Some of the more obvious choices are Chicago, Los Angeles, Santa Fe, Seattle, and of course, New York.

The secret to success with this plan, as with all the others, is do your research. Doing your research means finding out as much

information as you can about each of the galleries you are considering. You will want to know what kind of art they show, which artists they handle, if they are open to taking on unknown and emerging artists, what the space looks and feels like, and what kind of reputation the gallery has in the community. A good starting point for this information is the August issue of *Art in America* magazine, its Annual Guide to Museums, Galleries and Artists. You can purchase it as part of a subscription to *Art in America*, or pick it up separately at a newsstand. Inside you will find detailed listings of galleries throughout the country, including the name and address, phone, and contact person, the kind of work the gallery shows, which artists it represents, and the exhibitions it has mounted over the past year. There is also quite a long list of art consultants in the back of the magazine.

I think people who are not artists often feel that artists are inspired. But if you work at your art, you don't have time to be inspired. Out of the work comes the work.

There are lots of other art magazines, too, each of them carrying articles about art, artists, and the art world. Make a trip to your local library, or an international magazine stand, to find them. A good guide to New York galleries can be found in the book *The Complete Guide to New York* by Renee Phillips.

Don't forget to research online as well. Most art galleries and museums around the world maintain Web sites. This a great aid in finding appropriate spaces for showing your work. Using any standard search engine, type in the keyword that best describes what you are looking for. Keywords like "art gallery," "art museum," and "contemporary art" are probably good places to start, coupled with the name of the city you are approaching. Expect a barrage of information and a further need to refine your search before you get to just what you are looking for. Most Web sites offer some method of contact, usually e-mail. Why not e-mail them, telling them that you are planning a visit to their city, and asking if they can make suggestions or point you to a gallery guide? You might make a new friend. But be gentle about it, do not insist, or you could lose that friend just as quickly.

Once you have completed the preliminary research, the best strategy is to make a reconnaissance mission to the city you have chosen. Visit the galleries, view the exhibitions, chat up the staff members.

When you walk into a gallery, you will be able to make assessments concerning the feel of the space, the attitude of the personnel, and the quality of the installation that would be impossible from a distance. If the gallery passes your inspection, keep it on your list. If not, you have saved yourself a lot of unfruitful work. This trip is also a great way to discover galleries you didn't already know about. Since not all galleries are listed in *Art in America*, you may arrive at one gallery on your list and discover one next door you like better.

When you have arrived at a list of appropriate exhibition spaces, plan a second trip to your chosen city. This time you are going on an earnest search for suitable venues for your art. Write ahead to each prospective exhibition space. Your artist packet should contain a full set of information about you (slides, CD, bio, statement, reviews) and a cover letter asking for an appointment. The idea is to stimulate the gallery's appetite with images of your incredible art, then set up a time frame for them to view the work itself. If they want to see it, they need to make a decision to take action. Mail the packet about three weeks before your trip. Galleries who are not interested in your work will have time to return it, and the ones who are interested will have a chance to call you to schedule an appointment before you leave home. Galleries have a predictable cycle they go through each month; first they frantically hang the show, then they spend several weeks selling art and tending to other details, then they take the show down and frantically hang the next. If possible, plan your trip to coincide with their slow times and expect to be there a minimum of a week; two weeks is better.

A sample cover letter for a trip to another city follows. Use it as a guide for making first contact.

As soon as you arrive, telephone the galleries. Making these phone calls early in your trip will save you from experiencing the agony of being rejected in person. Not everyone will want to see you, but some will. If they are not interested in your work, ask them if they know of anyone in town who might be. Ask for the correct spelling of the name and the phone number. Then call that person, too.

Upon arriving at the galleries, pick up a copy of the local Art Guide. It will list current exhibitions and galleries that weren't listed in *Art in America* you might want to contact. If you have targeted places

Every work of art is the child of its time; each period produces an art of its own, which cannot be repeated.

WASSILY KANDINSKY

Date

Name
Address

Dear *(Important Person You Are Trying to Contact):*

Please consider my art for your gallery. I am an artist from *(name your town, state, or country)* making a trip to Seattle in March. I would love to show you my work at that time.

I will be in Seattle from March 5 to 15. I will call you when I reach town to arrange an appointment. I look forward to meeting you. Thank you in advance for your consideration.

Sincerely,

(Important Person Sending This Letter)

appropriate for your work, you should come home with at least one commitment and several maybes. You will get lots of rejections, too. File them under "So what?" You are on your way.

Targeting a foreign city. Different parts of the world have different practices regarding business and art, but don't let that slow you down. When approaching a foreign city, do as much research and preparation as you can and send out your packet; then just trot your pony on over there. You will make some mistakes, but you will also discover that you are doing a lot of things right. An attitude of adventure, forthrightness, and consideration can carry you a long way.

Researching art galleries in other parts of the world can be more convoluted than finding galleries in the United States. Your best bet is to do your research online. There is no European counterpart to the August issue of *Art in America*, but there are many international art magazines and some of them are available in the United States. A good source for these is an international newsstand, as well as the art library at your local university. When you peruse these magazines, pay as much attention to the ads as the articles. You may even find a gallery guide in the back of the periodical. Think of everything in the magazine as a clue. You can also try contacting the country's consulate for gallery and museum listings.

Once you have compiled your list of galleries, proceed just as you would for any American town. Send the gallery director or curator a packet with a cover letter providing your trip dates and contact information. If you are on a tight budget, you might consider sending a smaller packet with fewer materials, since international postal rates are more expensive than domestic rates.

It is a good idea to have your cover letter and artist statement translated into the language of the country you are visiting, particularly if you don't speak that language. That way, if you have to resort to sign language to communicate, you can at least hand them a document they can understand. Translators can be found in the language departments of any university, usually for very little money. You can also find them in the yellow pages.

No guts, no glory.
BETTE DAVIS

The first time I took my work to Europe, I was so nervous about my inability to speak French that I hired a teacher to help me learn to pronounce the main phrases in my translated statement. It only took a couple of hours, and it was worth it, if only for the unbridled laughter it produced in the French when I attempted to relate what I had learned. Watching me try to discuss complex aesthetic philosophical ideas in a language I didn't understand produced sympathy in my viewers, and soon they were contributing their version of English to the discussion. I made some wonderful new friends.

Using the world's biases in your favor. You might be able to skip a few career steps if you remember that the whole world is prejudiced. I'm not talking about racial prejudice; I am talking about location prejudice. No matter where you live, there is always some place more glamorous and another not quite so attractive. The art world has its glamour hierarchies as well. For more than half a century, New York City has been considered the focal point of the art world; before that it was Paris.

Because New York is the center of the art world, Manhattan art professionals sometimes have difficulty taking artists from other parts of the country seriously. The thinking goes something like this: New York is the center of the art world, so if you are serious about being an artist, you should be in New York. Therefore, it follows, that if you are not in New York, you must not be a serious artist. Within the United States itself there are similar hierarchies: Chicago, Los Angeles, and Washington, D.C. follow New York in art status (and any one of them will tell you that the others are not in their league), then the other major cities, followed by small towns everywhere. Status even differs among the small towns. Positioning on either coast is good; being placed in the center of the country is not so good. It's all foolishness, of course, but the biases are there.

New York *is* impressed with Europe, however. And the amazing thing is that Europe welcomes all artists. Of course, if you are from somewhere other than Europe, you are doubly welcome. The first time I took my art to Europe, even though I was a thoroughly unknown artist, apparently unreachable art professionals in France, Germany, Great Britain, and Italy opened their doors to me. This is partly because Europeans hold art in much higher esteem than Amer-

I prefer the errors of enthusiasm to the indifference of wisdom.

ANATOLE FRANCE

icans do, partly because they believe that looking at art by unknown artists is a pivotal part of their job and partly because, to them, non-Europeans seem exotic.

You can use this kind of circular thinking no matter where you live, not only to make things easier for your career, but as an excuse to have an adventure as well. Think about the whole world. Where would you like to go? Japan? Kenya? South America? The farther away from home you go, the more exotic you become. Of course, you can't just go to those places, you have to work, too.

Inventing a new form for showing your art. I can't give you instructions on how to do this since, by definition, a new form hasn't been invented yet. You can use the models described in chapter two as a starting point for ideas. A successful idea will combine at least some of the following characteristics:

- It will differ from the traditional gallery exhibition in some way.
- It will excite your imagination, energy, and passion.
- It will be unusual enough to attract media coverage.
- It will create intellectual dialogue in the art community and, one hopes, in the larger community as well.
- The process and effect of the project will be unpredictable.

Your new form does not have to embody all of these characteristics, but make sure that it includes the element of passion because whatever you invent is certain to involve lots of work. As a strategy for gaining the attention of the art world, an exhibition in an unusual venue can be amazingly effective, but as with everything else, the degree of success will be in proportion to the quality of the work.

Ensuring Positive Results

Whichever path or combination of paths you decide upon, there is always an element of risk, because putting your work out there means risking rejection. This is probably the most common reason that artists don't pursue their careers more actively, and understandably so; rejection hurts.

The notion of making money by popular work, and then retiring to do good work on the proceeds, is the most familiar of all the devil's traps for artists.

LOGAN PEARSALL SMITH

I can't protect you from rejection, but I can offer some techniques for removing the sting. What we want to achieve is maximum results from our efforts with a minimum of heartbreak.

The first tip. Do your research! (I seem to be repeating myself.) Find out as much as you can about the places you are thinking about approaching, and do not send art samples to a gallery if it doesn't handle your kind of work. Even with good research, you can expect only a 10 percent positive response rate.

Some artist consultants counsel a blanket-the-world-with-your-slides approach. I don't recommend it. Not only does this plan incur astronomical slide-duplication and postage costs, it isn't very effective, and it tends to make gallery owners reluctant to open their mail.

The second tip. Send out ten to twenty packets at a time (to your targeted list), and as soon as a set is returned, mail it to the next location on your list. That way you don't fixate on any one rejection. You also increase the odds that something good will happen so you can fixate on that.

The third tip. Think of your goal as collecting rejection slips. The more you get, the more successful you are. If you set a goal of collecting a hundred rejection slips, and you've done your research, then you will probably have to put up with at least ten acceptances. It's a nasty job, but somebody has to do it.

Interpreting a Rejection Slip

A whole book could be written on this topic. There are so many styles and degrees of rejection it boggles the mind. Most galleries have several versions of rejection slips stored on their computers that they modify slightly for each response. Here are some general categories:

The definite rejection. You can tell that you have received a never-darken-our-doors-again rejection if you get a form letter that says something like, "Thank you for sending your slides. We receive so

many inquiries that we can't possibly handle them all. Good luck with your career." This translates to "Don't bug us again." My advice is not to bug them again, at least until you have a completely new and different body of work. Let them go. Don't torture yourself trying to acquire their good opinion. You are unlikely to do so, and it will only serve to increase your anxiety level.

The conditional rejection. The text of this letter will include phrases like, "We enjoyed seeing your slides but are unable to accept work at this time. Please send us slides of new work next year." This is really a not-so-bad rejection. What it means is, they liked the work, but they don't think you are ready yet. They want to watch you over time to see how your work develops. This is a common practice. Galleries are often reluctant to invest in an artist until they are convinced of his or her commitment or until the work reaches a mature level, so they ask the artist to keep them posted. In your next cover letter, you can say, "Thank you so much for your warm response to my work last year. Here are some new slides as you requested." That way they will be reminded that they want to see the work, just in case they forgot.

The rejection that is really an acceptance (without the tedious bother of actually getting a show). This type of rejection is, of course, my favorite. These letters are not form letters. They are written in obvious response to seeing and liking the work. Sometimes the writers will go on at length about how wonderful your art is, but then finish with some reason why they can't act on their feelings. The reason could be that they are booked for two years, or that they love your work but they just know their clients won't go for it, or that it is too big for their space. A letter like this is a treasure, because it means that you have made a connection. Write them back immediately and thank them for their thoughtful response to your work. Tell them you are saddened that they can't work with you, but that you understand. Ask them if they have any suggestions for other venues for the work. Don't be a pest, but keep the lines of communication open. Send them new slides when you have them. Keep it friendly, and eventually it may turn into something.

> *I think all great innovations are built on rejections.*
> LOUISE NEVELSON

Eventually you will get one, then more than one, acceptance letter. You will be able to recognize it right away, without any coaching. My advice is to go out and celebrate.

Tomorrow the real work begins.

When Things Begin to Happen

Ziegler © 1996

"At your opening, I see that you had two glasses of wine, eight pieces of cheddar, eight crackers, and seventeen grapes. That, of course, will have to come off the top of your end."

Once people begin to be interested in your work, you will start participating in a whole new set of activities. You will form new relationships with a variety of art professionals, learn to deal with contracts and consignment forms, make framing decisions, ship your art, manage deadlines, and deal with sales. This can be a very exciting time, and a confusing one; the adventure has begun. This is what you wanted to happen, remember?

A useful rule of thumb when entering this new arena is: When in doubt, ask. Most of the problems that arise between artists and galleries occur because each participant makes different assumptions about the nature of the relationship. Don't be afraid of sounding like a beginner. Everyone is a beginner at one time or another, so why not take the opportunity to ask lots of questions. It is the quickest way to learn about the business and about the people you are dealing with as well.

Genius can probably run on ahead and seek out new ways. But the good artists who follow after genius—and I count myself among these—have to restore the lost connection once more.

KÄTHE KOLLWITZ

My personal strategy is to ask the dumbest question I can think of right away. After that, I can't be afraid of ruining my image. I know this won't work for everyone, but it gives me a tremendous sense of freedom, and I find it interesting to watch the effect on the person I am dealing with. If they respond with kindness and patience, the relationship will probably be a good one; if they are condescending and abrupt, I know I will have to be on my toes in dealing with them.

Once You Have Been Invited to Participate in an Exhibition

An invitation to participate in an exhibition is not the same as being invited to join a gallery; it is more like a one-night stand that lasts about a month. Over the length of your career, you will hang your art in hundreds, maybe thousands, of one-shot exhibitions, in many different kinds and sizes of exhibition spaces. Adopting a policy of communication at the start of your career will save you hours of frustration. There are specific issues you will want to discuss with the curator of each show.

Date and location of the exhibition. You need to know the opening and closing dates of the show, the reception date and hours, the due date for delivery of the art, and the date for the return of the art.

How many pieces will be included in the exhibition and/or how much space will be available for your work? If this is a juried show, the gallery will have already chosen which pieces are to be admitted into the

exhibition. If it is an invitational or a several-person show, the curator will probably want to choose the specific works to be shown, either by making a visit to your studio or from viewing slides of the work. For a one-person show, the artist usually has more control. If you can, visit the exhibition space before the show and talk to the curator about it. Doing so will help you anticipate and forestall potential difficulties.

Who is responsible for framing the art? The answer will probably be that you are. If the expense of framing the show will be difficult for you, ask the gallery if it has any suggestions for cutting the cost; perhaps it is willing to hang the show unframed, under glass. Or maybe it will frame your work for you and take the cost out of your first sales. There is always the chance that the gallery will agree to share the cost with you; it can't hurt to ask.

Who is responsible for hanging the show? Does the gallery employ a staff for the installation of its exhibitions, or will you be expected to hang the show yourself? If the staff is installing the show, how much input do they expect from the artist? Artists, especially at the beginning of their careers, are often nervous about hanging a show and tend to feel an urgent need to be in control of every aspect of the hanging. It is a good idea to give some attention to this matter, just long enough to ascertain that the curator is handling the work with care and sequencing the show with intelligence and attention. Beyond that, I have found that it is best to step back and allow the curator to do his or her job. As a professional, a talented curator can bring out the strength in your work in ways you may not have imagined. Ordinarily, the only time you will need to participate in the hanging is if a piece involves a particularly tricky installation; even then, give the curator plenty of room for input. You will probably be pleasantly surprised.

> *We moan about not working; and if we get a job we moan about the director, the script, and the reviews. If the play's a hit, we moan about the long run ahead of us. Then we moan because the play closes and we're out of work.*
>
> DEREK JACOBI

If the work needs to be shipped. Who will pay the shipping costs, and how is the art to be shipped? Standard practice is for the artist to pay

the cost of shipping the art to the show, with the gallery absorbing the return cost. The exceptions to this rule are juried shows, which often demand that the artist pay for shipping both ways. If it is a museum show, the museum usually pays for the shipping.

Exhibition announcements. Most exhibitions are accompanied by a printed announcement stating the date and location of the show, and the reception date, if there is one. For group and juried shows, the announcement usually lists the participants but does not carry a picture on the front. For one- or two-person shows, a reproduction of a work of art will often be added. You will want to find out if the announcement will be printed in color or black and white, and whether or not a photo of your work will appear. If the gallery won't pay for a color announcement and you can afford it, you might offer to share the cost of color printing. Since the announcement will reach many more people than will actually be able to attend the show, a reproduction of your strongest piece can give them a taste of theexperience. In addition, full-color cards with nice reproductions can be used long beyond the time frame of the show. Ask the gallery director to print some extras for your use later on. The gallery will usually agree to give you a hundred or so extra announcements without charge; very many more may mean additional "run-on" costs.

As an artist you have to be a thief and steal a place on the rich man's wall.

MARK ROTHKO

Mailing list. How large is the gallery mailing list, and who is on it? Is the gallery willing to pay postage for your mailing list as well? Usually it will assume the cost for at least part of your list; find out how many announcements have been allotted to you. Does the gallery want your list supplied on labels or on disk? When does it need the list?

Will there be a reception? Most shows have them. You will want to know the date and time of the reception, who will pay for it, and what will be served. Usually the gallery absorbs the cost of the reception, although today it is seldom more elaborate than wine and mineral water, with maybe some grapes or cheese thrown in.

Publicity. What kind of advertising will the gallery do? If it plans on mailing a press release, will it provide the promotional photographs or will you? When will the press release be mailed? Does the gallery have any special relationships with local critics? Is there any way you can help with generating publicity? There is a lot of give and take in this area. Each gallery has its own way of doing things, but usually it is thrilled if you are willing to take some responsibility for arranging publicity. Sometimes you may have to take the initiative entirely, but that is worth the extra work.

Insurance. Will the work be insured by the gallery? Most established galleries do insure artwork against damage, fire, and theft. If the show is in a café, or other space not normally used for exhibiting art, insurance may not be furnished. If not, you will need to decide whether you want to assume that responsibility. Insurance costs are very high, so you will have to weigh that against your ability to replace the art should something happen to it. Call your insurance company and ask about costs.

Gallery commission. When the work is sold, what percentage of the retail price will the gallery take? (This could range from zero to 60 percent.) How soon can you expect to be paid?

After the show. If the show is at a nonprofit space, alternative space, or museum, the gallery staff will expect you to remove the work as soon as the show comes down to make room for the next exhibit. If it is at a commercial gallery, they may want to keep some work on hand for a while to show to their clients, or they may want you to join the gallery.

> *Young man, you will never be rich until you are dead.*
>
> DEALER FRANK LLOYD
> TO
> ROBERT MOTHERWELL

Issues to Discuss with a Gallery That Wants to Handle Your Work

At last, a gallery is willing to take a chance on you. This is, you hope, the beginning of a long and happy relationship. Start it right by taking the responsibility for opening up the communication channels.

Topics for discussion should include, but not be limited to, the following.

The nature of the relationship. It used to be that when a dealer invited an artist to join the gallery, the invitation indicated a commitment to stand by that artist throughout his or her career. Today there are many variations on the theme. The gallery may want to try the work out for one show, checking the clients' reactions before making a more permanent arrangement. It may be interested in the art for one exhibition only (maybe the art fits the theme of a specific show but not the overall direction of the gallery), or it may want representation rights. If a gallery wants to represent you, you will need to find out if it expects exclusivity or not, and how it defines *exclusivity*. Exclusivity generally means that a gallery expects to be the only place in a given metropolitan area that handles your work; if someone in that area wants to buy your work, he or she must go to that gallery. Beware of any gallery expecting worldwide rights. Exclusive rights to a specific city is a more reasonable expectation. If a gallery asks for national rights, it must be willing and able to provide work to galleries in other regions for shows and sales. Few galleries have the staff, and connections, to do that.

Which work do they want? Sometimes a gallery will like your paintings but not your drawings. You need to clarify this so that you can find another dealer for your drawings if the first gallery doesn't want them. Sometimes the dealer can suggest a second gallery for the art. This can work to everyone's advantage if it's a happy threesome; but as always, communication is the key. The two galleries can use their double clout to promote the work, and you will be able to have all your work seen.

Find out how many pieces the gallery intends to keep on hand between shows. Will it want to keep the work indefinitely or send it back after a certain number of months? Does the gallery expect to receive the work from you matted and framed, or will the gallery assume that responsibility? Who will pay for shipping? What insurance coverage is provided? What is the policy on consigning work to other galleries? You will want to have a say in this, since otherwise the gallery can ship your work off to Mars without your knowing it.

> *As ugly as the work is, no work is so ugly that it can't be assimilated.*
> LEON GOLUB

How often can you expect to be given a solo show? Depending on the number of artists a gallery represents, an artist should expect to hang a show of new work every two years; sometimes less, sometimes more. There are many factors determining this, such as how many artists the gallery is prepared to handle and, of course, your own output as an artist. There is a wonderful painter, Katherine Huffaker Jones, who works in the studio every day and manages to turn out about

> *Being an artist is like walking a tightrope. All those little temptations are waiting underneath. The moment you try to please a dealer or make a couch painting, you've sold a little bit of yourself. You can never get back to the tightrope.*
>
> DOROTHY GILLESPIE

three paintings a year. She makes marvelous eight-by-ten-foot paintings with a tiny triple-zero brush. The work is so meticulous it takes her months to complete one piece. Obviously, she won't be ready for a show of new work every two years; six paintings do not fill a gallery. Other artists work very quickly and can fill a gallery every couple of months. If the gallery director thinks the work will sell, he or she is likely to arrange shows more frequently. Then again, the gallery may lean more toward group shows than solo shows. Ask what the policy is, and try to get at least a tentative commitment to dates for a solo show of your work. The dates may be changed later, but at least you will have a point to start from.

Is the gallery willing to sign a written contract with you? Dealers often balk at this. They cite reasons such as "the need for trust" and the relationship is "like a marriage," but I suspect that they are opposed to contracts because, without a contract, all the power lies in the hands of the dealers. Twenty years ago nobody offered artist-gallery contracts, but, thankfully, the practice is becoming increasingly frequent. If the gallery has a standard contract, don't just sign it; you will probably be giving away more rights than you want to. Ask a lawyer to review it and make the changes you need. Don't just show it to any lawyer; you need one who specializes in business law. You can find one, usually with a sliding pay scale to accommodate a limited income, through your state's Lawyers for the Arts organization (see appendices). Once you have consulted a lawyer, discuss the contract again with the dealer. A standard

contract is just a starting point. No one expects it to be signed without some discussion and changes. If the gallery doesn't have a standard contract, then use one that benefits you. I have included a copy of a contract written by the California Lawyers for the Arts in the appendices (see page 240). It seems to cover most of the important points.

A friendly way to institute a contract with your dealer was suggested to me by an art dealer in Washington, D.C. Let the contract develop organically, as the natural outcome of your discussions with your dealer. After you have talked with the dealer and discussed all the salient points regarding your relationship, have a lawyer draw up a contract tailored to fit the facts. The result should be a contract that meets the needs of both parties. If the dealer is reluctant to sign it, then consider carefully whether or not you want to get involved with this person. A dealer who is not willing to sign a paper that basically restates what has already been agreed to may not be willing to honor that verbal agreement in the future.

A contract won't protect you from crooks, but it will help avoid misunderstandings between you and honorable dealers. It will also protect you in the legal arena, should a misunderstanding ever go that far.

What are the gallery's responsibilities beyond the exhibition? What will the gallery do to promote sales and attract attention to your work? Does it have a strategy for promoting your art career? Does it have connections with collectors, critics, and curators to use on your behalf? Convey the idea that you will be expecting a dealer to take an active roll in promoting your career, and that you are willing to do your part in turn.

What does the gallery expect of you in return? Mostly it will expect you to continue to make incredible art; that's why it was interested in you in the first place. Beyond that, it will want you to behave in a professional manner, to meet your commitments on time, to be willing to meet with collectors when asked to, and to treat your dealers honorably.

VARA: Moral Rights in Your Art

What are moral rights in art? Artists' moral rights have been recognized in Europe under the term *droit moral*. These are rights that the artist retains in his or her work even after its sale and that remain with the artist regardless of who owns the copyright. The rights are separate from the economic rights protected under the Copyright Act.

What rights are "moral rights"? Moral rights are the rights of the artist to be able to claim or disclaim authorship in a work (Right of Attribution) and to maintain the integrity of his or her work of art (Right of Integrity).

How are they protected? Congress passed a law called the Visual Artists Rights Act (VARA) that amended the Copyright Act of 1976; it became effective June 1, 1991.

What does VARA do? VARA establishes a single federal standard regarding artists' rights to be applied to art created in the United States. It defines the term "work of visual art" and describes in detail the Right of Attribution and Right of Integrity.

A Work of Visual Art. Essentially, a work of art is:
- A painting, drawing, sculpture, print, or still photographic image produced for exhibition purposes only and existing in a single copy;
- A print in a limited edition of 200 or less, all signed and numbered consecutively;
- A sculpture produced in a multiple of 200 or less, all numbered and having the sculptor's name or mark; and
- A still photographic image produced for exhibition purposes only in a limited edition of 200 or fewer, all signed and numbered consecutively.

The Right of Attribution. The "Right of Attribution" is the right to claim or disclaim authorship of a work of art. This allows the artist to disclaim authorship if his or her work of art is mutilated or modified in such a way that it would harm his or her reputation as an artist to retain authorship of the work.

The Right of Integrity: The "Right of Integrity" is the right to preserve the integrity of the artist's work of art against intentional destruction, mutilation, or other modification that would harm his or her reputation, and to prevent the intentional or grossly negligent destruction of a work of "recognized stature." The exceptions to this right are damage or mutilation caused by the passage of time or inherent in the nature of the materials used and damage or modification due to conservation or exhibition, unless caused by gross negligence.

How long do these rights last? These rights last for the life of the artist for works created after June 1, 1991 (the effective date of VARA). For works created before June 1, 1991, VARA does not apply unless the work was not transferred until after that date. If VARA does not apply, the artist may be covered under state law if he or she lives in a state that has a law governing artists' rights. These states include California, Connecticut, Georgia, Louisiana, Maine, Montana, Massachusetts, Nevada, New Jersey, New York, Pennsylvania, Rhode Island, and Utah.

State law or federal law? VARA, which is a federal law, has precedence over (preempts, in legal language) state law. This means that its provisions control any issue. However, if state law grants more rights—for example, the rights last longer under state law, as in California—the greater state rights are not preempted and will apply.

What are the remedies if the rights are violated? VARA does not provide for any specific remedies, but because VARA is an amendment to the Copyright Act, the civil remedies under that Act apply. There are no criminal penalties.

Can the rights be transferred? The rights cannot be transferred, but they can be waived if the artist prepares and signs a written document expressly stating the right(s) being waived and the specific work is identified.

Do I have to do anything to have these rights? No. Just create your work of art, as defined in the law.

Copyright: Legal Protection for Your Art

What is copyright? Copyright is legal protection under federal law to "authors" (that's you) of "original works of authorship" (that's your photograph, painting, sculpture, or other type of original work).

The common misconception. Most people think that they have to put the copyright notice on their work in order to be protected. In fact, the author has protection as soon as he or she starts to make the work and it becomes "fixed in a tangible form of expression." However, if the author registers a copyright with the Copyright Office, he or she will be able to take advantage of the greater legal rights and remedies provided under the law, including attorney's fees.

Protection from what? For visual artists, copyright protection provides the artist with the exclusive right to do and authorize others to do the following:

- Reproduce the work;
- Prepare derivative work;
- Distribute copies of the work by sale, rental, or otherwise;
- Display the copyrighted work publicly.

Anyone other than the copyright owner who does any of these things without permission of the copyright owner is in violation of the law and is subject to civil and, in some rare cases, criminal penalties for infringement.

What is protected? Copyright protects the expression of an idea, but not the idea. For example, one can't protect the idea of a cat, but an artist can protect his or her painting, photograph, or sculpture of a cat. Names, titles, and slogans are not protected.

When is a work covered by copyright? Copyright exists as soon as the original work becomes "fixed in a tangible form of expression" that can be seen without or with the aid of a machine or device (as a film). Copyright law requires that the work have a minimal amount of creativity and originality. In order to obtain maximum protection, it is necessary to register the copyright with the Copyright Office of the Library of Congress.

Who is the owner of the copyright? The "author" of the work is the owner of the copyright, not the current owner of the work itself (no matter whether ownership was transferred by sale, gift, or otherwise), unless the author has transferred, in a signed, written document, one or more rights under the copyright. The only exception is work produced by an employee or "for hire." In that case the employer owns the copyright.

How long does copyright protection last? For the life of the "author" plus fifty years.

How is copyright indicated on a work? The copyright indication is called the copyright notice. It is not required, and failure to use it does not result in loss of protection. Lawyers will advise artists to use the notice in order to let the public know who the holder is, and to assert the right. (If you don't want it to show, put it discreetly on the back or side of the art.) Registering the work with the Copyright Office provides greater protection. Proper copyright notice contains three parts:

- The copyright symbol ©;
- The year of first publication (the distribution of copies of the work to the public by sale or other transfer; display of work not for sale does not constitute publication);
- The name of owner of copyright in the work (that is, you, the artist/author).

Proper notice will look like this: ©2006 Penelope Painter

The notice needs to be placed so it will give "reasonable notice" that the work is covered by copyright and be "permanently affixed" to the work.

How is a copyright registered? First, the author does not need a lawyer. To register a copyright with the Copyright Office of the Library of Congress, send the Copyright Office the following three things in the same envelope:

- An application form, properly completed (Form VA, for published and unpublished works of the visual arts);
- A check for $30 for each application;
- A deposit of the work being registered (actually a copy of the original work).

After the application has been reviewed, the author will receive a Certificate of Registration of Copyright. (That's it. You are fully covered.)

How do I get more information? Detailed instructions on all aspects of copyright can be obtained from the Copyright Office by writing to:

Registrar of Copyrights
Library of Congress
Washington, D.C. 20559

Or, call the Hotline at 202-707-3000. To order forms, call 202-707-9100. Information is also available on the Internet at:

www.copyright.gov/register

The Copyright Office publishes a wide variety of circulars in simple, nontechnical language that explain all an artist needs to know about copyright protection and registration. The best place to start is with Circular 1, Copyright Basics. Circular 2, Publications on Copyright, lists all the items published by the Copyright Office that will help artists understand the details of what they have to do to get the maximum protection available for their work.

What is the Resale Royalty Right? European moral rights also include the right of the artist to receive a payment each time a work is resold (sometimes only if at a greater value). The royalty right is similar to the royalties paid to songwriters, playwrights, and authors of literature, and is generally based on the idea that the artist should benefit from the increased value of his or her work of art that has resulted from the artist's increased reputation as he or she continues to produce work.

Is the Resale Royalty Right available in the United States? A section of VARA required a study and recommendation regarding the implementation of such a right in the United States. However, no federal legislation has been passed or even proposed to date because of opposition to its concept by some art dealers associations and others. This opposition is based, in part, on the fear that it would make it more difficult to sell work because the price would have to be higher to cover the royalty.

California, the lone exception. There is one exception to the absence of resale royalty rights in the United States. In 1976, California passed the Resale Royalty Act, which entitles the artist to 5 percent of the resale price, if the resale price is at least $1,000 and greater than the purchase price. In the case of a deceased artist, this royalty remains in effect for twenty years after the artist's death. If an artist, or his or her estate, cannot be located, the royalty is to be paid to the California Art Council, which will then attempt to locate the artist.

The legal information on pages 97–102 was generously updated by Alma Robinson, executive director of the California Lawyers for the Arts.

What to Expect When Working with a Dealer

The higher the status the gallery holds in the art community, the more professional you can expect it to be in its dealings with you. In addition, the higher your status is as an artist (the more well known you are), the more you can expect the gallery to do for you. For example, if you are just beginning your career, the gallery will probably expect you to bear the expense of framing your work. If you are more established, the gallery will assume that responsibility. The gallery's willingness to accept extra obligations is in direct proportion to the amount of money or degree of prestige it expects to gain from showing your work. This means that, regardless of the gallery's stated policy in dealing with artists, it may be open to making special arrangements depending on the situation.

Artists usually change galleries several times during their careers; the successful ones negotiate a more favorable arrangement with each move. This highlights the importance of learning to negotiate. Almost all artists I have met show a reluctance to negotiate, either by natural inclination or because their upbringing did not prepare them for it. I am one of those artists. For years, I meekly took the first thing people offered me because I felt uncomfortable asking for more. I was afraid I would have to become the kind of person I dislike, manipulative and argumentative.

If you never ask for what you want, however, you will never get it. I decided to make an experiment out of learning to negotiate. I wanted to see if I could get what I desired simply by asking for it. The next time I needed to discuss an upcoming exhibit with my dealer, I drew up a chart and took it with me. In the first column I listed all the things I wanted, in the second column what the gallery was offering; I left the third column open for writing down our compromise. When I sat down to talk with the director, I went over my list and asked for each item in turn. I didn't coerce; I didn't threaten; I

Thanks to art, instead of seeing a single world, our own, we see it multiply until we have before us as many worlds as there are original artists.

MARCEL PROUST

didn't manipulate; I didn't get all agitated. I just asked. I figured that if the director said no to everything I wanted, I would not have lost anything anyway. To my surprise, the gallery was happy to give me quite a few of the things I was asking for. With the other issues, I found that by discussing them with my dealer I learned more about how the gallery made decisions and planted the seeds for further discussion.

This is a pain-free, unbelievably easy, and morally clean method for taking care of yourself. It also sets the tone for your relationship with the gallery in the future. This approach creates a professional atmosphere, one of honest agendas and mutual giving and taking. As your relationship with your dealer deepens, you will begin to know each other and eventually trust that you are working together for the same end. If the relationship does not advance, you will be able to pinpoint where the problems lie.

For this trust to develop, you will need to be scrupulously honest and responsible in all your dealings with the gallery. This means meeting your deadlines; keeping the gallery up-to-date on your latest work; providing the gallery with whatever slides, bios, or other materials it needs to do its job; and never selling work behind its back or undercutting its prices. This doesn't mean that you can't sell work out of your studio; it just means that you need to have an understanding with your gallery about it beforehand. Most galleries don't mind if you sell work yourself, they just don't want to be cut out of the loop.

Protecting Yourself

Writing a follow-up letter. After you have come to an agreement with the gallery or exhibition director about your mutual expectations and responsibilities, write a follow-up letter describing your understanding of the discussion and mail it right away. The purpose is to prevent misunderstandings later on and also to serve as proof of your agreement in a court of law if necessary. The letter may say something like, *"Dear Fred: I am thrilled to be showing my work at your gallery during the month of July in 2006. My understanding is that my responsibilities include: (fill it in). You will be responsible for: (fill it in). If there is any error in my understanding of our arrangement, please let me know."*

Be fastidious in keeping a written record of all your gallery-related correspondence, phone conversations, and meetings. Whenever you talk with someone on the phone, record the gist of the conversation, date it, and put it in your files. Write a follow-up letter after every conversation, in person or on the phone, summarizing your understanding of the subjects covered in the discussion. If the gallery has a different understanding, it will let you know. You will then be able to clarify any points about which you disagree.

Writing a consignment agreement. One of the best ways to protect yourself and keep a record of your art at the same time is to use a consignment form that contains (in small print) all the main points you would have put in a contract. I have included a copy of the one I use in chapter six (see page 115). Dealers who object to signing contracts will often sign consignment forms without question, since they do it all the time. Always fill out a consignment form whenever your art leaves your studio, even if the gallery has a form of its own. It helps keep track of your art and assures you that the person you consigned the work to has agreed to your terms. Of course, it is useless if it is not signed, so always make two copies, one for the gallery and one for you, and get both signed when you deliver the art.

> *I don't advise anyone to take it [painting] up as a business proposition,*
> *unless they really have talent, and are crippled so as to deprive them*
> *of physical labor. Then, with help, they might make a living.*
>
> GRANDMA MOSES

Creating Your Command Post

"Maybe someday we could set aside a cave just for art."

Frank Cotham © 2001

Your office is the hub of your professional activities, the center point from which you enter the world as an artist. You will want it to be well organized and easy to work in, with all the procedures streamlined. The easier it is to work in your office, the less time you will spend there. That means more time for making art.

The ideal office includes a desk with filing cabinets, a computer, a printer, a telephone, and a comfortable chair, all preferably in a separate room. If setting up a private office is impossible for you right now, start with what is possible. Most office supply stores sell portable

filing boxes with handles that are easy to transport and perfect for keeping all of your materials in one place. Make the filing box your command center. If you don't have a computer, borrow a friend's or use one at a local copy shop for an hourly rate. Carry your portable office and a CD containing your standard letters and mailing list with you, and you can become fully functional in minutes at any borrowed or rented computer station. If you don't know how to use a computer and don't want to learn, you can find an enthusiastic and inexpensive work force at any university or junior college near you. College students understand how to use computers, and they always need work.

If being organized comes naturally to you, count yourself lucky. To you nonmethodical types, I'm sorry, but I don't see any way around it. Perhaps you can talk your beloved into doing this for you. Try pleading, "I'm just a flaky artist. I need someone more grounded, *like you,* to help me." Or maybe, "I am a genius. I only deal with the larger issues."

Genius begins great works; labor alone finishes them.
JOSEPH JOUBERT

Actually, some of the most successful artists have had just such an arrangement with their spouses. The artist makes the art and his or her partner handles the business. This can be heavenly if the partner believes wholeheartedly in your art and enjoys being a part of the experience. He or she will need to have the time to attend to your career on a regular basis, an affinity for business, and a policy of noninterference when it comes to the art-making itself. The last thing you need is someone else telling you what to paint.

Another plan is to hire someone to oversee your business for you. My first office assistants came from a local university. I hired them for one to two days a week at an embarrassingly low rate. Some of them were wonderful, knowledgeable, organized, and energetic; others were less than ideal. I always ask new assistants to make a commitment for a minimum of six months, because it takes that long to become familiar with the job. Even if someone else is running the office, you will still need to supervise everything he or she does, at least until you are secure in the knowledge that you and your assistant are on the same planet. I once had an assistant who filed everything under secret code names in honor of her stuffed animals to make the job "more interesting." I didn't discover this until I tried to find a gallery file while she was on vacation in Mexico. It was not my best day.

Make a habit of keeping clear and accurate records of everything that you do. This means producing a copy for your files of every letter and show application you send out and writing confirming letters after each phone call, as well as retaining notes from all your conversations. Set up your office so that creating a paper trail is easy; otherwise you won't remember where your slides are, how to get them back, or what you promised to whom. If you don't keep good records, you run the risk of losing a lot of those not-so-cheap slides, messing up on making your contact calls, misplacing your art, and screwing up your relationships with those dealers you worked so hard to get.

The miraculous computer. Aren't computers amazing? It may take awhile to get all the peripherals set up and the software properly installed, but when everything is running smoothly, a computer system can streamline your office work so it actually becomes pleasurable.

For your art career, you will want to create some basic materials that you can standardize and use repeatedly with minor changes. These materials should include a stationery and envelope template (unless you have preprinted stationery); a standard cover letter for sending out slides, your bio, and your artist statements (one for each different body of work); slide labels; and a mailing list. You can create most of these documents in any word-processing program. The exception is your mailing list, which should be created in a database that allows for indexing your entries and sorting them by category, so that you can easily access any part of your mailing list at any given time. It's also nice to be able to use the program for correspondence as well, and several programs offer this feature. Some applications with database features in use at the time of this printing are FileMakerPro, Microsoft Access, Microsoft Excel, Microsoft Outlook, ACT, and NowContact.

I arise in the morning torn between a desire to save the world and a desire to savor the world. That makes it hard to plan the day.

E. B. WHITE

If you don't own a computer, there is certain to be a place near you where computers are available for use by the hour. Try a copy shop or the library. Bring some blank CDs or DVDs with you to store your data on. And while you're at it, make two copies of your materials, just in case something happens to the first one.

A filing system. Keep your filing system simple and direct. The idea is to be able to find what you are looking for without a lot of effort. Standard file-folder titles can include terms such as Artist Bio, Artist Statement, Art Consultants, Art Dealers, Consignments, Donations, Exhibitions, Inventory List, Invoices, Juried Shows, Publications, Slide Masters (for keeping), Slide Duplicates (for circulating), Materials Out List, Plans, Goals, and Leads. Pick the categories that apply to you, adding to the list as necessary.

▬▬▬▬▬ Keeping Records of Your Activities

As a successful artist, you will be participating in numerous activities that may not be art but are essential to your career nonetheless, such as sending out slides for consideration, shipping artwork to and from exhibitions, and consigning works to galleries. You will need to keep track of all this. The best way to do this is to set up a simple, yet thorough, method for dealing with each activity. For sending out slides and other promotional materials, I use a Materials Out List; for keeping track of the location of my artwork, I use an Inventory List; and for consigning artwork to galleries I use a Consignment Form.

The Materials Out List. I became acquainted with the use of the Materials Out List when I took a job as an assistant to art dealer Yancey Richardson several years back. I don't know whether the Materials Out List is her creation, but she used it whenever she sent out any promotional materials, whether they were slides, CDs, or written materials—anything but the actual art. It quickly became apparent why, because it is amazingly easy to forget important details. The Materials Out List can remind you with the minimum amount of effort on your part. I have included a copy of my own Materials Out List. Lift it and use it as it is, or create your own, using mine as a guideline.

The form is self-explanatory. Fill out each section completely, especially the name, address, and phone number, even when you are in a hurry. Whenever I don't keep track of all the information, I always regret it. Six months later I will be reviewing the list, come across some name like Elroy Zruchisican, and not be able to remember who he is or where he lives or why I sent materials to him in the first place.

Most artists are forced to act as their own patrons.
JIM MELCHERT

Materials Out List

Date	Name and Address	Phone	Inclusions	Follow-up	Return date
			slides CDs prints bio statement SASE other		
			slides CDs prints bio statement SASE other		
			slides CDs prints bio statement SASE other		
			slides CDs prints bio statement SASE other		
			slides CDs prints bio statement SASE other		

If I haven't written in his address or phone number, I find it difficult to do my follow-up calls, obviously, and impossible to retrieve my slides.

In the Inclusions column, I circle the type of materials sent—slides, CDs, prints, or a combination—so that I don't have to keep writing the same information over and over. I also list the exact images sent. This can be helpful when your packet is returned with one slide missing, which is a fairly frequent occurrence. Often a gallery will keep one or two slides in case it has a use for them later on. I find it especially frustrating not knowing which ones; it's just a minor irritation, but you can avoid it by planning ahead.

> *A functional artist should have five shows waiting in the wings.*
>
> DOROTHY GILLESPIE

The Follow-up column is where you list your follow-up phone calls as you make them, and specific comments or requests made by the gallery. Use it as a reminder column, so you know what to do next. In the return column, I write in the date the materials were returned.

Keeping inventory. If you are even remotely prolific as an artist, it will soon become apparent that you are going to need some sort of tracking device to monitor the location of your artwork at any given moment. Most artists use an Inventory List, which differs from the Materials Out List in that it keeps track of actual art rather than promotional materials.

The secret to having a useful inventory list is to use it faithfully every time a piece of art leaves your studio, whether it is for an exhibition, on consignment to a gallery, or as a sale. If you are haphazard about posting this information, the inventory list will soon become meaningless.

I am including two versions of the Inventory List. The first one is for artists who make one-of-a-kind pieces; the second is for multiples.

If you make multiple images, such as photographs or prints, or if your work is constantly moving in and out of your studio for one reason or another, I recommend creating an inventory list with an entire page devoted to the activities of each piece.

Keep your Inventory List on your computer desktop, where you can find it easily. Be sure to back it up regularly onto a storage device. This is essential information you won't want to lose. To be really thorough, I suggest attaching a digital photo of the artwork to each page. That way there will be no confusion later on.

Inventory List

(for one-of-a-kind pieces)

Disposition Code: S=Sale; D=Donation; R=Rental; C=Consignment; L=Loan; E=Exhibition

Date	Art Title (Date)	Disposition	Name, Address, Phone	Return Date

Inventory List

(for multiples or artwork that is shown a lot)

Title of piece:

Date created:

Materials:

Negative number (if applicable):

Size of piece:

Size of edition:

Disposition Code: S=Sale; D=Donation; R=Rental; C=Consignment; L=Loan; E=Exhibition

Print #	Disposition	Date out	Name, Address, Phone	Return date	If sold, to whom?

The Consignment Form. I love my consignment form. It has saved me every time I have experienced any trouble over lost or damaged art work. Once it even came to my rescue when a disreputable gallery owner tried to involve me in tax evasion and an insurance scam. This dealer had held more than twenty of my photographs on consignment for some time, and had neither sold nor returned them. One evening, at a dinner party, a colleague mentioned that several of my pieces had been donated by the dealer to a local museum (obviously as a tax write-off). I was furious. The dealer didn't own that work. When I called her to ask for payment, she said I must be mistaken since all my photographs had been destroyed when her house burned down. "Wouldn't you rather have the insurance money?" she purred. All I had to do was falsify my copies of the consignment forms and send them to her. Since I knew for certain that at least some of the photographs had survived the fire, it was clear she wanted to involve me in fraud. I refused and pointed out that the works were in perfect condition when she received them because she had signed a consignment form to that effect. I told her that I expected payment from her and that I would turn this matter over to my lawyer. Eventually we settled out of court. I ended up with less than what was owed me (mostly because I didn't have the stomach for a long court battle), but if it hadn't been for my lovely consignment form, I would have ended up with nothing.

> *I've handled color as a man should behave. You may conclude that I consider ethics and aesthetics as one.*
>
> JOSEF ALBERS

Use a consignment form every time you ship or hand-deliver art work for an exhibition, or to a gallery or art consultant who will be selling or showing the work. The only time you don't need one is when you are selling the art directly to a client. If they are buying it, then obviously it is not on loan.

When you fill out the form, be sure to fill in all the blanks: your name, the gallery's name and address, and the period of consignment. If you are consigning the work to a gallery, it generally will want the work for a period of three to six months, but discuss the time period with the owner. If, at the end of that time, the gallery would like to keep the work longer, the consignment form will still be valid, as long

Works on Consignment Agreement

This agreement dated _____ is between _____, the artist, and _____, the consignee, located at _____. The consignee accepts on consignment for a period of _____ days the following artworks:

Title and Edition	Description	Size	Condition	Retail price	Comments

The works are on loan only. The artist retains copyright and full ownership of the artworks. In the event of a sale of an artwork, the artist will be paid _____% (percent) of the retail price within thirty days of the purchase. Works not sold within the agreed time will be returned to the artist in the condition received. The consignee is responsible for the full value of all works damaged while in his/her possession or due to inadequate handling or shipping materials and procedures. Works are to be insured by the consignee while in his/her possession.

Signed, _____, artist, and _____, consignee.

as you agree. If you want the work back, the consignment form will support your wishes.

In filling out the chart, be very specific about the condition of the work. Since I make photographic prints, I always list the edition number so that the client and I know exactly which photograph we are talking about. If the photograph is newly printed and has not been touched by human hands (other than the printer), I write "new" in the condition column. If it has been around awhile and is still in perfect condition, I write "good" or "perfect." I never send out work that is not in good condition. If there is a minor flaw, such as a bent corner, I mention it in the comments column. The comments column may also be used to insert extra information, such as whether the work is matted or framed.

The retail price is the price the work will sell for, not what you will get paid. In the small print at the bottom of the form you will see a percentage space (____%). Be sure to fill that out. With a commercial gallery, the split will usually be 50 percent, but sometimes the arrangement will be different. If your agreement is 60-40, with you getting the 60 percent, be sure that you write "60," not "40," in the blank.

Make three copies of the consignment form. One for you, one for the consignee, and a third for your files in case the others get lost. Deliver two copies with your signature to the gallery along with the artwork, requesting that the recipient sign them both and return one for your files. It's a good idea to enclose a self-addressed, stamped envelope to make it easy for the consignee to comply.

Upon receipt of the work, the gallery staff will inspect the art to make certain it is in good condition. Sometimes they find something wrong that you didn't see, which immediately makes filling out a consignment form worth the trouble. A problem has been solved before it has become a problem. The gallery director will pick up the telephone and mention that, for instance, there is a fingerprint in the lower right-hand corner. If it is a small thing, suggest that the director make a note of it on the consignment form before he or she signs it. If there is a major problem with the artwork, ask the director to return it for replacement.

Dealing with Pricing and Sales

Making pricing decisions. There are two ways to price your work. The first method, which I don't recommend, is to decide the amount you want to be paid (the wholesale price), and then let your various dealers add whatever they want when selling to their clients. The second approach is to set a selling price (the retail price), and decide in conjunction with each dealer or client the amount of commission he or she will receive from the sale of the work. If you are working with a commercial gallery, the commission will probably be 50 percent, which means you will only receive half of the retail price—so set your prices accordingly.

The advantage to the second pricing method lies in the fact that your prices will be consistent across the globe. This is worth considering. You don't want a client who bought a photograph for $2,500 from your New York gallery to discover that it could have been purchased for $2,000 in Los Angeles. The art world is very small; people talk with each other on the phone every day (that is how international galleries do business), and they do find out these things. You run the risk of appearing unprofessional, and worse, it brings into question the intrinsic value of your work.

There are several factors to consider when pricing your work, and this requires that you juggle all the elements until you arrive at an educated guess. In general, but not always, a painting on canvas will fetch a larger price than a painting on paper. A one-of-a kind piece will sell for more than a multiple. With multiple images, such as photographs or prints, the smaller the edition, the larger the asking price for each piece. For three-dimensional work, expect bronze sculptures to sell for more than paper ones. In the photographic market, the more archival (or permanent) the materials, the more collectors will pay. A work of art that takes six months to complete will need to be priced higher than one taking six days. And across the board, in every art genre, the larger the piece, the higher the price tag.

Another way of putting this is that the price of an artwork is dependent upon the following:

- Rarity. One-of-a-kind pieces are worth more than multiples.
- Cost of materials. Gold-leaf paintings sell for more than watercolors.

> *Great artists need great clients.*
> I. M. PEI

- Permanence. Paintings on canvas are worth more than paintings on paper.
- Productivity. An artist who paints three paintings a year can ask more for them than an artist who paints thirty paintings a year, assuming the art is obviously more labor intensive in the first case.
- Size. Bigger is almost always more expensive.

Another important consideration is an artist's track record. If an artist is a recognized international figure, he or she can command a higher sum. For artists who haven't yet reached that stature there are signposts that can signal a rise in prices. Look for indications of media attention, sold-out shows, museum exhibitions, and works sold at auction.

At the beginning of your career, you want to place your work inside the standard price range for the type and size of work that you make, and at the lower end of that price range. The advantages to this strategy are many. By pricing the work low, you will begin the process of getting the work moving. More people will buy it, which means more people will want to buy it, and you will start to develop a following. Pricing the work low creates room for the prices to increase, which makes you look successful and places your work in even higher demand. The last thing you want is to have to reduce your prices because they were too high for the market in the first place. At every point in an artist's career, he or she should appear to be a rising star, rather than a falling one.

One San Francisco art dealer described a scenario he told me happens all too often. A young artist, hanging his work in his first show (in a nonprofit art gallery or some other noncommercial space), will price the work to match the prices of artists who have a much longer track record. The work is really priced too high for his place in the market, but he sells a piece or two to friends and well-wishers. Then a gallery picks him up, and he learns he has to lower his prices in order to be affordable to its collectors. Now the artist has a dilemma. If he doesn't lower his prices, he won't be able to enter the larger marketplace, and if he does, he risks alienating his early supporters. This is yet another reason for starting out low.

But be careful not to price the work too low. If it is listed too far below the current market, it will be hard for collectors to take it seriously.

Invoicing procedures. Once a work of art has been sold, update your inventory list with the date of the sale, the name of the gallery or art consultant who made the sale, the name, address, and phone number of the collector who bought the work, and the purchase price. Sometimes galleries will neglect to pass on the latter information to you, either because they don't think you care about knowing it or because they prefer to keep their collector list private. Don't let this information slip away. People who buy your art are your supporters in the most literal sense, and you have a right and a need to know who they are and how to reach them. When, in the years to come, the Whitney Museum wants to mount your retrospective, you need to be able to tell it who owns your early work. Or, on a less happy note, if you and your gallery have a falling out, you don't want to lose your collectors as well.

Write an invoice for every sale, regardless of who sold it or where, and even if you have already been paid. Give a copy to the client, and put another in your files. You can design an invoice form specifically for the purpose, or just use your letterhead. The invoice information should include the date; the name of the gallery, if applicable; title, date, and description of the purchase; retail price and any commissions or discounts you have agreed to; and the total due and amount received. If the work was sold from the gallery's inventory, indicate it on the invoice. If it was shipped from your studio, note the method of shipping. An up-to-date invoice system is an excellent way of keeping track of the state of your business. It provides easy access to information when doing your taxes, and, if necessary, will serve as proof to the IRS that you are indeed a working artist.

Shipping Your Art

In preparing art for shipping, anticipate what could go wrong and plan for it. The packaging should be made of strong water-repellent materials that absorb shock and are easily handled. If the packing materials are to be used for return shipping, they should come apart and go together again without self-destructing or creating extra work for the person receiving the package. Depending on the type of art to be

Always do right.
This will gratify some
people and astonish
the rest.
MARK TWAIN

A Simple Invoice (printed on your letterhead)

Date: Invoice number (optional):
Sold to: Name
 Address

Title of piece: *Retail price:*

"Unique Masterpiece" $1,000.00
Edition # 499/500
1998
gelatin silver print

Dealer discount 50% –500.00

Subtotal $500.00

Tax (if applicable, added when selling directly to the client) 0.00

TOTAL DUE $500.00

Work shipped to above address by UPS on Tuesday, April 10, 2006.

Payment due upon receipt of invoice.

shipped, materials to keep on hand for shipping might include corrugated cardboard, ⅛-inch Masonite, plywood crates, bubble wrap or Styrofoam popcorn, plastic sheeting or bags to wrap the art in, plastic shipping tape, and strapping tape.

A simple and effective method for shipping two-dimensional objects such as unframed drawings or prints is to place the art

between two slightly larger pieces of Masonite and cover the Masonite with a layer of cardboard on each side. The Masonite is strong enough to protect the work from almost any kind of shipping damage, and the slightly larger size will protect the corners of the artwork, the most vulnerable part. This larger-size package also will protect the work of art from knife damage when it is opened. The cardboard adds an extra layer of strength.

The procedure is as follows:
- Place the artwork inside a plastic bag (an archival brand if possible), and cut a small hole in the bag to allow excess air to escape.
- Place the plastic bag in the center of a piece of Masonite. Two inches of Masonite should be visible around each edge of the artwork.
- Tape the work at all four corners so it doesn't slip.
- Place the consignment forms to be signed by the recipient on top of the art, taking care that there are no staples, paper clips, or rough surfaces that could damage the art.
- Place the second piece of Masonite on top of the first, creating a sandwich.
- Put a piece of tape on each side of the sandwich to hold it together.
- Insert the sandwich between two pieces of corrugated cardboard (with the ridges of each piece going in opposite directions to increase strength).
- Seal all four sides with plastic shipping tape.
- The package is ready to be addressed.

Framed pieces and three-dimensional artwork will need to be shipped in a crate, which should be slightly larger than the art. The area around the art should be filled with materials that protect and cushion the work and firmly hold it in place. Most shipping crates are constructed of plywood with screws rather than nails so that they can be opened quickly and reused easily. Never send glass through the mail. If you are shipping framed pieces, be careful to use Plexiglas instead of glass.

For detailed information about preparing different kinds of art for shipping, I suggest the clear and concise *Way to Go*, written by Stephen Horne and published by the Gallery Association of New York State.

There is a thin line between genius and insanity. I have erased this line.
OSCAR LEVANT

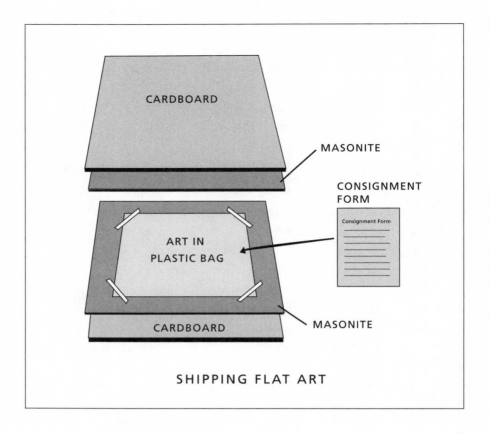

CARDBOARD

MASONITE

CONSIGNMENT FORM

Consignment Form

ART IN PLASTIC BAG

CARDBOARD

MASONITE

SHIPPING FLAT ART

Shipping materials such as cardboard and Plexiglas can be found at any art supply store as well as some packaging and plastic supply stores, Masonite and plywood at your local lumberyard, and bubble wrap and custom-made cardboard boxes at a mailing supply store. For ready-made shipping cases designed specifically for shipping art, see the appendices, or look for advertisements in art magazines.

Shipping companies. The safest and most professional way to ship art is to hire an art shipping company to do it for you. Unfortunately, this is also the most expensive, often prohibitively so for many artists. Most galleries don't use them either, unless the art is particularly difficult to handle; they prefer to use less-expensive carriers. One of the most affordable, UPS, can be quite safe, providing you take some precautions. The first is to package the work well, protecting it with a strong layer

of wood (such as the Masonite suggested above). The second is to purchase extra insurance up to the full value of the work. Shipping insurance is inexpensive and can really help soothe your broken heart if something should go wrong with the package en route to its destination. Federal Express and other carriers are also good choices for shipping your work. Shipping companies have size limitations, so check with them first about current regulations.

My own experience with UPS has primarily been a happy one. It has shipped my work for many years, with only one problem delivery. An art gallery in Los Angeles had shown my slides to a collector, who promptly bought four pieces and requested that I ship them from inventory. I packaged the prints as I suggested above, with two pieces of Masonite inside a cardboard cover, but when the package arrived, it had been folded in half. The Masonite was broken, and the artwork mutilated. I still haven't figured out how that happened. The gallery owner pulled out her trusty camera and took pictures of the package before she opened it, then called UPS to report it. The UPS office sent an inspector, who agreed that the shipping company was definitely at fault. Since I had purchased insurance from UPS to the full value of the work, it had no choice but to pay up. I got busy printing another set of photographs for the client. In the meantime, another collector came into the gallery, saw the damaged photographs, and decided he wanted a set for himself. I was ultimately paid for twelve photographs instead of four. Not a bad day's work, but it could have been an unhappy one if I had cut corners on packaging or insurance.

> *Too much complaining and too little work.*
> GEORGIA O'KEEFFE

Developing and Maintaining a Mailing List

As an artist, one of the most powerful things you can do for your career is to create, maintain, and *use* an up-to-date mailing list. Making a habit of sending announcements to the people on your list whenever you have an exhibition will go a long way toward advancing your career. The perfect mailing list contains the names and addresses of all your past and present supporters, as well as of people you hope will support you in the future. Keep this list on a computer, so that it will be easy to add and delete names and make address changes. Start your

list with your current address book and include everyone you know and interact with in your daily life. Include friends and family, of course, but don't forget your coworkers, doctor, dentist, and insurance agent. These people may be among your first collectors.

After these people, add the names and addresses of the art professionals in your geographic area. You can locate this information in local newspapers, regional art periodicals, and your August issue of *Art in America*. Be sure to include the name of the appropriate contact person for the type of art that you make. If there is an art museum in your city, telephone and ask the name and job title of the painting curator (or photography curator, etc.), so that your mailing list is tailored to the people you want to reach. It should include curators at museums and nonprofit spaces, gallery directors, and art critics.

> *I love deadlines. I like the whooshing sound they make as they fly by.*
> DOUGLAS ADAMS

Eventually you will want to compile a list of the top national and international art professionals in your area of interest. As part of your campaign to generate interest in your work, make a habit of mailing an announcement to each of them at every opportunity, particularly if the announcement carries a picture of your work. Curators in Chicago may not travel to Texas to see an exhibition, but receiving the announcement will begin the process of making them aware of who you are.

Maintaining a mailing list can be an endless chore. People are constantly moving and changing jobs, and there are always new people to add and others to delete. Almost by definition, your mailing list will be out of date. Update information regularly, weekly if you can, so that the job doesn't become too daunting.

Preparing for the Tax Man

Doing your taxes as an artist is not much more difficult than what you are doing already. You will need to add a Schedule C (Profit or Loss from Business or Profession) to your tax return, keep clear records, and save receipts and show announcements. None of this is difficult, but it should be done fastidiously in case you ever have to explain yourself to the Internal Revenue Service.

The IRS has never taken very kindly to artists. This is because no self-respecting IRS auditor can believe that anyone would willingly participate in an activity that doesn't turn a profit. Being the distrustful people that they are, IRS inspectors assume that being a starving artist must be some fancy tax dodge. Their job, as they see it, is to prove that you are an amateur so that your expenses won't be deductible. The best way to thwart them is to make money. The second best way is to *try* to make money.

The IRS looks for certain signals that you are indeed a professional artist. Jo Hanson, an artist who has been audited by the IRS eight times, and has beaten them at their own game every time, has written a marvelous (and short) book called *Artists' Taxes: The Hands-on Guide*, in which she lists the activities the IRS examines. (The book is available from the San Francisco branch of the California Lawyers for the Arts.) According to Hanson, you should keep a record of sales and customers (your invoices will suffice), maintain an inventory of work for sale (your inventory list), keep receipt and expense records (save all business receipts), and keep a separate bank account for your art activities. If you don't want to incur the expense of a separate bank account, you can use your personal account as long as you make a note next to each check designating whether it was written for business or personal use.

If the IRS wants proof that you are a professional artist, give it to them. You are already doing all these things anyway, just make sure your records are complete.

- Maintain a mailing list, which is proof of your connection to your clients.
- Send out announcements of all your art activities (proof of attempts to attract more clients).
- Save at least one announcement from each show (proof that the show actually did happen).
- Keep copies of all your cover letters to galleries (proof that you are trying to sell).
- File copies of the letters you receive in return (proof that others are responding).

The saints are the sinners who keep on going.
ROBERT LOUIS STEVENSON

All of these activities are indications that you are behaving as any businessperson would to try to grow your business. Taking these measures will lift you out of the realm of "hobbyist" and force the IRS to take you seriously.

I hope you will never have to discuss your business endeavors with the IRS. If all the lines on your tax form are properly filled out and free from mathematical errors, and if there are no outrageously large or unusual deductions, you should be okay. Consider using one of the tax preparation software programs on the market, such as Intuit's Turbo Tax. If you can afford it, have an accountant do your taxes. Then, if you do get audited, you will have a professional to help you deal with it.

Staging an Art Exhibition

M. Stevens © 1984

Conceiving and producing your own exhibition, rather than sitting and waiting for the art world to take notice of you, can be an exhilarating way to enter public life as an artist. In the process you will learn how to plan, mount, and publicize a show and develop an understanding of the amount of work involved and what needs to be attended to when. These skills can free you from the tyranny of the gallery system; or, if you decide to work with a gallery, they will

place you in a better position to know when your dealers are doing their job. A successful exhibition can bring art to a larger audience, improve the neighborhood, and provide quite an adrenaline rush for you.

You will need to decide whether to put on a solo exhibition or to include other artists. A one-person show looks better on the résumé, but a group show usually attracts more people. With a group or two-person show, the work can be shared among the participants so that no one person has to do it all. Attendance will be multiplied since each artist will be inviting people from his or her own support group, costs can be shared, and you will have someone to laugh and cry with. If you mount a solo show you will gain all the glory, and you won't have to deal with possible personality conflicts, which can sometimes emerge when any group of people tries to work together. Regardless of the style of exhibition you decide upon, planning ahead will be the key to your success.

Finding a space to hold the show. Any building with empty walls is a good candidate to house your exhibition. Start by checking out public spaces like cafés and government buildings that already have exhibition programs in place, but don't limit yourself to those possibilities. Go on a reconnaissance mission to the area of town where you would like to hold your show. Look for hallways in corporate buildings, large meeting rooms, library spaces, church meeting areas, empty storefronts, companies and organizations with lovely, pristine spaces just waiting for your art to grace them. If you choose a location not ordinarily used for art exhibitions, you may be able to take advantage of the uniqueness of the event when writing publicity for the show.

When approaching the owner of the space, be friendly and businesslike. The idea is to convince owners that you will act responsibly when using their building and that you will be open and reasonable in your dealings with them. Bring slides of at least some of the artwork to be shown, so that they will have a visual cue on which to base a decision, particularly if the art is difficult work. You don't want to have to cope with censorship issues later on. If you are dealing with a large organization, try to avoid discussing your proposal with people at the

There is nothing new in art except talent.
ANTON CHEKHOV

Exhibition Time Line

At least three months before the show:
Find exhibition space.
Decide on show dates.
Decide on reception date.
Decide on show title.
Delegate tasks.
Photograph sample artwork for press release.
Telephone local newspapers and
 magazines to find out press release
 lead times.

Ten weeks before the show:
Write the press release.

Eight weeks before the show:
Mail press release. (May need to be
 mailed slightly earlier or later
 depending on the publication.)
Design announcement.

Six weeks before the show:
Take announcement to printer.
Update mailing list.

One month before the show:
Make final decisions about which
 art to include.
Frame the art.
Buy stamps, labels, and other supplies for
 mailing announcements.
Assemble binder with bio, statement,
 and images for each artist in the
 show.

Two weeks before the show:
Mail announcements.
Plan and order food for the reception.
Decide what you are going to wear.
Line up helpers to take care of food
 and sales at the reception.
Make a description label for each piece
 in the show.
Write price list.

Several days before the show:
Hang work.
Round up nonperishable reception supplies
 and a reception book for visitors to sign.
Make last-minute changes in labels and price
 list.

Before the reception:
Purchase perishable foods.
Set up refreshment table.
Set up guest book, artist binder, and slide
 viewer (optional).

At the reception:
Make visitors feel welcome.
Have fun.

During the run of the exhibition:
Arrange private tours.

After the show:
Take down the art.
Deliver pieces to people who bought them.
Repair and paint gallery walls.

middle-management level. They are usually in no position to make a decision and tend to slow down the process. Ask to speak to the owner, and when you reach him or her, don't spare the flattery. People who have built their own businesses are usually proud of them. You can gain a lot by letting them know how much you would like your art to be shown in their environment.

Most of the time you will find that people are thrilled at the prospect of hosting an art show. Occasionally you will encounter someone who is reluctant for insurance or other reasons. Unless you really must have that space, let it go and move on to your second choice. You will find lots of people who are delighted to hang your art. If the building you have chosen is empty, the building owner may ask for some sort of rent payment in exchange for use of the premises. You may be able to bring this cost down, particularly if the building has gone unused for a long time, by explaining that you need the space for only a short time (one to three months), that your very presence will improve the property (by cleaning, painting, if necessary), and that the publicity involved with the exhibition will bring attention to the building itself, thus showing it off to advantage to any prospective tenants.

Some of the world's greatest feats were accomplished by people not smart enough to know they were impossible.

DOUG LARSON

If you are looking for a space not usually used for exhibitions, be sure to consider, and discuss with the owner, how the work will be mounted on the wall. You don't want to find out later that the wallpaper is covering concrete, or that the owner refuses to allow you to put any holes in the walls; this makes it very difficult to hang art.

Deciding on exhibition dates. The traditional time period for an art exhibition is one month, but for your purposes six weeks is better. You want to allow plenty of time for the publicity to take effect. In order for most weekly and biweekly publications to consider reviewing a show, the art should be on view for at least four weeks. If the reviewer sees the show in the first week and writes the article the next week, and the publication prints it the third week, that leaves very little time for people reading the review to get down to the gallery. Most magazines require that the show be hung for even longer, since they only publish once a month.

Group Show Tasks

Show Coordinator: Acts as the gallery liaison, ascertaining things like the amount of wall space available, how much time will be allotted to hanging the show, the quality of the lighting, and special requests or expectations of the building owner. This person also will be the committee coordinator and the central clearinghouse for information among the artists in the show. This is not a job for a general; find someone less bossy, more like a diplomat; otherwise everyone will become irritated.

Installation Chairperson: Oversees the installation and removal of the exhibition. If necessary, returns the walls to their previous condition. Ideally, the Installation Chair should have a committee of three to five people, depending on the size of the show and the amount of time scheduled for installing it. He or she should know how to use a hammer and a level.

Written Materials Coordinator: Completes the finishing touches for the show, including designing and printing the labels to be installed next to the art, preparing the price list, purchasing the guest book, and organizing a three-ring binder with bios, statements, and slides of all the artists in the show. This is a good job for someone with computer skills.

Reception Coordinator: Coordinates the food and wine for the reception, and the clean-up after it. Recruits several nonartist helpers to attend to the food table and the bar during the reception.

Announcement Designer: Designs the announcement for the show, oversees the printing, buys the stamps, prints the mailing labels, and coordinates the mailing party. Graphic design experience is helpful, but not necessary.

Press Release Committee: Writes the press release, copies it, collects photos from the artists, puts together press packets, and mails them. The ideal committee should consist of several people, so that no one has to assemble the mailing alone.

The reception can be held at the beginning (an opening reception) or the end of the show (a closing reception). An opening reception is preferable because it gives the viewers time to return a second and third time, perhaps to view a piece they were taken with or to bring friends. Schedule the opening reception a few days after you actually hang the show, so there is time to remedy any unforeseen problems and get some rest before the event.

Deciding on the show title. The show may or may not have a title or theme. If it is a one-person show, the title can be something like *Betty Boop: Recent Work* or, if the art in the show is from a specific series, *Betty Boop: Lipstick Paintings.* The more specific (and interesting) the title is, the more people it is likely to bring in. If you wish to attract the attention of the press, you will want to have a catchy title.

Finding a title for a group show can sometimes be a challenge, depending on how much the artists have in common. If possible, choose artists whose work has some relationship to yours so that a theme becomes obvious. If there is no apparent theme uniting the work, get together and brainstorm. You'll be surprised at the wonderful and/or outrageous ideas a group of creative people can come up with. If you find you can't agree on anything, a simple listing of the artists names will be fine.

Delegating Tasks

Whether yours is to be a one-person show or will include a cast of thousands, planning ahead for the various tasks is essential. If the show is all yours, you will need to ask friends for help, enlist the aid of your studio assistant, or hire outside help for at least part of the work. The following is a task breakdown for a group show. For a solo exhibition, go over the checklist with an eye toward planning when and where you will ask for assistance. If necessary, you can do almost all the tasks by yourself, but they will take longer to complete.

Starting the buzz for the show. Publicity for the show should begin almost the moment the show is conceived. You can hire a publicist or

Courage is resistance to fear, mastery of fear, not absence of fear.

MARK TWAIN

do it yourself. Most artists choose to do it themselves because publicists are expensive, and it's not easy to find one with knowledge of the art world.

Let's assume you are doing this yourself. Your first job is to build a media database. (See chapter ten for details on how to do this). As soon as you know the date of your exhibit, send a "save the date" notice to your contacts, using their preferred method for receiving information (which you obtained when you first built your media database). This notice starts a buzz while you are polishing your press release packet. It can be in the form of a postcard, an e-vite, plain e-mail, or a printed letter. Keep it simple; include just the basic information for the event: where, what, who, when, how to contact.

Creating your press packet. Some press contacts will want to receive the press packet electronically; some will want a paper version. Be ready with both. Your press packet should include a press release, a bio, a statement, reviews (if any), your Web site, and images of your art.

If you are sending the press packet by mail, insert a letter-size computer printout with several images of your art. Most publications will eventually want a digital file if they are going to write about you, so indicate on your image page just how they can obtain it. Digital files can be downloaded from your Web site, put on a CD and mailed to publications, or e-mailed directly to them. Publication standards generally dictate the image file be 300 dpi at approximately 4" x 6". If a publication wants a bigger image, it will probably send a photographer.

Writing the press release. The press release should be written following a standard form that should not be deviated from. Publications receive thousands of press releases, and the person in charge of receiving and reading them will usually not be amenable to giving extra time to anything that makes his or her job more difficult. The purpose of the press release is to entice the publication to write about the show, doing so in the simplest, most direct manner possible.

The press release should be placed on official-looking letterhead. You may use your personal stationery, or a letterhead designed to

With an apple, I will astonish Paris.
PAUL CÉZANNE

African Mammal Therapy League • P.O. Box 666, New York NY 10024 • 212-555-4444
www.africanmammals.com

— *PRESS RELEASE* —

CONTACT: Jane of the Jungle
(212) 555-1111
jjungle@africanmammals.com

FOR IMMEDIATE RELEASE
(Photo Opportunity)
JPEG available

PHOTOGRAPHS BY TROUBLED CHIMPANZEES

—WORLD PREMIERE—

January 31, 2006

For the first time in human history, the African Chimpanzee community will exhibit recent photographs by prominent artists in a two-month exhibition at the See-No-Evil Gallery, 123 West 57th Street, New York, NY. The exhibition will open on April 1, 2006, and run through May 30. The opening reception is Friday, April 3, from 5:00 to 7:00 P.M. Works included in the exhibition are 20" x 24" Ektacolor prints from the Old Leaf Series by Wally Cole, 30" x 40" silver prints from the Troubled Water Series by Brenda Whitney, and 16" x 20" Cibachromes from the Friendly Lice Series by Sam de Vader.

Well known in their native habitat, artists in this exhibition present their work for the first time to the human community. The works deal with issues of alienation, ecology, and species prejudice.

Wally Cole, who recently changed his name from Abdul the Great, presents twenty Ektacolor prints that examine the evolution of leaves produced by the trees in his backyard in Kenya. The photographs, taken over a fifteen-year period, poignantly reveal the heroic struggle for survival these trees endure.

Brenda Whitney, a recent émigré from the Congo, creates her work by immersing black-and-white film in samples of water from the Congo River. The result is a series of eerily corroded negatives that are then placed in an enlarger and printed to 30" x 40". Hauntingly beautiful, yet emotionally disturbing, these images make visible unseen terrors hiding in the water.

Sam de Vader has spent the last five years learning to speak the language of lice. Communicating by elaborate hand and leg gestures, along with a series of small bites (or "nips" as they call them), African lice have developed a sophisticated language. De Vader's photographs create a glimpse into the intricacies of this language.

###

reflect the group. Begin with the words "Press Release" at the top and in the center. Below, on the left-hand side, the word "Contact," followed by a name, phone number, and e-mail address, should be prominently displayed. Opposite the contact name and on the same line, type the words "For Immediate Release." If the event will include some unusual or visually interesting activity, or the presence of a controversial or famous person, add the words "Photo Opportunity." Below that, indicate if digital files are available, and what format they are in.

The press release should have a headline. This is meant to be an attention-grabber, so try to make it as interesting as possible.

The most important information (who, what, where, when, how, and maybe why) should be written concisely into the first paragraph. A busy editor may only read this far before making up his or her mind, so write the first paragraph as though it is the only chance you have to get his attention. Editors tend to look for press releases they can steal sentences from; it makes their job so much easier. Write yours with their interests in mind.

The rest of the press release can elaborate on the information presented in the first paragraph, with each successive paragraph being less important than the one before it. Aim for brevity. Don't exceed two pages for the entire document; one is even better. Finish the document by typing three number signs in a row (###). This convention indicates the end of the press release.

Sending out your press release. Don't just send out the whole press packet indiscriminately. You will waste a lot of time and money. Instead, send the press release solo to all the contacts on your press list by their preferred method of contact. Follow this up with a phone call, e-mail, or fax to see if the person wants a full packet or is interested in doing an interview. Not everyone will want to know more, but some will, and so begins your lifelong relationship with the press. Treat people with respect and sincerity, and it will be a fruitful and pleasurable one. If you contact someone who isn't interested, don't take it to heart, just move on to the next one.

Designing the announcement. The obvious purpose of the show announcement is to generate attendance at the show. The real value of a

> *Life is a great big canvas, and you should throw all the paint on it you can.*
>
> DANNY KAYE

show announcement goes far beyond the exhibition. If it is good, it will continue to create interest in your art long after the show is over. An exhibition announcement should indicate where the show is being held, the theme or title of the show, the dates of the exhibition, the reception date and time, and the gallery hours. If the flyer announces a group show, the names of all the artists in the exhibition should be prominent; don't just print the title of the show alone. Part of the purpose of the announcement is to create name recognition for the artists involved, and that's difficult if their names are not included.

In designing an announcement for a one-person show, seriously consider including a color reproduction of one of your pieces. Look for a printing company that specializes in printing full-color exhibition invitations at reasonable prices. I have listed a few in the appendices. Others can be found online or listed in the advertising section of local and national art magazines. Look for companies that print full-color postcards or greeting cards in relatively short runs. A color announcement with a picture has many advantages. Seeing an image of one of the artworks before the show can often convince an undecided collector to attend the event. An announcement with an image on it can provide a glimpse of the show for those people who live too far away to travel to the exhibition. Sometimes the picture alone can create a sale. I once received a phone call from a collector in Texas I had never met. She had seen the full-color announcement I had sent to a colleague and called to buy the piece over the phone.

And the trouble is, if you don't risk anything, you risk even more.

ERICA JONG

An announcement with an image on it will continue to work for you after the show is over. Include it in your promotional packet along with your slides, bio, and statement to add another layer of credibility to your career. If you can afford it, print extra announcements just for this purpose.

Early in my career, I sent a full-color reproduction of one of my photographs to a curator at the Palais de Tokyo in Paris. Although the show was in California and I had never met the curator, I had always hoped I would someday take my work to Paris. A year later I was able to go, and when I arrived I discovered my announcement pinned to the bulletin board next to her desk. I was thrilled! She had liked the image enough to hang it where she could see it every day. Not only

did she see it every day, but everyone who walked through her office saw it as well. You can't get better advertising than that.

I always keep my eyes open for great show announcements and flyers printed in interesting ways. When I find one, I throw it in a file so that when it's time to design my next announcement, I have plenty of good examples to start with.

Printing costs: Costs for printing an announcement can vary widely. The cheapest way to print an announcement is to do it yourself, either with your computer printer or a copy machine. This is only good for very small runs, since ink and paper costs for home machines can get astronomical quickly, not to mention repair costs if you have a meltdown. The advantage to printing announcements this way is that you have complete creative control, which is also its disadvantage. If you are a perfectionist, or just a regular obsessive like me, you can drive yourself crazy, or into bankruptcy, trying to get it just right.

For larger runs, or because you want your announcement to have a more professional look, consider going to a professional printer. Printing technology is constantly changing, so the type of press your printer uses will dramatically affect the cost.

Working with a printer. The first question you should ask any printer is: Do you have a digital press (new technology, good for full-color printing), or are you using offset lithography (old technology, good for one- or two-color printing). If the printing service doesn't have the kind of press you need, go elsewhere. Both types of presses can do everything, but costs soar if you try to use either of them for the wrong job. Full-color printing is much cheaper on a digital press than it is on an offset lithography press. With one- or two-color printing, the question isn't so much cost as control and quality. If you decide to print an announcement in puce and lavender, and you want to pick out the exact ink colors, offset is the way to go. If you don't mind that the ink colors are an approximation made by mixing four colors, you can still do the job on a digital press, although it won't cost any less than full-color.

The next question you should ask the printer is: What form do you want my materials in? This will save you headaches, and money, later.

Success is a matter of luck—ask any failure.
EARL WILSON

The printer will tell you which computer programs he prefers and the digital specifications he needs from you. (You can also find this information online, if the printer has an active Web site.)

If you haven't a clue what the printer is talking about, you have two options. One, hire a designer (or enlist a knowledgeable friend) to do it for you or, two, have the printer do it all from your sketch. Either of these options will add to your costs, so make certain to find out beforehand exactly how much you will be paying for the service.

Your printer can show you paper and ink samples and explain the cost variables. Ask to see examples of previous printing jobs. If the quality isn't up to your standards, look for another printer. Find out how long it will take to complete the job. It's a good idea to agree on a time line in advance so the announcements will be certain to be ready. Get the work to the printer early, so if anything goes wrong, there is time to correct it.

Mailing the announcement. The main purpose of the announcement is to entice people to attend the reception and, if not the reception, then to visit the exhibition during its run. Mail the announcement two weeks before the opening of the show so that, when it arrives, the receiver will have enough time to plan ahead for the event, but not so much time that he or she forgets about it. Handwrite a short note on cards to people you know, or want to know, as an added inducement to attend. It doesn't matter what you say; the fact that you took the time to write a personal message will have a positive effect. "Looking forward to seeing you" and "Come celebrate with me," or even "Hi, Betty!" are appropriate notes. Don't pretend you know the people if you really don't under the misguided assumption that they will think they must have met you somewhere and so feel compelled to come. Your ploy will be obvious, and it will only serve to convince them never to come near you. If your work appears in a show with several artists, highlight your name with a felt pen when sending the announcement to your personal mailing list.

I always love holding a mailing party when I have a lot of invitations to send out. You will need some willing friends, the invitations, a mailing list printed on labels, stamps, refreshments, and an evening to spare.

You will probably be using first-class stamps for your mailing unless you want to send it bulk mail, which demands a lot of extra time and work for very little savings in cost. Consider getting a bulk-rate permit only if you are sending an extremely large mailing, particularly if you intend to do it more than once a year. Be prepared to pay a yearly fee to the post office for the permit, and an extra fee if you want the number preprinted on the card (thus avoiding hours of stamp-licking). You will also be expected to presort the mail according to post office regulations (which are elaborate, but not difficult). If you don't have the time or the energy to prepare the mailing yourself, there are companies who will do it for you. Prices and services vary, so call several before you make up your mind. You can find them in the yellow pages under mailing services.

E-mailing the announcement. Increasingly, artists are using e-mail as a way to announce their exhibitions. This is an excellent idea, providing the recipient likes getting announcements in this form. See chapter ten for details on how to do this.

Framing the art. A whole book can be written about framing, and several have been (and examples are listed in the appendices). I am going to assume, just for the moment anyway, that you are not interested in becoming a professional framer, and will concentrate instead on current practices and prejudices in framing contemporary art. Framing styles go in and out of fashion, just as art does, so you will need to know the doctrine of the day in order to make conscious choices concerning it.

The main rule of thumb when framing contemporary art is that no part of the framing structure (this includes the mattes) should take the viewer's attention away from the art, unless the frame itself is part of the piece. Translate this to mean: choose a simple frame, one without curlicues, gold accents, or a fabric inlay. If you are matting the art, the matte should be made of 100 percent rag (for archival protection of the art) and should always be white, off-white, or occasionally black or gray. Never ever use a colored matte, especially not one with layered colors surrounding the image, even if your framer suggests it.

> *Imagination is more important than knowledge.*
>
> ALBERT EINSTEIN

Colored mattes are red flags to today's curators and critics. They scream "Amateur." Framers like to suggest layered and colored mattes because it's more interesting for them to create a complicated frame, and they can charge more for it. You don't want an interesting frame. You want a frame that makes the art stand out.

If the work is very postmodern, you may decide to add an elaborate frame as a tongue-in-cheek comment on the culture. Artists who work in this mode think of the frame as a part of the art and make their choices based on this.

If you visit a top commercial gallery, you will see several variations on framing. Small- to medium-size pieces will be framed in simple wood or metal frames with white mattes. Large paintings will be either painted around the edges of the stretcher bars or enclosed in thin strips of wood or metal. Occasionally you will see strange clunky-looking frames with stuff glued to them or sleek wide frames made out of sheets of metal, or boxes made out of Plexiglas, but in each case, to prevent the presentation from looking amateurish, the reason for an unusual framing decision should be obvious.

As for expenses, the more you do yourself, the less the frames will cost you. The cheapest and most versatile framing method is to purchase metal frames from a mail-order company and assemble them with a screwdriver. You will also need Plexiglas, a backing board (a piece of cardboard the same size as the Plexiglas), and wire or brackets for hanging the work. If the work is to be matted, you can buy a matte-cutter and archival board and cut them yourself (be prepared to make lots of mistakes at first), or shop them out to a framer. A framer mattes work every day, so if you want perfect mattes and don't have time to develop the skill, this might be a good choice for you.

If you can afford it, consider having a framer do it all, particularly if you are interested in a wooden frame, since these take a little more skill to assemble. To find a good framer, call local galleries whose art looks well framed and ask who they use. Galleries always know the name of the least expensive good framer in town.

Hanging the show. General decisions on what will be included in the show should be made long before the actual installation begins. With

> *The best way to have a good idea is to have a lot of ideas.*
> LINUS PAULING

a group show, since everyone's work will be a different size, a fair way to divide the exhibition area is to measure the total wall space in the gallery and divide it by the number of artists in the show. A hundred feet of wall space divided by ten artists will result in an allotment of ten feet each. It is up to each artist to decide how to use this allotted space. If an artist makes eight-foot paintings, he or she will be able to hang only one piece in the show; if the work is the size of a postcard, many more can be exhibited in the space. If an artist makes sculpture or installation art, adjustments may need to be made in the allotment of space

On the day of the installation, all the art should arrive at the exhibition site ready to hang. That means the framing decisions have already been made and carried out and the pieces are finished right down to the wires on the back. Start by placing each piece on the floor in front of a section of the wall you think will complement it. Do not

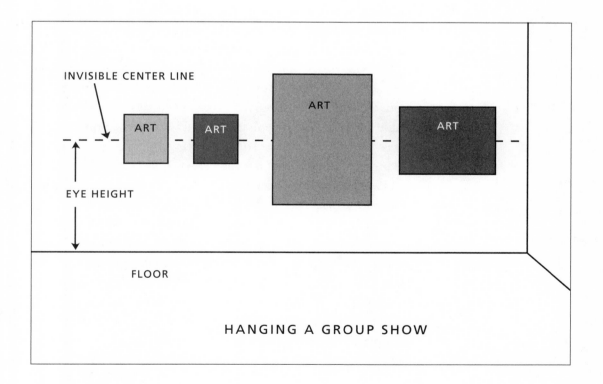

HANGING A GROUP SHOW

hang anything until all the pieces are placed. This is particularly important with a group show since, by definition, it is a group effort and each participant needs to be satisfied with the result.

A few rules of thumb for placing the work: Start with the problem pieces first, the ones that can only hang in a few locations because they are very large, very fragile, or employ sculptural elements. Once you have these placed, a pattern will begin to suggest itself, and the other art will find its spot. Try to keep all the work by one artist in the same location, creating a series of mini solo shows within the larger show. Sculpture presents a special problem. It will need to occupy floor space in a location where it cannot be easily damaged or stolen and will not cause an accident.

Theft is not often a problem in an art show, but it does happen; and a few precautions can be taken to save your work from light-fingered art lovers. If the art is a wall-piece such as a painting or drawing, there are special security hanging devices available that attach the art securely to the wall. The Oz Clip is the most common. For small sculpture on a pedestal, construct a Plexiglas box to fit on top of the pedestal and attach it to the pedestal with screws. A thief will have to carry off the entire pedestal in order to steal the sculpture.

You will need supplies and a set of tools for installing the show. Bring lots of nails and picture hangers, a hammer for pounding them, a tape measure, a level for checking the straightness of your work, and cotton gloves to protect both the art and your hands. Bring pliers or wire cutters in case you need to adjust the wire on the back of some of the pieces, and extra wire in case you screw up. You will need glass and Plexiglas cleaner for removing fingerprints, as well as soft cloths and paper towels. You also may need to bring a ladder.

Hang the show so that the center point of each piece is at eye level. Stand back from the work and imagine an invisible line going through the middle of each piece and parallel to the floor. Or don't imagine it. Make it easy and get a string and stretch it temporarily across the wall, securing it with a couple of push pins. Adjust the art up or down in relation to this line. Now check to see if there is enough room between each piece. You should be able to look at each work of art without having the piece next to it insist on equal time. It is okay to glimpse

other pieces with your peripheral vision, but it should be clear that each piece in the show is meant to be enjoyed as its own experience. If two paintings are placed too close together, they will be seen as one piece. Hanging too many pieces in a show is a common mistake of amateur artists, so a good rule of thumb is: Once you have placed the work, remove one piece from each wall.

When attaching a piece on the wall, use two nails rather than one so that it will remain level. Once the piece is up, place a level on top to check that it is straight, tugging it slightly one way or the other until you are satisfied with the result.

When all the artwork is hung, next adjust the lighting. If you are lucky enough to be using a gallery blessed with track lighting, this is a simple matter. Climb up a ladder and aim the lights at the art. The lighting should be even across the entire piece, and it may take several lights to accomplish this if the artwork is large. You can also change the lightbulbs from spotlights to floodlights or vice versa. Spots provide a beam of concentrated light in one area, while floodlights spread the light over a wider surface.

If the show is hung in a hallway or a public building, examine the existing lighting. Often the simple act of changing a lightbulb can make a dramatic difference. The worst situation is a room full of fluorescent lights. Standard fluorescent lights have a greenish tinge that can make almost any art piece look washed out. The good news is that daylight-balanced fluorescent bulbs are available. If the space comes equipped with regular tungsten lights (normal lightbulbs), switch to quartz lights. You can learn about lighting options from a store that specializes in lightbulbs, or go to a home improvement retailer like Home Depot and talk to the resident expert. If you will be buying quite a few bulbs, you can sometimes convince the shop proprietor to lend you several to try out first.

If all else fails, there are always clip-on lights. Almost every hardware store sells them. Look for the kind with a ceramic base rather than a plastic one. The plastic can melt when using high-voltage light bulbs, creating a fire hazard.

Descriptive labels should be hung on the wall next to each art piece, always on the same side (usually the right) and at a uniform

height throughout the show. Each label should contain the name of the artist, the title, edition number (if applicable), year, and materials. Upscale galleries never put the price of the piece next to the work, so I don't do it either. Instead I design a price list on the computer, print from five to ten copies, and put each one inside a plastic sleeve. The price list should contain all the information on the labels, plus the size of the piece and the price. Viewers interested in buying work can carry a price list around with them as they view the show.

The reception. A successful reception is one at which everybody who comes has a wonderful time. In many ways it is like a party, but different in that, for you, it is a chance not only to bathe in the accolades showered upon you but also to do some serious networking.

Most receptions serve an alcoholic beverage, usually wine (presumably to lighten the atmosphere), and some sort of nonalcoholic beverage. Beyond that, anything goes; you can stop there or add a full buffet. You can make it simple by serving chips and dip, or go all out and hire a catering service. If you decide to serve food, make it finger food, since people will be carrying it around with them while they socialize. Don't serve messy food; you don't want it splattered on the art. Music creates a lively atmosphere, and live music can be an additional draw; but don't let the music overshadow the art or be too loud to allow conversation. You need to be able to communicate.

In addition to food and drink, you will need a table to serve it on, a tablecloth to make it look civilized, ice to keep the beverages cold, glasses, plates, tableware, serving utensils and bowls, napkins, and a trash can with lots of liners. You will also need people (other than exhibiting artists) to serve the drinks, put out the food, keep the food table tidy during the reception, and clear away the empty glasses.

You probably have friends who would be perfect for this job. It requires the type of person who wants to go to the reception to be supportive but isn't comfortable spending three hours standing around. This gives them something to do. If possible divide the job into shifts, with a bartender and a food monitor for the first half of the reception, and a second pair for the second half.

I succeeded in simply attending as a spectator to the birth of all my works.

MAX ERNST

You should have someone, other than one of the artists, who is designated to handle sales during the reception. The artist's job is to welcome people to the opening, to discuss the art with them, and to stand around looking like a genius, *not* to soil his or her hands with things like money.

Don't expect a lot of sales at the reception; people want to contemplate a work of art before they buy it. Before the show, purchase some red stick-on dots at a stationery store just in case; the sales coordinator can put them on the wall next to the work as pieces are sold. If you are feeling mischievous, place a red dot next to a few pieces even though they aren't really sold, or arrange to have a friend buy a piece during the opening so that people can see the dot actually going up. Sometimes seeing a red dot can cause a run on the market.

Be sure that anyone who buys a piece knows the work will remain on view until the exhibition is over. If a buyer insists on removing the work before the end of the show, put another piece in its place. An exhibition with pieces missing looks unprofessional and tends to make the viewer think more about what is missing than about the art that is there.

Place a guest book in a prominent location during the reception so that interested viewers can add their names to your mailing list. If possible, erect a small light table with slides of pieces not hung in the show so prospective collectors can view the full range of each artist's work. Several copies of the price list, artist bios, and statements should be placed inside plastic sleeves and available for people to carry with them as they tour the show.

How to behave at your art opening. Arrive early and plan to stay until the end. The opening of an exhibition of your art is not a time to be fashionably late. People are coming to see and meet you, and it can be very disappointing for them if you are not there. Art world professionals often try to attend many openings in an evening, and you don't want to miss the opportunity to connect with any of them.

Be friendly to people you don't know. Art openings are uncomfortable places for people who don't know anyone. Treat them as you would a stranger in your house. Sometimes, if artists are shy or nervous, they have a tendency to want to huddle with their friends all night. This

> *No, painting is not made to decorate apartments. It is an instrument of war, for attack and defense against the enemy.*
>
> PABLO PICASSO

makes it hard for others to approach you, and you run the risk of missing out on sales and other opportunities. Tell your friends you have to circulate.

If this is a group show, place yourself within eyesight of your own work. Don't hide around a corner somewhere feigning nonchalance. You want to watch the responses your work is receiving, and, more important, you need to be within reach when people want to meet you.

Help the other artists in the show. If you see people looking at another artist's work, go over and tell them a little about the artist. Offer to introduce them. Often a viewer will be interested in a piece but is too shy or polite to hunt the artist down. Ask the other artists to do the same for you, too. This keeps the energy high and creates an atmosphere of excitement for the viewers as well as the artists.

Keep your drinking to a minimum. It may look like a party, but for you it's work and you need to have your wits about you. After all the work you have done to create this moment, don't ruin it by slobbering drunkenly over a prospective collector. Go out to dinner with your friends afterward. Then you can celebrate.

During the run of the show. Once the art is up and the party is over, put your feet up for a day if you wish, then prepare to get back to work. Now is a good time to follow up on leads generated at the opening and to arrange for people who couldn't attend the reception to see the work. If the show is in a café, you have a perfect excuse. Invite the person to dinner or drinks. You can have a relaxed social visit, surrounded by your art on display. If the show is in a gallery-type setting, arrange to meet the person there or, if they prefer to go alone, gently remind them of the show dates and then back off. Persistence is a good thing, pushiness is not.

When the show is over. Taking down the show is never as much fun as hanging it, but it goes faster. Once the work is down, check the walls for holes, scrapes, or other damage. The gallery owner will probably expect you to return the space to the condition in which you received

I love chaos.... It's the poetic element in a dull and ordered world.

BEN SHAHN

it. This may mean spackling and painting the walls. Return the lighting fixtures to their original condition as well.

Don't forget to deliver the art pieces to collectors who bought them.

And, pat yourself on the back for a job well done.

There is a vitality, a life force, a quickening that is translated through you into action, and because there is only one of you in all time, this expression is unique. And if you block it, it will never exist through any other medium and be lost. The world will not have it. It is not your business to determine how good it is; nor how valuable it is; nor how it compares with other expressions. It is your business to keep it yours clearly and directly, to keep the channel open. You do not even have to believe in yourself or your work. You have to keep open and aware directly to the urges that motivate YOU. Keep the channel open. No artist is pleased. There is no satisfaction whatever at any time. There is only a queer, divine dissatisfaction; a blessed unrest that keeps us marching and makes us more alive than the others.

AGNES DEMILLE TO MARTHA GRAHAM

Making Connections

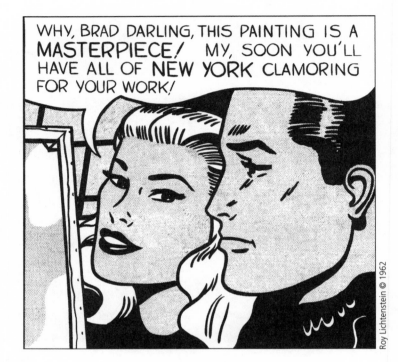

Roy Lichtenstein © 1962

Connecting with other human beings is really what your quest is about. Of course, you want to exhibit and sell your art and be acclaimed for your efforts, but the vehicle that will make all these dreams come true is your connection with others. Every achievement I have made with my art came not just from all the hard work I put into it, but because someone, somewhere, saw the work, liked it, and helped it to reach even more people. You can't have successful shows if there is no one to see them or no one to write about them. You can't have sales if there is no one to buy the art. At every point, you have to interact with others to make things happen.

I'm sure you have heard the phrase, "It's who you know that counts." Usually this is spoken disparagingly, with a shrug of the shoulders, by someone who feels he or she wasn't born into the right social circles. What isn't said is that you can know almost anyone you want to, with a little effort on your part. What also isn't said is that you never know which path will lead to the person who can help you nor, for that matter, who that person is.

The key is to meet new people with a pure heart. If you see yourself as a person in need and other people as possessing what you want, you will come off as a hustler. The people you meet won't want to have anything to do with you, and you won't like yourself very much either. If, instead, you set out on an adventure carrying art you believe in and approach each new person with generosity, you will find your social and business circles growing.

One of the best ways to widen your circle of art-world connections and find new venues for exhibiting and selling your art is to take your work to a new city in search of opportunities to show it. Choose any city, national or international, with a large and active art community. Once you have decided on the town, there are three approaches you may take: the Best Way, the Second Best Way, and the Still Okay Plan.

The Best Way is to choose a new town—Chicago, for example—and go on a scouting mission to check out the lay of the land. While you are there, make a list of the exhibition spaces you find. Return home and write letters to all of them, reappearing in Chicago a month or so later with your art. The advantage to this plan is that you can weed out inappropriate places early, discover others that aren't listed in the guidebooks, and have twice the number of chances to interact with the people you meet.

The Second Best Way of approaching a city is to skip the scouting mission and go straight to the business of making appointments for showing your work. The disadvantage to this plan is that it will be a less-efficient, less-focused use of your time. You may have to waste several days showing your work to people who won't be right for it, but serendipity has a way of coming to your aid when you need it. The advantage of this plan is that you have to come up with travel expenses for only one trip instead of two. This can be a big advantage if your bank account, or time, is limited.

The Still Okay Plan is to skip the travel altogether. The disadvantage of this plan is that you won't be able to see the exhibition spaces and meet the people face to face. This makes it harder to bond and more difficult to make decisions regarding individual spaces, but it is still okay. When employing this plan, use the telephone as much as possible.

I'm going to describe the Best Way in detail, and you can choose the parts of the information that pertain to the approach you decide to use. Some of these ideas have already been covered in chapter four, but I am including them again in this chapter so that the information here is complete.

> *Reality is nothing but a collective hunch.*
> LILY TOMLIN

The Best Way to Approach a New City

The scouting mission. Before you embark on a scouting mission, be sure you research the city art scene online, and scrutinize the August issue of *Art in America* for galleries that might be appropriate for your work. (Unfortunately, *Art in America* only lists American cities. For foreign locations, see suggestions in chapter four.) When you arrive in town, pick up a local gallery guide at the first space you visit and search it for additional names. Then take several days to scout the galleries, museums, and nonprofit spaces on the list. When you walk into the galleries, if you see art you like, don't keep it to yourself; tell the person at the desk how wonderful the work is and why you like it. You may find yourself engaged in a fascinating conversation. Use common sense about this; if the gallery person is busy with a client or on the phone, don't force an interaction.

Why talk to these people? First, it's fun. As an artist, you think about art all the time, and there is nothing more pleasurable than finding another soul who thinks about art, too. Second, if you find you connect with the person, it may lead to something else. Third, talking to the staff of a gallery is an excellent way to discover if their philosophy jives with yours. If so, the space may be a good choice for your follow-up trip.

While you are there, ask gallery people how they prefer to be approached for show consideration. Mention that you are an artist and want to send a packet. To whom should the packet be addressed?

Introduce yourself to the people you are talking to (this is the beginning of Name Recognition!), ask their name in return, and thank them for their assistance. On rare occasions—very rare occasions—a gallery person may ask to see your work at that moment, so it is a good idea to carry a set of slides, or a CD, and a bio just in case.

Do not insist that the attendants look at your art right then and there. Gallery people may appear to be doing nothing, but they are working hard to keep business booming (or they think they are, at any rate). They will not look favorably upon you if you force them to stop and pay attention to you. More important, they will not look favorably upon your work.

Another certain irritant for the gallery staff is for an artist to come into the gallery, drop off a packet, and then walk right out again without even stopping to glance at the art. If you are not interested enough in the gallery to look at the art, why should the gallery be interested in you?

Preparing for the business trip. Once you have completed your scouting mission, return home and plan your attack. Your first activity should be to write thank-you notes to all the people you met and had any real interaction with, preferably on a color postcard of your work (more Name Recognition). Then make a list of all the galleries, non-profit spaces, museums, and art consultants you would like to approach. Your second trip should be scheduled for a month to six weeks after the first, no longer or the people you met might forget who you are. Three weeks ahead, write to all the names on the list and enclose your packet. Use the cover-letter format I described on page 25, but add a personal note reminding the people you met on the scouting trip about the encounter. Something like, "I was in your gallery last week, and you kindly showed me the Paul Klee drawings in the back room. As you suggested, I am sending a set of slides for your consideration." The point of the note is to remind them that they have met you and that you felt it was a pleasant interaction. This can become the foundation for building a relationship.

Planning the business trip. While you can stay wherever you want on the scouting trip, your choice of lodging is important on the business trip. If you have friends or family members in the area, you might be

> *Before, I had no taste for anything. I was filled with indifference toward everything that people wanted me to do. But the moment I had this box of colors in my hands, I had the feeling that my life was there.*
> HENRI MATISSE

tempted to stay with them to save hotel costs. Consider carefully whether staying with them will be a comfort to you or will add to your responsibilities. I can promise you that after a long day of marching from gallery to gallery, your feet will hurt, your emotions will be played out, the adrenaline you have been running on will desert you, and you will be in immediate need of a soft bed where you can put your feet up and zone out. If you are sleeping on your hosts' couch in the living room, especially if they have children who commence the day at 5 A.M., you will soon be in a state of advanced exhaustion. If cost is an issue, consider sharing the trip with another artist. Sharing the experience with someone else, someone who is also courageously putting art out there, can make it much more pleasurable.

You don't have to stay at a hotel, just someplace private and close to the action. When I go to New York, I sublease an apartment in Soho from a friend. People going on vacation are often looking for someone to sublease their places; you can discover them online, or through local newspapers and art magazines.

What to bring. Imagine ahead of time what it will be like to carry your work from gallery to gallery, open up your portfolio, and show it to people in places where you have no control over the circumstances in which it will be seen. Obviously you want to control as many of the variables as possible.

The first is transportation. If you are traveling to a large city like New York, expect to do a lot of walking. Gallery districts can go on for blocks and blocks. You can take the subway or a taxi to different areas of town such as Soho or Uptown, but within an area hiring a taxi isn't practical. I strap my portfolio to a small handcart and drag it happily behind me. The cart can become unwieldy when climbing more than a few stairs, so I avoid the subway.

When I am traveling to a town like Dallas, where everything is spread out, I rent a car to carry my work. Since it is easy to drive right up to most galleries and museums, I don't always need my luggage cart, but I keep it in the car, just in case.

In Paris, neither a car nor the cart is all that practical. Even if I ignore the fact that driving in a foreign country makes me a nervous wreck, it is impossible to find parking anywhere near the places I want

to go. So I bring plenty of taxi money and, because one often has to walk long distances, my trusty cart. But Paris is covered with cobblestones (charming at any other time) and filled with buildings completed before elevators were invented. I often end up carrying my cart as much as I pull it. So, when choosing a handcart for your trip, consider its weight as much as its load-carrying ability.

The second thing to consider is which art to bring and how to protect it. The carrying case should be easy to open, and it should show your work to its best advantage. For small works on paper, such as drawings or photographs, a large black portfolio case (such as the kind available from the Light Impressions catalog) full of matted prints can create a professional impression. Avoid portfolio cases with binder rings and plastic pages. Placing almost any work of art inside those plastic sheets will make it look cheesy. Besides, you don't want to mimic a traveling salesman. Consider getting a clamshell portfolio (one that opens completely flat), so that you can present the art easily without removing it from the portfolio. Before you purchase any portfolio case, hold it by the handle to see how it fits your body. It should clear the floor when you are holding it. If you have to bend your elbow to carry the case, your arm will grow very tired. If the finished size of your art measures 11" x 14", purchase a 16" x 20" portfolio case, then matte each piece to fit. Use two-ply matting board (archival, of course) rather than the usual four-ply board. Since two-ply board is thinner, you can fit more art into the portfolio while carrying around less weight.

Pay special attention to the sequencing of your art. Place your strongest images first to capture your viewer's attention, followed by the rest, then finish with another dynamite piece. Of course, all of your pieces should be your best. Never include work you don't feel able to defend wholeheartedly, but within that category there are always a few that stand out. The portfolio should carry fifteen to twenty pieces, rarely more; otherwise you may lose the attention of your viewer. Always leave them wanting more, rather than saturated by the ordeal. When you sequence the work, pay attention to the effect each piece has on the one next to it, since that is the way they will be seen. Rearrange them until you have the strongest possible line-up.

If you create large paintings, sculptures, or installation work, your preparation will be more challenging. Most galleries want to see at

You shouldn't say it is not good. You should say you do not like it; and then, you know, you're perfectly safe.
JAMES McNEILL
WHISTLER

least one actual piece of art. I know painters who have traveled successfully by removing their canvases from the stretcher bars, rolling them up, and carrying them inside cardboard or plastic (lighter!) tubes they have fashioned with a shoulder strap. Shoulder straps are something to look for in any carrying case. You never know when you will need your hands free.

Artists whose work will not travel—sculptors, installation artists, and painters of large canvases—will need to create presentation materials to convey the power of the work. Possible choices might be a mock-up (a portable version of the piece), drawings or computer printouts showing the piece installed, or 4" x 5", or maybe even 8" x 10" color transparencies of actual pieces. If you bring large transparencies or slides, invest in a portable light table (battery powered) for viewing them. Nowadays they make light viewers small enough to slip into your briefcase. You don't want to rely on the light sources at the gallery.

A laptop computer that points to a well-executed Web site or a special presentation of your work is also an option. Make sure the batteries are fully charged. It may happen that the dealer would rather use his or her computer to view your work, but you should be fully prepared for any situation. It may be tempting to want to use your Web site alone as a presentation material, especially since you have put so much time into making it perfect. But let the computer/Web site be your supporting material rather than the main show, especially if the work has any kind of tactile quality. Most dealers feel, and I agree, there is no substitute for the real thing.

Regardless of the kind of art you make, pay as much attention to the presentation of your work as you do to your art. Present yourself as the professional you hope to be. Everything should be designed to be easy to handle, since looking at your portfolio should be a positive experience for the viewer. Bring lots of extra sets of slides, CDs, bios, statements, and business cards for giving to gallery personnel who ask for them.

You will need a methodical method for keeping track of your appointments. You can use your laptop computer, PDA, or even your cell phone if it has enough options. My preference is my laptop, because I can retrieve and send e-mail and also create a database before my trip of all the people I intend to contact, which I can update

Always be nice to those younger than you, because they are the ones who will be writing about you.

CYRIL CONNOLLY

daily with new information as the trip progresses. Then it's all ready to use when I return and need to do follow-ups. If you don't own a laptop and are reluctant to buy one just for a small trip, consider renting one. It's really not that expensive or such a bad idea when you consider they go out of date within a few years anyway. If you aren't going to be using it between trips, save yourself some money and rent one. Or if you are in the market for a computer anyway, consider using a laptop as your main computer. It wouldn't work for me because I need everything ergonomically just so, and because I like the added oomph I get from my jazzed-up desktop computer, but many people like the freedom a laptop gives them.

A cell phone is a must. You want to people to be able to find you wherever you are. Make sure your cell phone number is included on all your communications.

When you arrive. The first thing to do is start calling the names on your list for appointments. Your inclination may be to put this off, but don't give in to that: the demands on your time will increase as the trip advances. By the end of the expedition, you will be wishing you had just a few more days to follow up on the new leads you have generated.

Those dreaded follow-up phone calls. Thank God for the telephone! You pick up the earpiece, dial the phone number of a prospective gallery, and say, "Hi! I'm Earnest Artist. I'm a painter from Miami, and I sent you slides last week along with a letter saying I would be in town for ten days. Do you remember receiving them? You do?! Yes, the paintings with snow on the palm trees! Right! And angels on Rollerblades, yes! You hated them? Oh."

Praise the Lord for the telephone! Because of this miracle of technology, you were able to experience this less-than-perfect moment from the comfort of your hotel room. This is far better than trudging to the gallery, portfolio strapped to your back, and being told the news to your reddened face, perhaps even in front of witnesses. And because you were miles away, stretched out on the bed, you were relaxed enough to turn this apparent disaster into a triumph, "I'm sorry the work isn't right for you, but thank you for being so candid. I wonder, do you know anyone in town who might be

No one can make you feel inferior without your consent.

ELEANOR ROOSEVELT

interested in this work? The Snow Palm Gallery? What is the phone number? And who should I ask for? Terrific! Thank you."

The next step is a piece of cake. Why? Because within five minutes, in the midst of being rejected, you bagged yourself the most coveted of prizes, a promising lead. Now all you have to do is call the Snow Palm Gallery. "Hi! I'm Earnest Artist. David Dope, of the David Dope Gallery, suggested that you might be interested in my work...," and you are in the door.

Of course, not all of your attempts to connect will work out happily. Expect about a 10 percent positive response rate. At every opportunity, ask for suggestions and follow them up. The names in your address book should begin to multiply. Don't forget to ask for names in all the categories of art professionals you want to meet, including art consultants, museum curators, directors of nonprofit spaces, magazine editors, and private dealers, as well as gallery owners.

Presenting your portfolio. Start with the assumption that the person who has agreed to see you may only spare you ten minutes to present your work. He or she may wave you into a room the size of a closet with papers piled high on the desk and say, "So, let's see it." This usually doesn't happen, but be prepared for it anyway. Bring everything you need to present the work at its best in the shortest amount of time. If the art is small enough, say matted drawings, carry it in your clamshell portfolio so that you can show the pieces in their own pristine environment, thus avoiding the cluttered desk. If you are using a laptop computer, make sure the battery is fully charged and practice opening the file ahead of time to make sure there are no glitches. If you are showing transparencies, carry a small, portable light table that runs on batteries. (You can't be sure there will be an available electrical outlet.) Avoid covering the art with plastic bags or slip sheets if you can, unless it is absolutely necessary for protection. Removing and replacing slip sheets can waste a lot of time.

I always carry a stack of bios, statements, slides, CDs, and reviews in my carrying case. When I open the case, I hand a bio to the client, giving them something to look at while I unpack my art. I place the work in a stack facing the client, and then I watch for clues. Most people want to look at the art at their own pace. Unless they are handling my

I never got a job I didn't create for myself.
RUTH GORDON

art with a lighted cigarette in one hand and are swirling a glass of bourbon with the other, I let them do it.

I usually start out by telling them a little about the work, a sentence or two describing my process and concerns with the work. Then I shut up and let them look. They will either start talking themselves, ask me questions, or look at the work in silence. What I am doing at this point is matching my energy to theirs. There is nothing more futile than trying to communicate with someone when you are both trying to talk at once, or when one person is thinking at racetrack speed and the other person's brain is lying in the sun. When I walk into the room, I drop whatever level of energy I happen to be carrying (which is usually panic energy) and allow myself to settle into the other person's speed. This has the added advantage of taking my attention off of myself and directing it toward someone else, and soon I forget to be nervous.

The person to whom you are showing the work may be the kind of person who likes to do the talking. You can learn a lot from listening. Sometimes the responses can be very insightful, sometimes they reflect more about what the person had for breakfast than anything having to do with your art. Pay attention and file the information away for later contemplation. If you get the same response from several people, it is time to start taking it seriously. I have shown my portfolio hundreds of times, and my experience has been that when one person picks out three pieces because they are so good, the next person will pull out the same three because they are so bad. Over the years, it has gotten to the point that I can almost tell which art school someone attended, and their year of graduation, by which pieces of my work he or she likes.

Sometimes the person wants to hear you talk and will ask you questions about the work, or mention other artists who work in the same vein and ask you what you think of them. If you have a background in art history, or if you spend a lot of time attending galleries and museums, you will probably know whom they are talking about. You *should* know whom they are talking about. You should also know how the work of those artists differs from yours and be able to discuss that.

I have an exercise I give in class called "Your Place in Art History" to prepare students for this kind of situation. They are required to

No opinion, however absurd and incredible, can be imagined, which has not been maintained by one of the philosophers.

RENÉ DESCARTES

research where their own art fits into art history for an oral presentation to the class. They are asked to include the movement or tradition from which their work stems (for example, German expressionism), define the main thrust of the movement in a sentence or two, then name three artists from that time period whose work can be seen as antecedent and three contemporary artists whose work can be compared to their own. For this exercise to be useful, the artists you research must have a direct relationship to your art; they should not be drawn from a list of random artists you admire.

Another thing you can do for yourself is to rehearse the presentation of your portfolio with friends, encouraging them to ask you questions about the art so that you can practice formulating your answers.

Sometimes the gallery person just wants to look at the work in silence. You can usually recognize this type of person when he or she grunts dismissively every time you open your mouth to talk. This is your cue to shut up. Try not to take it personally. These people come from the school of thought that believes art must speak for itself. They want a private experience with the work. Let them have it.

After you return home. Write follow-up letters to everyone you met, thanking them for their time and attention. If they said or did something that was particularly meaningful to you, let them know it. If you spent two weeks in a city and met with thirty or so art professionals, you should have returned with at least one positive response, probably more. Regardless of how many actual commitments you bagged, remember that your real purpose was to plant the seeds for future relationships, and you did that admirably. It may not have been easy schlepping your art from place to place, but you did it!

Now begins the process of courting your contacts. Put their names and addresses on your mailing list, and every time your art is in an exhibition, large or small, send them an announcement. If they are even mildly interested in your work, their interest will grow. One of my former students, photographer Frank Yamrus, has used this approach successfully in dealing with prospective galleries as his career progressed.

> One thinks like a hero
> to behave like a
> merely decent
> human being.
>
> MAY SARTON

Unaware that I knew Frank, a San Francisco art dealer was praising his method of approaching her. Apparently Frank had sent her a packet some time earlier with the usual set of slides, bio, and statement. She glanced at them, thought they were moderately interesting, and returned them in the SASE he had provided. I don't think she even included any kind of letter when she returned the work. Frank dutifully added her name to his mailing list and sent her an announcement whenever his work was exhibited, expecting nothing in return. The gallery owner saw the postcards, looked at the images of his work, and became more interested with each mailing she received. When Frank had completed a new body of work, he again sent a slide packet to the gallery. This time she looked it over with interest. Although she eventually decided against adding him to her stable (his work didn't quite fit the gallery's focus), she has taken an interest in his career and when an opportunity arises to recommend his work, she happily does so.

Relationships, of any kind, don't happen overnight. With every new contact you make you are creating the beginning of a new association. Don't expect instant results. You are in this for the long term.

Skipping all that travel and planning your campaign from home. If you are unable to undertake all the travel just described, start out by choosing a city to approach, just like you would have above. When you make your list of targets, be as all-inclusive as you can. Your list should be anywhere from twenty to eighty names long. Don't just find the names of one or two galleries and send your packet to them, thinking you will find others if they reject you. This is the surest way to court heartbreak, because you will become invested in their acceptance. The days will drag by as you wait for their answer, becoming increasingly nervous over the outcome. No, no, no, *mon cher*! Don't do this to yourself. You are not a wallflower hoping against hope that someone will show pity and dance with you. You are a brilliant artist in charge of your life. Send out twenty packets at once to the top names on your list. When one packet is returned, put a check by the name and send the packet out again to the next person on the list. Simple. Easy. Professional.

> *I always have the impression that the work is apprentice work, and that if I can just finish it, then I'll really do something good.*
>
> SUSAN SONTAG

As an excuse to make verbal contact with the people to whom you are sending your packet, and also to expedite matters, telephone the gallery a few days after it has received the packet. Ask whoever answers the phone if the work has arrived. If the person is not sure, describe the art to prompt his or her memory. See if you can engage the person in conversation: "Does the packet seem to be in order? Did you address it to the right person? Does the work seem like it might be right for the gallery? If it is not right for them, do they have any suggestions for you? What is the name of the person you are talking to?" Don't be a pest, of course, just make contact. If the person wants to chat, so much the better. Keep notes while you are talking, writing down any business information the person might give you as well as any personal comments. If the person you are talking to says he or she won't be able to attend to your materials until after returning from a vacation in Bermuda, make a note of it. The next time you talk, ask how the trip went.

I remember one January when I was filled with the urge to sweep my life clean, as I do every year at that time. That particular year, I was irritated that more than a hundred sets of slides had been out in the world for some time. I was tired of it. I wanted them back. I went down my list of delinquent slide returners and started calling. "Hi. My name is Cay Lang. I sent a packet to you eight months ago and received no reply in return. I wonder if you could locate it and send it back. Yes, I will wait while you look in your files." By the fifth call, I got lucky. The receptionist found the slides and liked them. She asked if she could keep them one more day to show to her boss. I generously acquiesced. The gallery ended up selling more than fifty photographs to one of its clients, enough to fill the top two floors of his skyscraper in New York.

Never explain—your friends do not need it and your enemies will not believe you anyway.

ELBERT HUBBARD

Other Ways of Connecting

Entering the art world through the side door. One of the best ways to become part of the art scene is to volunteer to help at a nonprofit art space, museum, or art gallery. These institutions are often understaffed and the people overworked. Decide how much time you can give, then telephone the art space of your choice and ask for the volunteer coordinator. Even if you can only be there every other Thursday, the little you do can make a big difference to the organiza-

tion. It may need help with fund-raising, hanging exhibitions, membership, or any of a thousand other details. The advantages for you are many. You will learn behind-the-scenes information about how the art world works. You will forge relationships with other art professionals in an atmosphere of dedication to a cause worth fighting for. You will gain respect and gratitude from the staff members. And later on, if there is a chance for them to help you out, they will be thrilled to do so because they know you to be a committed artist. Don't expect them to give you a show, however, as this could be seen as a compromise to their integrity. What they can do is keep an eye out in the larger art community and, when an opportunity arises, put your name forward. This is a big thing. In the art world, word travels quickly. Conversely, if you don't live up to your commitments, such as not showing up to hang a show, those words travel quickly, too. When you agree to help an organization, keep your word.

Attending gallery openings. Most galleries hold an opening reception for each new exhibition. Attending these events can be a great way to learn more about the structure of the art world as well as provide a fine opportunity for networking. When you go to an art opening, pay attention to everything: the art, of course, and the way the show is hung—but also the people. See if you can tell by the way a person is dressed which part of the art world he represents. Who are the artists? The gallery owners? The critics? The collectors? If you like the show, introduce yourself to the artist and the gallery director and congratulate them on the installation. The amount of mingling you do is entirely up to you. If you are the kind of person who likes meeting new people, art openings can be a lot of fun. If you are shy, go anyway and participate as much or as little as feels right to you. If any particular gallery consistently shows work that you feel is in alignment with your own artistic direction, make a point of attending all the openings. The gallery owner will notice and be appreciative and, when you are ready to present your work to him or her, be more likely to give you a chance.

Using your Aunt Emma's contacts. You may have an influential family member or friend who wants to help with your career. Maybe your

Enthusiasm is the electricity of life. How do you get it? You act enthusiastic until you make it a habit.

GORDON PARKS

aunt plays bridge with the director of the local museum. This is wonderful, and when she offers to telephone the director on your behalf say "Yes! Thank you!" But you need to understand, even if Aunt Emma does not, that her influence may get you in the door, but nothing more is guaranteed. If a gallery director wants to maintain a reputation for integrity, he or she can't give exhibitions to relatives or friends unless those relatives or friends have already gained some reputation as artists. If the director compromises this policy, his or her own career could go down the tubes. But a person in that position can look at your work, make suggestions, and, on occasion, if the work fits with the mandate of the museum, do more than that.

Applying for a residency at an art colony. A short period spent at an art colony can be a wonderful experience on many levels. The most obvious is the fact that you are given room and board and a studio and nothing is expected of you in return except that you make art. What isn't mentioned is that a residency can provide an intense bonding experience with other artists. Being removed from the demands of your real life, stimulated by the thrill of making art all day (usually in a beautiful setting), and surrounded by other artists who are experiencing the same thing can create a deep connection. To receive a residency at an artist colony (like the MacDowell Colony or the Djerassi Foundation, for instance), you must submit an application for consideration. Although the competition is steep, winners are chosen for their art rather than for their résumé, which means beginners have a chance, but be aware that it may not happen instantly since many art colonies have a several-year waiting list. Some of the artists you meet there will have established international careers; others were chosen (like you) just because they make amazing art. Some well-known artist colonies are listed in the appendices.

Becoming an art writer. This path may not be for everyone, but for those people who can combine a love of writing with a love of art, becoming an art writer is guaranteed to connect you with art-world inner circles. People may not always like art critics, but they invite them to all of their parties. Gallery owners, nonprofit-space curators,

Artistic growth is, more than anything else, a refining of the sense of truthfulness. The stupid believe that to be truthful is easy: only the great artist knows how difficult it is.
WILLA CATHER

and museum directors all know that if they want the public to attend their events, they need to get coverage in the local media. So if you are an art writer, the galleries will court you. What a nice change from being an artist, where you have to court the galleries. The downside is that once you have become defined as a critic, it is often difficult for the art world to accept that you are also an artist. It is not an insurmountable obstacle, but the art writers I know who are also artists all complain about it.

If you decide to do this, don't do it just for the perks. Becoming a writer takes as much commitment and hard work as becoming an artist. The impulse should come from within. Most publications will advise you to write a sample review and mail it to them. If they like it, they will either print it or give you another assignment, and you are on your way. Eventually they will send you a check for your efforts. When you open it, you will understand why critics always have that lean and hungry look. They are outrageously underpaid.

Authors are sometimes like tomcats: they distrust all the other toms, but they are kind to the kittens.

MALCOLM COWLEY

Going Online

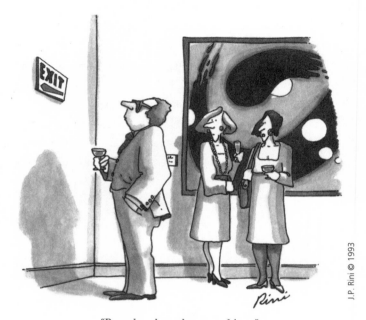

"Roger has always been text-driven."

The title of this chapter either has your heart skipping with a virtual "Yippee!" or has you sagging in your armchair mumbling "Oh my god! She's got to be kidding!" (In online parlance: Omg! Pls say ur jk!)

I am not kidding. Having an online presence is absolutely essential to your success as an artist. There are lots of good reasons to have your work online, but the pivotal one is this: the Internet is quickly becoming, and soon will be, the principal means of communication on the planet.

The question is not, "Should I put my art online?" But "How should I put my art online?"

At this point in time, there are three options open to you for putting your art online: joining an existing group Web site, using a Web

template, or making your own site from scratch. In writing this chapter, I have decided that it would be more helpful to you if I emphasize how you make these choices, rather than focus on the details of how they are done, since the technology will have changed before we can even get the trees felled and the ink mixed to print this book.

That means that at every juncture, you need to take the initiative to ask the experts around you, what is the best way of getting this done? This question will serve you well in any case. With it, you can hitch your skateboard to any changes in technology and roll along with them.

▬▬▬▬ Option One: Joining an Online Gallery

The term "gallery" is used loosely all over the Internet, and as far as I can tell, just means "group." Advantages to joining an online gallery include the fact that most, or at least some, of the work is done for you, which is wonderful if you are unfamiliar or uncomfortable with the Web. Online galleries claim to bring a lot of traffic to their sites, and some actually do, but "traffic" and "collectors" are not the same thing. The point of having your work online is as a communication tool, not a sales tool in most cases, so don't expect joining an online gallery to suddenly increase the sales of your art. A drawback to using an online gallery is that the pages are preformatted, so there is little room for individualization. But it's not a huge problem if you just want a place to showcase your art without having to think about it too much.

Before you commit to any online gallery, do your research. Start by checking out online galleries used by artists you know or admire. To do this, pull up a search engine like Google or Yahoo! and type the artist's name into the search box. Does the artist's online gallery appear near the top of the search results? Go to the Web site and travel around the pages. Are the artists easy to find? Do you like the way the site works? Start a list of galleries you like enough to revisit.

Next, go back to your search engine and type in every combination of words you think might lead you to something good, like "online galleries" or "wildlife painters." When the search engine gives you a list, go to every one that seems promising. Then go through the Web site page-by-page until you decide either against it or for it. If you are for it, add it to your list. The final list should have three to ten strong possibilities. Make sure

Making money is art and working is art and good business is the best art.
ANDY WARHOL

Some Terms You Might Find on the Internet

Crawler—a program that searches the Internet and attempts to locate new, publicly accessible resources, such as WWW documents, files in public FTP archives, and Gopher documents. Also known as a robot, or spider.

Cyberspace—the digital world constructed by computer networks, and in particular, the Internet.

Domain name—The address or URL of a particular Web site, it is the text name corresponding to the numeric IP address of a computer on the Internet.

Evite—Web site that enables sending online invitations to events. A link to Evites can be placed on individual Web sites to allow visitors to generate publicity for the site and related events.

GIF—graphic interchange format. On Web pages, images are usually created in GIF because the files are small and can be downloaded quickly. Many Web authors use GIFs instead of JPEGs, to get that "melting onto the screen" effect that happens with interlaced images. GIFs are best with solid colors and text.

Google—a hybrid search engine that ranks the popularity of results that match a keyword search.

Hit—the method used to determine the amount of traffic, or visits to a Web site. Originally done by counting the number of requests for and deliveries of a file. Now, each element of a requested page (including graphics, multimedia, and the HTML file itself) is counted as an individual hit.

HTML—HyperText Markup Language. The coded language used for publishing hypertext on the World Wide Web. It tells a Web browser how to display text and images.

Internet—an international system of linked computer networks that facilitates data transfer and communication services such as remote login, file transfer protocol (FTP), electronic mail (e-mail), newsgroups, and the World Wide Web.

ISP—Internet Service Provider. A company that provides users access to the Internet. Accounts are usually billed on a monthly basis.

JPEG—Another type of minimal graphics format commonly used online; these files download even faster and contain better resolution than GIF. JPEGs are best for gradients and photos.

Keyword—the term or phrase you type in order to begin an online search.

Link—Text or images on a Web page that a user can click on in order to connect to another document, Web page, or Web site.

Online—the state of being connected to the Internet.

PDF—portable document format. The format was created by Adobe Acrobat to enable sharing of documents in a standardized electronic form. PDF documents cannot be readily modified and thus provide more security for a document with broad circulation.

RAW Image Format—RAW images are the raw information captured by the photographic sensor in a digital camera. Most, if not all, digital SLR cameras have this option and a few of the mini-SLRs have it. These photos require special software from the manufacturer to see and edit them.

Search engine—Web technology that serves to index or catalog data on the Internet. Search engines locate specific information through the use of keywords designated by the user.

Site map—A list of text links connected to the content of a Web site in its entirety. Designed to help users navigate large, complicated sites.

Thumbnail—A small-scale image that enables the display of multiple images on a single Web page. When a thumbnail is clicked, the image enlarges for more detailed viewing.

TIFF—Tagged Image File Format; used for still-image bitmaps. The shorter file extension, TIF (without the second "F"), is used for PC-based TIFF files.

URL—Uniform Resource Locator; term that describes the location and access method of a resource on the Internet, i.e., a Web site.

Web host—an interconnected group of Web servers containing Web site data that other computers can access through the Internet. Web hosts also provide technical resources and Web site maintenance.

Web server—a computer that stores the files and programs that make up the site, and then allows visitors to access and read those files.

Yahoo!—A search engine edited by humans, giving users relevant results in a clear, consistent, categorical manner.

Web designer—the designer who creates the look and feel of a Web site, including the navigational elements such as links, buttons, etc.

they are all galleries you can join; some online galleries are closed to outsiders.

Online galleries come in several forms.

Brick-and-mortar gallery Web sites. These sites belong to galleries that exist in the real world and which have added an online component to their business. Not all real-life galleries have their own Web sites yet, but they will eventually. The great thing about these galleries is that you shouldn't have to do any work at all. It's the responsibility of the gallery to post your images to its Web site. Unfortunately, if it is a commercial gallery and you are not in the gallery's stable, you won't be able to exhibit your art on its Web site.

If you belong to a real-life gallery, or are considering getting one, be sure to check out the Web site. Look it over critically. Does it present the artists and their work to their advantage? Is it easy to navigate? Does it convey a presence you can be proud of? If your gallery's Web site is nonexistent, or less than ideal, it's time to start working with the staff to create or improve it. (Gently, of course, this stuff is scary to a lot of people.)

Some well-designed online brick-and-mortar galleries at the time of this publication are www.mixedgreens.com, www.maryboone gallery.com, and www.alonakagangallery.com.

Virtual galleries, fee-based. A virtual gallery is one that exists only in cyberspace. The fee-based form of the virtual gallery charges the artist a fee to have his or her work online, providing all the tools necessary for creating and maintaining a Web presence. This can include a setup fee, a monthly fee, a price-per-image fee, and/or a percent-of-sales fee, but you can bet that money changes hands.

It's not usually all that much money, however, and if you find a good fee-based gallery you can expect to be provided with an easy-to-follow template so that putting your Web site together is relatively painless. The Web site should provide you with enough virtual room for your site to grow as your career grows.

The gallery should be actively marketing your art by bringing traffic to the site, although as I mentioned before, be under no illusion that traffic will translate into sales. The best virtual galleries will even allow

Everything you can imagine is real.

PABLO PICASSO

you to have your own domain name without their name muddying it up, so that if you later decide to create your own Web site, your address can go along with you. Some fee-based galleries you might check out are www.artspan.com, www.mesart.com, and www.portfolios.com.

Juried virtual galleries. Some fee-based virtual galleries are juried. The obvious advantage to this is that you will be grouped with a (presumably) higher quality of artists, which in turn, is more likely to attract serious art world attention. Many of the juried virtual galleries take a percentage of sales, so they are more likely to actually sell something. Watch out though: read the fine print carefully before signing up. Sometimes juried galleries expect an exclusive contract for Internet sales, which can get sticky if you are connected with a real-life gallery or want to show your art on more than one Web site (which you do). Examples of juried sites include www.projekt30.com, artistsregister. com, www.guild.com, and www.studiodirectart.com.

Virtual galleries, community based. These Web sites are created by art organizations as a way to showcase their members' art and to present the organization's issues and concerns to the public. An advantage to being on this type of Web site is that the credibility of the organization is conferred to you and, as such, can increase your exposure to art people, rather than just random Web-surfers. Putting your art on this kind of Web site is usually free, as part of your membership. That also means you will have little, or no, control over how the Web site looks. Here are a few examples of community-based online galleries: Chicago Artist's Coalition at www.caconline.org, International Sculpture Center at www.sculpture.org, and Photographic Society of America at www.psa-photo.org.

Option Two: Creating a Web Site Using a Web Template

Some Web sites offer tools for building your own Web site but don't do any outreach for you. Using a Web template is an easy way to get your art online (using your own domain name) without having to learn Web site design or hire a designer. There are two downsides to

> *Why make art?*
> *Because I think*
> *there's a child's voice*
> *in every artist saying:*
> *"I am here. I am some-*
> *body. I made this.*
> *Won't you look?"*
> CHUCK CLOSE

this: you have to stay within the design parameters of the template, and you have to create your own traffic (but you will have to do that anyway since most traffic to group Web sites consists of just people wandering through). Expect to pay a setup fee and a monthly fee as well.

You can also use a Web template that comes with a software package such as Macromedia Contribute. Many software packages have some version of a template, so check the software you are already using: you may find a template that will work for you.

Examples of Web template sites are www.foliolink.com and www.mac.com.

▬▬ Option Three: Creating Your Own Web Site

The best thing about creating your own Web site is the pleasure of holding complete control over how your art is presented on the Web. If you create your own site, you won't have to put up with bad design, information not pertaining to your art, or finding your art buried sixteen pages deep into the site where no one can find it. When people visit your Web site they see what you want them to see and only what you want them to see. The downside is that sometimes it gets lonely out there in cyberspace if nobody comes to visit you. So one of the responsibilities of having a personal Web site, whether you make your own or use a Web template service, is going the extra step to create traffic to it. (Read more about how to do this later on in this chapter.)

I think that all sorts of art activities, whether written, played, or visualized, are attempts to send messages from one person to another.

BARBARA KRUGER

When you create a Web site, the first decision you will need to make is whether to do it yourself or hire a Web designer. This is a no-brainer; make the decision based on your heart. If you want to do it yourself, take a class in Web design (you don't have to learn HTML or any other code; plenty of software programs can do the code for you) and go for it. Building your own Web site will take time, but it's not that hard, and it can be great fun if that's where your interests lie. But don't do it just to save design fees. Building a Web site takes focus, and if you are not really interested, it can easily turn into one of those projects that never gets finished. If you want your own Web site, but don't want to build it

Artist's Web Site Checklist

_____ Step One: Get your domain name

_____ Step Two: Create a site map

_____ Step Three: Create the visual design

_____ Step Four: Build the site

_____ Step Five: Start creating links

_____ Step Six: Find a Web host

_____ Step Seven: Create, print, and mail your Web launch card

yourself and can't afford to pay a designer right now, consider joining an online gallery or using a template, until you can.

Finding the right Web designer. Choosing a good Web designer is essential to ending up with the Web site you want. A Web designer works on two levels, what you see on the page (the visual design), and what you don't see, the pulleys and levers that make the whole thing work (the code). You want to find a designer who does both well. Ask around, have people you know used a designer they liked? Go to the designer's Web site. Do you like the way it looks? Is it easy to move from location to location within the site? Does the logic of the site make sense?

> *Someday artists will work with capacitors, resistors, and semiconductors as they work now with brushes, violins, and junk.*
>
> NAM JUNE PAIK

When working with a designer, expect that a basic Web site will cost a minimum of $1,500, with yearly updates anywhere from $300 to $500 (that's in San Francisco, in the year 2006). I give this number as a ballpark figure; please adjust it to absorb economic and technological differences for your place and time. Beware of bargains; a Web site that is unprofessional, unwieldy, or unavailable will irritate your visitors. You are trying to entice people to your Web site, not annoy them. If your budget is really tight, search the art schools for recent graduates with degrees in Web design. Because they are new to the field, they may

cut you a deal in order to build their design portfolio, and because they are fresh out of art school, they should be conversant in the latest technologies (unless they got a "D" in Web design). Regardless of whom you decide to hire, be sure you go to every Web site the designer created to verify the quality of the work before committing.

Before you start working with a Web designer, you need to negotiate a contract with him or her. One thing you want to be sure of is that you retain copyright ownership of your Web site. If you don't get this into the written contract, then the designer will own the copyright by default, and you don't want that. You need to be able to change or update your site on your own, or to hire someone else to do it if your relationship with the designer doesn't work out. Also, request the right to keep a copy of your site on your computer so that you can make changes and updates yourself (this will save you a ton of money in the long run). Find out if the designer is available to do the entire site, as well as ongoing updates, and get the total estimate for all of it before anyone starts to work on it.

Some design firms include hosting as part of the package, so make sure to read the contract carefully to see exactly what you are buying. Artist Rachel Powers tells of a family member who recently got caught in a $400 hosting renewal fee each year from a Web design firm. Most design firms or designers will mark up the price for these things, so just be sure to read the fine print.

What to include on your Web site. The perfect artist's Web site should include everything you would include in your artist packet and more. You need images of your art, a current bio, statements for each body of work, an upcoming exhibitions list, contact information, a press page, and links. Make a list, or site map as they call it, of all the things you want to include.

If you are short on time or money, start with the basics: a gallery of your artwork (maybe six pieces), your bio, and an artist's statement. A Web site this size is fairly easy to handle, and you can add to it as your needs grow, and as time and money allow.

Do *not* include pictures of your family, interests, or hobbies. Your Web site should be professional and specifically designed for your art career. It's not only your online identity; it's a must-have component

to your artist package. This is what galleries, prospective buyers, returning buyers, and general visitors will see. Some artists include other areas/topics that cover their "day job." I recommend that you stay away from this: it will diminish your stature as a serious artist.

The next step is to create the visual design for your site. Start by perusing Web sites you admire. Regardless of whether you work with a designer, or design the Web site yourself, the more you know about what you want, the more likely you are to end up with it. When you find a Web site you like, note the things you like about it, but don't copy it outright. You want your Web site to be your own. Make notes about what you like, make sketches, bookmark Web sites—whatever it takes for you to be ready to go.

Once you have your site map and your visual design, it's time to build the site and create the code. This is something you will need a professional to do, unless you have decided to take classes to learn to do it yourself. Part of this step is choosing the technology that's right for your site. It's a challenge, since there are so many software programs out there, and they are constantly changing. A good rule of thumb is to stay away from the latest and the greatest developments in technology. They look fantastic on a state-of-the-art computer, but may not be accessible on an older model. You want people to be able to find your art, not be barred from seeing it.

Finding a Web host. After your Web site is designed you will need a place to park it. The Web hosting service is like a landlord, and you are renting a space from it. Your Web site will live within its building but will be accessed using your URL, which is also called the domain name, although there is a slight difference. The domain name will be on every page within your Web site, although the exact URL of each page may be slightly different.

There are many Web hosts out there, and they offer different levels of service. Most Web hosting "starter packages" provide enough storage or features for an artist's Web site. Your Web hosting service should provide toll-free twenty-four-hour customer support, a simple interface for updating your site, enough storage to get you started (at least 2 gigabytes), and enough bandwidth for lots of people to visit your site at the same time (25 GB/month should do it).

Hell, half the world wants to be like Thoreau at Walden worrying about the noise of the traffic on the way to Boston; the other half use up their lives being part of that noise. I like the second half.

FRANZ KLINE

What to Include on Your Web Site

Images of your work. Put your most current work at the top level of your site and the rest in archives or galleries. Display a small version, or thumbnail, of your work that can click to a larger view. (The larger view should be no larger 500 x 500 pixels. Images should be created at 72 dpi at the exact size you want them to display for the best quality.)

An artist bio. This is the same bio you have in your artist packet (see chapter two).

Statement for each body of work. The statement for your current work should be the most prominent; the others can be associated with your archives or subsequent galleries.

Upcoming exhibitions. This should include links to the venue's Web site, links to maps, and directions. You may want to display a preview of the work you will be showing, as well as including a link to e-mail you with questions.

Mailing list or guest book. This can be as simple as a link to e-mail you with contact information or a form that allows visitors to fill in their address and contact information. Web designer Tracy Rocca recommends gathering the following information on your mailing list: first and last name, mailing address, e-mail address, a place to write a note or message, and an option to be sent up-dates via mail or e-mail.

Your contact information. You will need to have a link for e-mail contact on your Web site. Don't just type in your e-mail address on the site; it's an invitation to spam mailers that crawl around the Internet collecting Web addresses. Instead, make it a link so that "contact (your name)" appears on the Web site and the address is in code. You can also include your phone number and city and state. Your real-world address is optional, depending on how comfortable you are with giving out personal information.

Press information. The point of a press page is to make it easy for someone to write about you. This page should include photos to download in both high and low resolutions, a (PDF) version of your bio and statements, a (PDF) version of your press release, copies of past press releases, and articles written about you. All of these things should be viewable online in HTML, but downloadable as PDF files.

Links, links, links. Brainstorm affiliations and art world connections who may want to link to your site and vice versa. The more links you have, the easier it is for search engines to find you, but be sure they are all professional links. Don't include any links you wouldn't want to include in your artist packet.

Making updates. Ask your Web designer for a tutorial on how to update your Web site. You will want to be able to add things as they happen, like your newest artwork, upcoming show dates, and latest critical reviews. This will save you money in designer's fees and ensure that the information won't have to wait until the designer has time to get around to doing it. You will need to install the software on your computer, of course, and your designer can help you with this. If you need a large-scale update, or complete redesign of your site, let the designer do it. Paying a designer to fix the Web site after you have messed it up often costs more than having the designer do it in the first place. As mentioned, it's also a good idea to negotiate an update fee in advance so you don't end up with an unwelcome surprise.

Drawing People to Your Site

Most people think that building the Web site is enough. I call it the "Build It and They Will Come" syndrome. Unfortunately, no matter how beautiful your Web site may be it will remain lost in the virtual world until you place it on the "map" of the Internet.

How to Get Your Own Domain Name

Your domain name (URL) is your Internet identity; it's your address on the Web. When you go online to any Web site, at the top of the window you will see that Web site's URL (mine is http://www.caylang.com). Like your real name, you want it to be the same throughout your life as an artist. You want people to be able to find you ten years from now to offer you that solo show at the Whitney.

Even if you are not ready to build your own Web site, you should purchase your domain name right away. You will need it someday, and you don't want someone else to have control over your name. Nothing is more dispiriting than typing in your name to discover that Web address belongs to a stripper, or a used-car salesman. So do it now. You can apply for and receive a URL without having to publish a Web page for years, as long as you pay your annual subscription fee.

Tips for choosing a good URL. Your first choice should be your name, the name you use in signing your artwork. As the Internet becomes more crowded, it will become harder and harder to do this. Those of you with the name Bob Smith already know this. I predict that it won't be long before parents are choosing their children's names based on available URLs and registering them before birth.

If your name is taken. Ask yourself what people might type into a search box to find you. It should be related to your art career, not your hobbies, or family, or your hard-won title as Belch Queen in high school. This is your first chance to create an online image, so choose it carefully. Your domain name can only include letters, numbers, and hyphens; no other symbols or spaces are allowed. Choose a domain name that is easy to say, understand, remember, and spell. For example, you may not want to select www.scents.com, because that could be confused with www.cents.com, or www.sense.com, when said over the telephone or radio. Also, be careful with the use of hyphens and numbers, as they can make domain names harder to type and recall. Make your domain name as short as possible; it should be easy to remember.

Don't just compose a slight variation and register it. If caylang.com was taken, I could have registered as cay-lang.com, but that wouldn't have been my wisest choice. People looking for me would still type in caylang.com and end up at the wrong Web site. Similarly, if you can't get ".com" as an ending, don't go for ".net" or any of the others on offer. ".com" represents the word "commercial," and it is an unrestricted global domain name extension. The other extensions have restrictions on the type of site they can host and are not as frequently referenced.

If someone else has registered your name, create a variation that distinguishes your site from that person's site and maybe says a little about what you do. Options for me might have been caylangart.com or caylangstudios.com. The trick is to distinguish your Web site without getting too specific, because you may want to change your creative focus at a later date. Caylangstudios.com is a better choice for me than caylangphotography.com because at the moment I'm more of a writer than a photographer (I heard that joke! What I meant was, right now I am doing more writing, okay?!). I want to leave room to grow and change as I wish. Other possible endings include fine art, sculpture, photo, atelier, and so on.

Registering your domain name. Domain name registration is typically billed annually, and fees average about $10 a year. You own the domain name as long as you continue to pay for it. If you stop paying, your name will expire and become available to the public.

Be sure to register the name yourself. If you have your Web designer or anyone else register your domain name, that person becomes the legal owner of the name even if he or she is registering it on your behalf.

When looking to register your domain name, look for a registrant that is well established, has toll-free twenty-four-hour customer support, Web hosting services in addition to domain name registration, and e-mail address forwarding so you can start using your domain in your e-mail address (ie: johndoe@johndoe.com).

A few well-established domain name registrants at the time of this publication are www.smallbusiness.yahoo.com/domains, www.godaddy.com, www.network solutions.com, and www.verio.com.

Your ultimate goal is to ensure that those searching for your site on the Web find it. This means giving search engines such as Google or Yahoo! the tools necessary to lead those interested in your work to your Web site. You want your name and your Web site to appear at the top of the search results when someone types your name into a Yahoo! search box.

It sounds easy enough, right? Someone searches for your name and (voilà!) you magically appear in the search result. But how did the search engine find your site in the first place? Behind the scenes in the virtual world, search engines use applications called "crawlers" (also known as "spiders") to search Web sites and rank them based on their content's relevance to your search. The more relevant the Web site is to your search, the higher the ranking will be.

So, if you type the word "banana" into a Google search, the search results should show pages listing Web sites about bananas. And in a perfect virtual world, only Web sites about the fruit would appear. Unfortunately, in the *real* virtual world (did I lose you?), typing in the word "banana" will probably result in a list that includes Web sites about songs with the word "banana" in the title, plastic containers called the "Banana Guard," a dancer named Fanny Banana, and several Web sites that appear to have no relation to your search at all.

What causes this confusion? Crawlers, which bounce from site to site throughout the Web and rank each one according to its document features such as text, written descriptions, and associated links. Crawlers don't know the difference between a banana and a dancer; they are just trained to identify a word. So anything with the word "banana" in it gets picked up by the search engine, even if it doesn't have anything to do with the actual fruit. So watch out! If you don't actively prepare for this, your Web site—and the person searching for your site—may get lost in the shuffle, or worse, end up on the banana page.

I begin to feel an enormous need to become savage and to create a new world.

PAUL GAUGIN

Unfortunately, your task is made more difficult by the simple fact that the strategies for helping search engines find your Web site are in con-

stant flux. In fact, they've changed twice in the time it's taken me to write this chapter! For this reason, I'll go over a few of the tactics that should stick around for a while. They should be good for your site regardless of what the latest crawlers are up to.

Page titles. Be sure you have your designer or Web developer create a title for each of your pages. The title is the name that appears in the top bar of the browser window. Not only is it the first thing a search engine crawler counts, it is the first thing most visitors see once they find your Web site. I also recommend using a different title for each page that describes the content. And be sure not to use all CAPS; some search engines penalize for this.

The work of art is a scream of freedom.
CHRISTO

Meta tag description. Meta tags are hidden behind the scenes in the code, invisible to the viewer. They are your Web site's way of saying "Psst! Over here!" to the search engines. The meta tag description simply tells the search engine what your site is about and what it can expect to find within its content. Be sure to ask your designer or developer to write a meta tag description that includes, at a minimum, your first and last name, geographical area, art discipline, and medium.

You may also choose to utilize a second set of meta tags called "keywords." Keywords are used to identify words you believe people would use to search for your Web site. For example, good keywords for a Web site about bananas might be "yellow," "monkeys," or "Dole." It is worth noting, however, that there is currently an ongoing debate about the effectiveness of keywords. While standard several years ago, they are sometimes ignored by some of the newer search engines. A simple description is much more useful when optimizing your site for search engines.

He that will not apply new remedies must expect new evils; for time is the greatest innovator.
FRANCIS BACON

Text on your pages. Like the second set of meta tags, the idea here is that you want to predict which words a person would type into a

search box to find you. Unlike meta tags, however, these words actually appear on your site's pages and not in secret code. For most artists, these words (like above, also known as "keywords") would be your name, medium, and geographical location (i.e., Tracy Rocca, oil painter, San Francisco). And you want to use these words as much as possible within the text of your pages. It helps to include many variations of important words such as capitalizations, pluralities, and synonyms. It also helps to use two words for your keywords, such as "oil paintings" as well as "paintings." (As a trend, this makes me very sad. I really value things like poetry and metaphor, which are lost to a crawler. Oh well.)

Don't get too flashy. Avoid blinking, flashing, and moving graphics. The purpose of your site is to showcase your work, not to look like an online casino.

Don't keep visitors waiting. Avoid bogging your pages down with large graphic files. If visitors have to wait minutes for a graphic to load, they may just move on to the next site.

Don't reinvent the wheel. Use the formula that works for presenting and browsing artwork online. If most artists' Web sites do things a certain way, then follow along, because your visitors will expect things to work the same way on your site.

Skip the intro. If you are going to include an intro page on your site, you should allow visitors to skip it if they choose.

Wait until you can do it right. A rushed or poorly designed Web site can do more harm than good. Launch a Web site when you have the time to make it a good reflection of you as a professional artist.

Tracy Rocca is an artist and Web designer in the San Francisco Bay Area.

Images. Always add descriptive text, or ALT tags, to your images. ALT tags will not be seen by the viewer but will appear if the images are unavailable for any reason. Including keywords in your ALT tags can help you achieve better rankings and will also make your site accessible to the visually impaired.

Creating links. Search engines also rank you by your popularity. Your popularity is measured by how many *other* Web sites provide links to *your* Web site, and vice versa. The trick is to create "reciprocal links." In other words, your relationship with other Web sites cannot be one sided. Simply adding links to every Web site in cyberspace won't help

Preparing Your Art for a Web Site or E-mail

Open an image using your imaging software. Using a cropping tool, cut out any extraneous background so that all you see is the image alone or on a white background. You don't want any distracting visual information around your art.

Look at the colors. Do they seem to be accurate? Are the colors bright with plenty of contrast? If not, you will have to adjust the color. If you are adjusting the color for use on a monitor, CD, or the Web, first make sure that the color format is set to RGB (red/green/blue); if the final product will be printed material, such as a show announcement, set the color format to CMYK (cyan/magenta/yellow/black). You will then be able to adjust the colors and contrast to your taste. The goal is to get the image as close as possible to the original artwork, but don't despair if you can't get it to match exactly. Every monitor is different.

Adjust the size. To size the image for viewing on a monitor, change the dpi to 72, and set the width and/or height to something close to 3" x 5" (approximately 215 x 350 pixels). This is a size that will look good on most monitors and in e-mail. When you are finished, save the file with the Save As command, so that it is saved separately from your original scan.

Create a file name. Make the name descriptive enough to be identified apart from the original source.

Save that beauty!

you—you need those Web sites to link *back to you*. The most useful link for an artist—and the easiest to get—is one with other artists (but make sure they are artists you respect). Other linking possibilities include, but are not limited to, venues that have shown your art, articles about you and your art, artist friends, educational institutions you are affiliated with, and art organizations. Also consider creating links to Web sites your clients might be browsing. But don't blindly link to everyone you

Two Ways to Use an Image in an E-mail

If you want the picture to show in the body of the e-mail. Open a new e-mail and create your message in HTML format. (You may need to choose HTML format in your mail program's preferences.) Write your e-mail. Click on the area you want the image be placed (usually at the end, sometimes in the middle of your message.) Click on Insert Picture or Place Picture, and voilà!, a work of art appears in your e-mail.

If you just want to send a file to people to download and use for reprint or other purposes. First find out the form and size file that they need. Then just attach it in the "attachments" area of the e-mail.

Always send the e-mail to yourself first. It should arrive promptly and open easily. If it bogs down your computer, make the file size smaller (unless the recipient has stated a specific size). The last thing you want to do is alienate the recipient by freezing his or her computer.

know. Links should be professional; poor link choices may jeopardize your credibility.

When you find Web sites you would like to link to, send them an e-mail offering to setup reciprocal links with them. Flattery is always a wise strategy. While some may answer right away, don't be surprised if others take a little while. People often put this kind of thing off, especially if they are not quite sure how it's done. Ask them for their URL (i.e., their Web address) and give them yours in exchange. Your designer can implement the links, or you can do it yourself depending on the kind of Web site you are using.

It may be hard for an egg to turn into a bird: it would be a jolly sight harder for it to learn to fly while remaining an egg. We are like eggs at present. And you cannot go on indefinitely being just an ordinary, decent egg. We must be hatched or go bad.

C. S. LEWIS

Swapping links with people and businesses is great, but swapping banner ads is not. If the person you wish to link with wants to place a banner ad on your site, say no. It will detract from your art and make you look cheesy. The links page should be easily found on your Web site, but should not overwhelm it.

Another way to "get out there." You can also attract people to your site by listing your events (exhibitions, lectures, etc.) on local events calendars. List with as many of these as you can find: it can't hurt. Find specialized search engines with art-related topics or the Web site for your local paper and get your event and URL listed with them. Some art directories online are www.laughingsquid.com, www.artline.com, and www.flavorpill.com.

Stay current! Your site should change frequently. Search engines give preferential treatment to newer content when all else is equal. You should update your site regularly with fresh information such as new artwork, recently scheduled exhibitions, or the latest articles written about your art. If you can't think of anything else to add, write an article yourself on a related topic or list your recommended exhibitions, art events, or articles you found interesting.

Further thoughts on staying current. Do it because you want people to come back to your Web site. It's hard enough to get their attention in the first place; you don't want to lose it once you have it. A regularly updated site shows that you are working, actively producing new work, and that you are a vital, interesting force in the world!

Emphasize your individuality. Although I said above to keep your Web site simple, that doesn't mean to make it humdrum. Your art is your own, so make sure your Web site captures what's unique about it.

What search engines don't like. Cheap tricks! One popular trick is to include hundreds of keywords on your pages as invisible text (when

the background and the text are the same color). Tactics such as this may have had success in the past, but those days are long gone. Trying to fool a search engine today might get you and your Web site banished from search results all together. Remember, good content presented honestly is the key to high ranking and higher traffic to your site.

Check to See If It's Working

Once you've optimized your site, you should begin to see changes to traffic to your Web site. This can take anywhere from a few days to six to eight weeks. The easiest way to find out if your tactics are working is to enter your name into a search engine box,

The typewriting machine, when played with expression, is no more annoying than the piano when played by a sister or near relation.

OSCAR WILDE

like Google, MSN, or Yahoo! Try several different search engines to see how you're doing. Did you make it to the top of the list? Did you even make it to the first page? Your Web host should also offer a service for keeping track of who visits your site, when, and where they came from. This can be valuable information for finding out just who you are reaching and who you still need to reach.

At Last! Your Web Launch Card!

Once your Web site is up and running, it is time to send out an announcement card inviting everyone you know to visit. I'm not talking virtual here, I'm talking about a real-life, hold-in-your-hand announcement card heralding the birth of your Web site. Create a card along the lines of an exhibition announcement, with a photograph of one of your best artworks on it (never waste a chance to show people your art) and your Web address. This is a great excuse to connect with all those people you want to know

Be courageous. It's one of the only places left uncrowded.

ANITA RODDICK

about your art and a good way to bring them from the real world into your virtual one. Use your entire mailing list for this: your friends, family, colleagues, dentist, doctor, and every gallery or art world

Jan Camp's Tips for Making an Artist's CD

Tip One: The images

- Use your strongest images. Not the ones you like best, but the ones that translate best when viewed on a monitor.
- The images should be large enough to see good detail and small enough to fit comfortably when viewed on a 14-inch monitor (7 inches high by 10 inches wide, at a resolution of 72 ppi, or 504 pixels high by 720 pixels wide at 72 ppi).
- Save the images as JPEGs at the maximum quality (or with no compression).

Tip Two: Supporting materials

- Include your résumé, reviews, biography, and statement.
- Save your documents in Rich Text Format (RTF) or Portable Document Format (PDF).

Tip Three: Three ways to put the disk together

- If you know how to burn a disk but not much more, you can burn all the image and text files onto a disk without any particular organization.
 - Make your file names short and descriptive.
 - Add a text file named imagelist.rtf (or imagelist.pdf) that lists all the image files on the CD (with the title, dimensions, year, etc.) so that viewers can find their way around and know what they are looking at.
- If you know Adobe Photoshop, you can choose File>Automate>Web Gallery and fill in the required fields to automatically create an interactive display of the images and text in HTML. Include instructions to "double-click the index file to start."
- If you are familiar with some other program, such as Macromedia Flash, Dreamweaver, Microsoft PowerPoint, FrontPage, Adobe Acrobat, GoLive, or one of the various movie-editing programs, you can use that to organize your images and documents.
 - If you use a program that requires a "player" (such as Flash and movies), be sure to include the player on your disk so that the user does not have to open special programs on his or her computer.
 - Most computers have built-in viewing capability for JPEG, RTF, PDF, and HTML files.

personage you always wanted to meet. You'll be surprised who responds. Just recently I received a phone call from the wonderful painter Jamie Brunson extolling the virtues of the Web launch card. She mailed one out when her Web site was ready, and among the recipients of the card was a gallery Jamie had always admired. After seeing the card, and visiting the Web site, the gallery director e-mailed her and offered a show.

The Dark Side of the Internet: Image Theft

Images are easy to steal on the Internet: it doesn't take any special equipment or know-how to do it. Any bozo with a keyboard can copy and download any image he or she sees. That's the bad news. The good news is that since most images on the Internet are such a low resolution, what is taken will be a very raw version of your art, good enough for the Internet, but not good enough to reproduce in print in the real world. For myself, if I discover someone has stolen one of my images for his or her Web site, I insist that the thief give me credit for it, and let it go at that. I look at it as changing a rip-off into free advertising.

But there are things you can do to foil the crooks. You can add a copyright symbol (with the year and your name) directly to the image

I am always doing that which I cannot do, in order that I may learn how to do it.
PABLO PICASSO

by adding a text layer into the image itself. If you want even more protection, try some of the more advanced tricks such as image slicing, using your art as a background image, or disabling the browser's "copy" functionality. Ask your Web developer or designer about these techniques if you're concerned.

If someone steals your image. You are not without options. The first thing to do is to contact the people who used your image and ask them to either remove the image or append credits and contact information to it, depending upon your preference. You might try asking a fee for the use of the image, although if they are the kind of people who steal art, they are unlikely to be willing to pay for it.

If you can't resolve the issue by communicating with them, your next step is to contact that Web site's ISP host. If you don't know who the ISP host is, a Web site called samspade.com can help you find it. The ISP host is required under the Digital Millennium Copyright Act to remove the offending image. ISP hosts are typically very responsive, but if not, write a letter reminding the ISP host of its legal responsibilities.

What an artist is trying to do for people is bring them closer
to something, because of course art is about sharing:
you wouldn't become an artist unless
you wanted to share an experience, a thought.

DAVID HOCKNEY

Going Public

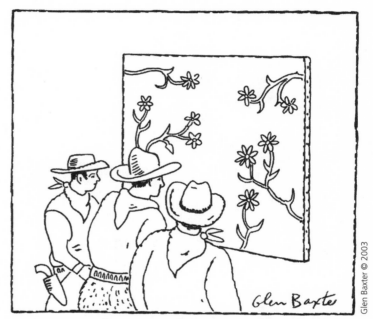

Glen Baxter © 2003

THE CRITICS SPOTTED THE BOGUS
ROTHKO ALMOST IMMEDIATELY.

Learning to attract the media is essential to your success as an artist. It will make the difference between remaining perpetually mid-career or reaching the top of your field. And there is no question that once you reach the top of your field, becoming adept at working with the media is crucial to staying there.

How to Start

Start by being yourself, your best self, by your own definition. Don't let anyone try to turn you into someone else, not your gallery, not

your mother, not your best friend. Your job as an artist is to be an individual; your uniqueness is where your art comes from. That is what makes your art interesting; trust that it will make you interesting to the media as well.

Position yourself as a leader in the community; that's the artist's role in a healthy culture. Throughout history, the artist has been the truth teller, the weather vane, and the visionary of his or her community. Whether or not we live in a healthy culture is up for discussion, but regardless, proceed as if we do, as if your role is important and central to the culture. As you begin to go public, don't present yourself as a beggar craving attention, but rather as a person of vision (which you are) ready to take public responsibility for what you know.

Don't pay any attention to what they write about you. Just measure it in inches.

ANDY WARHOL

The secret is to learn to be public without really caring what the public thinks.

I want to tell you about two artists I know. The first, who shall remain nameless, is an exceptional young artist, a person of unique vision, who started a body of work using butterfly wings as his medium. Butterfly wings are beautiful in themselves, but it was the way he used them that made the work interesting, and from the very first show he started getting media attention. It wasn't long before strangers introduced to him would say, "Oh, are you the butterfly guy?"

Self-esteem is for sissies.

TOM ROBBINS

Instead of recognizing this as the first step toward national and international recognition, he saw it as being pigeonholed. Being called the Butterfly Guy bothered him so much that he stopped doing the work altogether. He still had things he wanted to do with it, but he refused to be "labeled" and moved on to something else. This is self-sabotage at its clearest. Instead of letting the current work catapult him to the next level, he had to start his career all over again.

If Andy Warhol had minded being called the Soup Can guy, we might not know his name today.

I'm not suggesting that as an artist you should continue to do work just because it has caught the media's eye. Your role in the culture is that of the visionary, and as such it is absolutely central that you stay true to your vision. Do the work you need to do, for as long as it takes,

regardless of what anyone else thinks about it. Then milk it for all it's worth. The idea is to let each body of work propel you to the next stage of your career, to create an audience and a market ready and hungry for everything that you do.

The second artist is sculptor Michele Pred. Michele created an amazing body of work using items confiscated by the airlines. When the work was ready, she took it to local galleries hoping to get a show. They all seemed to like the work, but none were willing to take a chance on an unknown, so Michele took control. She found an empty storefront, installed the art, and sent out invitations and press releases to everyone she could think of. The press loved the art, and she got coverage in all the local papers. The local TV stations put her on the eleven o'clock news. CNN noticed and ran its own two-minute spot, which resulted in a write-up in the *New York Times*. All of these things together brought her collectors, show offers, commissions, and galleries begging to handle her. Within a year she had sold her first piece in the $20,000 bracket and was being courted by several prestigious galleries. She has since joined the Nancy Hoffman Gallery in New York and has had shows in London and Sweden, as well as across the United States. She has now moved on to creating a new body of work, and when it is ready, she has the support system in place to get it out there.

If you are going to have any success, you will be categorized somehow, good or bad.

RICHARD ESTES

Creating your media database. Your first step toward building public recognition is to create a media database: a list of contact people at magazines, newspapers, radio stations, and TV stations who are in a position to trumpet your art to the world if they choose to do so. As with every other part of your career, look at building your media database as a chance to create connections with people who appreciate what you do.

To develop a useful media list, you will need a database software that allows you to assign and search by categories, keywords, and e-mail addresses, as well as name, address, phone, and fax. Some database software programs currently on the market are FileMaker Pro, Microsoft Outlook (the full program, not just the free e-mail), ACT, Microsoft Access, and Now Contact. You can use this same database program for your regular mailing list, the one that includes all the art world people

as well as your friends, family, and colleagues. Having all your mailing list data in the same database makes it easy to put together any list you might need at a moment's notice. Having it all together also makes it vulnerable to loss, so make a backup copy of the information every time you make a change to it.

Your media database should include reporters and writers whose articles you may have read, or heard, or seen. Include all the print and online magazines, newspapers, and radio and TV programs that cover topics relating to art in general, or your art in particular, even if you don't yet know who the contact person should be.

> *For 500 years artists have been courting hype; it was virtually a Renaissance ideal. Michelangelo, Cellini, Vasari, and Caravaggio were some of the greatest self-promoters of all time. To them you can add David, Delacroix, Courbet, Rodin, and Picasso.*
>
> DANIEL KUNITZ

Your next step is to contact each entry on your media list, by phone, e-mail, or fax. Start with the telephone if you can. It offers the most personal contact. Even though you are calling to get information, you are also calling to begin building a relationship, and there is nothing better than the human voice for that. Ask the following questions and record the answers in your database:

1. *What is their preferred method of contact?* Some will want to receive press releases printed on paper; others prefer the information to come by e-mail. If they want e-mail, you will need to be able to attach your art to e-mail (see page 183).
2. *How far in advance of an event do they like to be contacted?* This is crucial; some publications need only two weeks (newspapers mostly), others as much as three months (glossy magazines).
3. *Are they interested in your art event or issues or subject matter of your work?* If not, remove them from your list. If they are, and they seem to want to talk, chat them up.
4. *Is he or she the appropriate person in the organization to send the press release or packet to?* If not, ask for the name and contact information of the person you want. Then call that person and go through the questions again.

Remember, your job at this point is to make a new friend, or at least, not make a new enemy. If they feel like talking, great! If not, just get

the infomation and move on. Make note of everything in your data-base so that when you next contact the organization or individual you will be and sound prepared.

By now it is probably dawning on you that building a media data-base is a big job. You are right, but you don't have to do it all once (unless you have put it off to the last minute, and your show opens next week. In that case, you're too late anyway, so start working on it now for the next show). Do as much as you can, when you can; anything is better than nothing. If you really don't want to do it, con-sider recruiting an assistant from the local university to help you or hiring a publicist. Even if you hire a publicist for your art event, you will still need to build a media list for other occasions.

> *I don't paint pictures in the hope that people will understand them. They understand or not, according to their capacity.*
>
> PABLO PICASSO

Hiring a publicist. This can be wonderful, or useless, depending on a number of factors. Publicists are expensive, so be sure that you get the right one. All publicists have media databases already built, but their media lists may be too broad for your needs, or they may not address the art world. You want to find a publicist who specializes in the arts and has a personal relationship with reporters who cover topics relat-ing to your work. If you decide to hire one, be sure that you under-stand exactly what he or she is going to do for you and what it will cost. A good way to find an arts publicist is to contact organizations, or artists, who have recently received a lot of press and ask who their publicist was. Even if they didn't use a publicist, they might be able to give you some tips or names to add to your database.

Using Your Media List

Now that you have your media database, what do you do with it? Use it! Use it for everything that you do. No art activity, no show, small or large, should occur without you having contacted the press. In chap-ter seven, I wrote about writing a press release, and putting a press packet together, to announce an exhibition. There are many more ways to use these materials. Here are just a few.

Solo shows. Talk to gallery directors to find out when (or if!) they are sending out press materials, what they are sending, and whom they are sending materials to. You may need to do this for them. One of our Leap artists, sculptor Stan Stroh, was offered a residency and exhibition in a nonprofit space in Arkansas. He was thrilled and went there a month early to build a site-specific sculpture. It was good that he did so, because when he arrived, he discovered that the gallery had done very little to contact the press. So he did it himself and ended up with two print articles and a spot on a PBS talk show. The gallery director was flabbergasted. "That was my job!" he said. Maybe, but he wasn't doing it. Even if your gallery is already sending out press materials, you may discover that it focuses entirely on the local press, ignoring the national magazines entirely. If that is the case, you should be the one to take up the slack.

Group shows. If your art has been included in a group show, send out a personal press release emphasizing some aspect of your art as a side story to the show. Another one of our Leap artists, painter Michael Rosenthal, found himself in a large group show, at about the same time that he decided to quit his full-time job at Stanford University. He sent out a press release emphasizing the fact that he was choosing the life of the artist over a successful career in academia. He got lots of coverage.

Open studios. If you don't have a show lined up, this is a good way to draw attention to your art.

A new body of work. Whenever you finish a new body of work, find a way to announce it to the public.

The Secret to Getting Media Attention

Media people can't cover every story that comes across their desks, so how do they decide what to write about and what to ignore? It helps to know the fundamental question that goes through the mind of every editor, reporter, and producer: Why would our readers (or listeners, or viewers) be interested in this story now? Basically, what they

are concerned about are three things: their audience, the story, and "Is it news?"

First of all, "readers and viewers" are a big concern to any media publication. A ski magazine is not going to be interested in writing about your art unless it somehow addresses the stated interests of its readers. This is why tailoring your media database specifically to your art is so essential. But don't limit your media list to art publications; include other special interest publications if their interests coincide with your artwork. Ski magazines are a perfect choice if your artwork is about snow.

The idea of a "story" is a concept you may not have addressed yet in terms of your art. What is the story that makes writing about your art an interesting proposition? There may be several possible stories surrounding your art, but promote only one at a time. Media articles are short and to the point, so the writers of these articles need you to provide them with a story that can be easily reported in this way, not an endless saga.

The only thing worse than being talked about is not being talked about.

OSCAR WILDE

What makes a story timely? Pay attention to articles in magazines and newspapers to see what the current news topics are. Is there a way to attach your art event to any of them?

People in the media call the focus and timeliness of a story its "hook." Use your imagination to find your own hooks. To start the process, here is a short list of possible ways of getting media attention. Choose the ideas that relate to your artwork and the direction you are already heading, and expand upon them. For instance, you may be a photographer in the process of creating a body of work about homeless people. Maybe the people you are shooting have been complaining that the trash in the city is increasing. This could come under the concept of "Do some research" (see below), and a possible press release heading might read, *Photographer of the Homeless Reports Trash Is on the Rise.* (All right, so it's not a brilliant idea, but it's not that bad either. I bet it would snag an article or two.) More ideas:

You were born an original. Don't die a copy.

JOHN MASON

- Emphasize what is new, different, or distinctive about your art or your career.

- Is there an Overcoming Adversity story that can be linked to your art? Use it.
- Use your ethnicity to your advantage.
- Use your age or gender to your advantage.
- Piggyback onto current news.
- Do some research to merit news attention.
- Sponsor a contest or award.
- Launch a community service project.
- Hook up with an organization or business that will sponsor your art.
- Find a holiday or anniversary relevant to your work.
- Suggest a surprising twist on a received opinion.
- Provide a pretext for a light witty report. (Humor always sells.)
- Tie what you do to the season.
- Revive a tradition, or if your art revives a tradition, emphasize that.
- Play the local card. Local Artist Makes Good is always great for a headline.
- Highlight a comeback.
- Donate your art to a good cause.

Try to give and not just get. Remember, you are building relationships. Sure, you want publicity, but take every chance you can to help reporters do their job. Listen; don't just talk. Let every interview be an interaction rather than just your chance to pontificate. Don't exaggerate (it makes you look smaller, not larger), and definitely, do not lie, ever. The reporter's reputation will rest on what he or she writes: if a lie you told comes back to kick the reporter in the teeth, you will not be forgiven for it.

If you enjoyed the interview process, write a handwritten note, letting the journalist know how much you appreciated it. Add a list of upcoming shows or projects you might have forgotten to mention. That way, if the journalist has another deadline looming, he or she might think again of you. A thank-you note is always welcome (and really quite rare. Most journalists say they hardly ever receive any), but don't send gifts. Reporters are insulted by this; it's too close to bribery. If the interview was a bust, and the resulting article less than

ideal, send a note anyway. Thank the journalist for the article, saying something like, "Although I disagree with your comments on my art, I appreciate the time and attention that went into them." Never miss a chance to take the high road, and who knows, it might change the writer's mind about you.

Another generous thing to do is to send reporters information on other artists or art events they might be interested in from time to time. This helps out the reporters, and other artists, and gets your name spoken with praise. Make sure the information you send is tailored to the reporter's interests though; otherwise it's just more unwanted stuff.

Courting the critics. Most people who write about art fall into one of two categories, the art writer or the art critic. The art writer considers his or her job to be that of an advocate for the arts, to get people into the galleries to see the art. The art critic wants people to go to the galleries, too, but he or she is more interested in creating discourse around the art, raising issues, provoking thought. Art writers, just like feature writers and reporters, are looking for "hooks" in your press materials that will entice people to want to see your show. Critics will be more interested in the art itself.

You should be able to identify which category writers fall into by reading their articles. Send your press materials to both kinds of writers, being especially careful that your images look their best. *San Francisco Chronicle* art critic Kenneth Baker says that he's gone to more shows based on a strong image than he ever has from written materials he received. Believe him, and never include images that aren't perfect.

Tailor your press packet to the type of coverage you are looking for. For the art writer, or feature writer, the focus should be on why the work is interesting to the public. For the critic, emphasize the issues raised by the art. And remember, to get reviewed, your visual materials are your best shot.

Courting the art world. I am defining the art world as the gallery owners, curators, art consultants, art historians, art writers and critics,

You're there to be shot at, and that's part of it.
NORMAN MAILER

I'd like to live like a poor man with lots of money.
PABLO PICASSO

and artists who populate the realm of art. The art writers and critics are the only ones who should receive your press packet, but the others deserve attention, too.

In chapter two, I related in detail how to put together an artist packet, and whom to send it to. The artist packet is perfect for introducing yourself to people in the art world, but it's cumbersome and expensive to send and not always appropriate. Once gallery owners or curators know about your work, your job is to stay in touch but not to force yourself on them. A good way to do this is through an announcement.

Make it your practice to print a show announcement, with a picture of your latest art on it, for every show you are in, even if it's just a group show. The best announcements are standard postcard size, with one image and your name on the front, surrounded by a white or neutral background. Mail announcements to every art professional on your mailing list. That way they can watch your art grow and develop, without ever actually attending a show. You can also send this announcement as an e-mail, (see chapter nine), but be careful about it; many people do not like getting unsolicited e-mail, especially if that e-mail bogs down their computer. A printed show announcement is always well received; it doesn't require a computer to be experienced, and it feels good in one's hand.

Participate in the World Around You

There are many ways you can start to take your place as a leader in your community. Look around you. What issues do you care about? Start from there. When you have an exhibition of your art, why not set aside the sale of a piece to go to a good cause? You can put this piece on eBay to sell it (www.ebay.com), simultaneously gaining a collector, advertising your show, and giving to something you care about.

Another way to participate in your community is to put together a public event, perhaps a panel discussion, or a fund-raiser. Consider writing articles for local publications, or even letters to the editor. Maybe you have been bothered by the fact that the local animal shelter needs better facilities; think of ways you can promote your art and

the shelter's needs at the same time. The possibilities are boundless once you start thinking this way. Plus, it feels great.

Your personal public self. How you deal with people one-on-one is important too. Your materials may get them to turn their heads in your direction, but it's how you behave that will make the difference. I'm not talking about your personality (it's too late to change that!); I'm talking about your professionalism and your manners.

When Gary Knecht came to speak to the Leap class, he asked the students to e-mail their résumés to him in advance. To my embarrassment, only three of the twelve students got around to doing it. They all had excuses, but as far as Gary was concerned, excuses didn't cut it. On the night he came to speak he told them why. He had set the assignment not to read the résumés, but to see who followed through. His point was this: when an opportunity presents itself, it's your job to act on it in a timely manner. If not, the opportunity disappears.

I would also like to point out that when you do not respond to a professional request, you are quietly insulting the person who asked. It's as though you are saying, I know you want to see my work (or interview me for an article, or buy a piece, or put me in a show), but I don't think it's important enough to bother. Most of the time the opposite is true; the artist thinks it's so important that it makes him or her too nervous to act. But that isn't how it feels on the other side of the request. At the very least it's irritating; at the worst it's insulting.

I bet all artists reading this have let an opportunity slip through their fingers, because they just couldn't bring themselves to follow up. I am guilty of it, too. But I'd like to ask you to make a promise to yourself that next time you will not drag your feet longer than two weeks. If someone is hot to see your art, that enthusiasm has a shelf life; it will get replaced with other enthusiasms if you wait too long. Two weeks is the longest you can expect people's attention spans to last. After that, you have to start all over again.

One of my former students called as I was writing this section, and he sheepishly admitted that he had let an opportunity go by more than two years ago, but he was almost ready now to act on it. Was it too late? he wanted to know. Of course it's too late! Did he think that

My fan mail is enormous. Everyone is under six.

ALEXANDER CALDER

gallery was just sitting there waiting for him for two years? No, a million things could have happened and probably did happen to affect the focus and direction of the gallery in that time. He is going to have to start over with it. If the gallery remembers him at all, it will remember him as a flake. If he wishes to regain the gallery's good opinion, he will need to be exceptionally professional, and timely, in all of his dealings with it.

If you start the ball rolling by sending out press packets, make those follow-up phone calls right away. Don't you be the person who drops the ball; it screams of unprofessionalism. If the person you sent the packet to isn't interested, be courteous and move on. It's not rejection; it's just business.

Pay attention to what you write in your e-mails. Don't make the mistake of thinking that because e-mail travels quickly, it should be written quickly. Your e-mails stand for you, just like all your other materials. Rewrite each e-mail at least once, making sure that the letter communicates clearly what you mean to say. Online jargon is not appropriate for a professional communication.

Prepare in advance to say thank you, and do it at every opportunity. One good way is to have note cards printed with your latest image (easy to do on your computer) and dash off a handwritten note each time someone does something nice for you. Make it a habit. A short card sent today will not only brighten someone's world, it will continue to create goodwill for you in years to come.

Helpful Hints

I call this chapter Helpful Hints, but I think of the information it contains as more along the lines of ways of thinking that are absolutely essential. Throughout the book you have absorbed information on how the art world works and the ways in which it is changing, methods for creating a professional artist's packet, criteria for planning a career strategy and carrying it out, the best ways of dealing with

galleries and exhibitions, suggestions for streamlining your office, directions for staging an exhibition from beginning to end, and the development of networking skills. All that is terrific, but it is just information. Information is important, but it won't take you very far without tenacity and an open mind and heart.

▬▬▬▬ Creating Your Own Art Community

One way you can help yourself keep on track is to create a support group with other like-minded artists. I don't mean a loose friends-support-friends kind of association. What I am talking about is a group of artists who have come together for the specific purpose of helping each other launch (or resume) their careers. One of the reasons my six-month class works is that the students come with a high level of commitment and a willingness to work at a brisk pace. Each week we deal with a different aspect of the problem (for example, writing a statement or setting goals) and we don't move on until everyone is up to speed. Peer-group pressure can work wonders in your life. You will find yourself dealing with things you have been putting off for years rather than having to face the group with some lame excuse like, "I would have brought my statement, but the baby threw up on it."

The focus of the group should be clear to everyone involved. The group I am suggesting is really a business group, where members report on their business activities at each meeting, and offer and receive help and suggestions from the others in turn. Another more traditional type of artists' group is a critique group, which is designed to discuss the art itself. Or you can create a hybrid of the two.

You can use this book as your outline for setting weekly agendas. Why not produce a group show as well? I can guarantee that the members will surpass themselves to get the work done. Who wants to risk screwing up an exhibition with their entire social circle in attendance? The prospect of public humiliation can be a big motivator; it has worked for me on many occasions.

The group should meet regularly, with not too much time between meetings. I like a weekly format; things move fast enough for you to

Life shrinks or expands in proportion to one's courage.
ANAÏS NIN

That ripoff Kosuth! I thought of it first!
WILLIAM WEGMAN

feel your life changing, but not so fast that you can't keep up. Group dynamics are different in every circle, but there are a few pitfalls that seem to occur in almost every group.

When you change your life in this way, it can bring up a lot of fears and free-wheeling emotions. Be careful that the group doesn't degenerate into a therapy session. Create an agreement with each other that you will concentrate on business goals; personal problems can be dealt

Keep away from people who try to belittle your ambitions. Small people always do that, but the really great make you feel that you, too, can become great.

MARK TWAIN

with elsewhere. It is okay to acknowledge that life is difficult and people have problems, then immediately move on to the project at hand. If you don't, you will find the group falling apart in a few weeks because the members feel frustrated that nothing is getting done.

Also, fear and anxiety have a tendency to be catching. You can't help feeling anxious, but you can control what you do about it. Instead of allowing those emotions to fester, realize that inventing failure scenarios is your psyche's way of trying to make sure that nothing changes. Your insecurities will do everything they can to convince you that some external person or thing is the real source of the problem. Anxiety and excitement are two faces of the same kind of highly charged energy. Choose excitement instead.

Another problem that seems to recur is a marked difference in each person's comfort with speaking in the group. Some people never say anything, and others won't shut up. This can drive everyone crazy. There is an easy way to deal with this. Buy a wind-up kitchen timer and give each person exactly ten minutes as you go around the circle making reports on what you have done. Don't miss anyone. Every week, every person should have a chance to speak. Do this from the first meeting, so that everyone accepts it as a given. If you wait until you have a problem, the big talker in your group will become insulted, then you will all have to talk about it even more.

The group should number no more than twelve, and ten is ideal. In a group this size, every person should have enough time each week to deal with the things they need to deal with. A typical meeting should last no more than three hours. Choose the members of the group

carefully. Look for a certain level of competence in the art; you can't market work that isn't ready. Look for commitment and a willingness to work hard. Look for emotional stability. And look for people you want to spend time with.

If you live in an isolated area or have recently moved to a new town, you may not know enough artists to start a group. Don't be shy. Put an ad in the local paper, hang flyers in the art department at the local college, try the community art gallery. You will be amazed how many other artists feel isolated, too, even in urban areas. Even if you can locate only one other person, if it is the right person, whole new worlds can open up.

> *A man can fail many times, but he isn't a failure until he begins to blame somebody else.*
>
> JOHN BURROUGHS

Regardless of whether you are working with other artists or by yourself, certain beliefs and attitudes are essential for living a full and successful life as an artist. Don't shortchange yourself in these areas; your outlook on life is what it is all about.

Absolutely Essential Ways of Thinking

The art always comes first. It is easy to lose sight of this when you become embroiled in the demands of business. The truth is that, without the art, there can be no business. Remember that it is the work that counts most, and allow nothing to leave your studio before it meets your standards. Your career as an artist will be based on the quality of your art, and the quickest way to end a career is to send out work that isn't ready.

Make the best art you can, then push yourself further. An artist is always in the process of becoming. If you find yourself repeating past successes, making the same painting over and over, or painting to please your friends or your dealer, you are probably avoiding the next step in your growth.

Develop regular work habits. It's great if you can get to the studio every day, but it is not necessary. What is necessary is to maintain regular work habits. Every time you quit working on your art for any

period of time, you have to undergo the agony of getting started again. Resuming art production when you haven't attended to it for a while is not just the simple act of picking up a paintbrush. (Actually it is, but it doesn't feel like it.) You have to go through all the emotional roadblocks you have created for yourself before you can get there, which can be very convoluted. You have to carve time out of the other demands and interests that have moved into your life, and those other things will not go meekly. Once you have achieved regular work habits, hang onto them fiercely. Even if you have a limited time to work, once your mind accepts that every Saturday and Sunday afternoon it will get to think about art, it will begin to jump immediately to the point where you left off last time. This means the art continues to get deeper each time you work.

Get a studio. It doesn't have to be glamorous, it just has to be yours. The basic requirements for an artist's studio are privacy and the freedom to make a mess and leave it there. Working on the dining room table until the kids come home just does not cut it. You need to leave your art out so that you can pick up where you left off. You need to be able to see the work fresh the next day. You also need the freedom to make mistakes without anyone else seeing them. Without these things, the work will not grow. If necessary, declare your studio off-limits to your loved ones. An artist needs to have a place where he or she can be free from judgment, no matter how well meaning.

Mixed-media artist Sas Colby offers some tips for protecting the sanctity of your studio. She marks her planned studio days on the calendar so that she doesn't inadvertently double-book her time. She is careful never to invite anyone to meet her there and adamant that no phone be installed. When she arrives at the studio, she is ready to work, secure in the fact that she won't be interrupted.

If you can't afford to rent a studio separate from your house, perhaps you have some options you haven't considered. A spare bedroom or garage can work. Maybe you have a friend with extra space. Is there an empty building that has gone unrented in your town? Perhaps the owner will let you use it in exchange for watering the lawn, or a free

painting, or token rent. Occupied buildings are more attractive to prospective purchasers. Your presence alone could be enough payment. Look around you. You have more options than you think.

Learn to balance your life and your art. This is the real trick to living your life as an artist. Without your art, your life won't be full. Without a life, your art will become stale. Realize from the beginning that you are here for the duration. Treat all the components of your life—your family, your friends, your work—as gifts. It may not be easy, but you will find room for them all. But make sure that the things you give time to are of your own choosing rather than done to meet someone else's expectations. There *is* time in your life for everything that you care about, but not for everything that everyone else cares about. You have to be the protector of your time.

Beware of destructive assumptions. The art world, just like any other subculture, is full of widely held beliefs about itself. One particularly insidious belief is that it is almost impossible for an artist to *fill in any goal*: find a gallery, get a show, sell his or her art, get an appointment with a museum curator.

Where do people get these ideas? And why do they hang on to them?

Guess what: It isn't brain surgery. Having an active career as an artist is only hard if you decide it is going to be hard. You could just as readily decide it is easy. It could be exciting. It could be enlightening. It could be a chance to learn something new. Climbing a mountain is climbing a mountain. It takes effort, but so does everything else. Besides, you know it can't be all that hard, because look how many other people have already done it.

There was a woman on the radio who was being interviewed because she had just completed building a log cabin all by herself. She taught herself how to do it. It took her three years working on weekends and after work. The interviewer was amazed that anyone would spend that much time building a house, but the woman answered, "I had a choice. I could work for three years and end up with a log cabin, or I could not work on it for three years and not have one. Either way I would be putting in the same amount of time."

Watch out for midcareer bitterness. Taking a passive attitude toward your career can result in a bitterness that can eat you up and take all the joy out of everything, including making art. This phenomenon occurs when an artist despairs because his or her career hasn't gone as far or as fast as expected. Here the artist is, after all these years of slaving away in the studio, and nothing to show for it. Maybe he or she got a little attention early on and then *pouf!*, it all just disappeared. It's not that the artist isn't talented, or dedicated; often the artist is both. Bitterness is a result of thinking the world is supposed to come to you, but it really doesn't work that way. Remember my friend who waited patiently in her second-floor apartment for her White Knight until she realized that his horse wouldn't fit in the elevator? Like her, you have to go outside to meet him.

And, you have to be methodical and thorough. You have to be prepared to go out and look for him every day until the job is done, no matter how long it takes. There is nothing more discouraging than making a half-hearted attempt at handling your career. It gives you the illusion that you tried and failed, when really you never tried at all.

Bitterness is a choice, not a reality. It is the choice of the passive. Another choice is to take action. People who take action feel powerful, and people who feel powerful become powerful.

More on midcareer bitterness. Sometimes the bad taste in your mouth is a result of disappointment with the art world itself. When you chose to be an artist, it was partly because you thought that here was one career that was free from self-interest; a place where people cared about the more important things. Then you became involved with the art world and discovered that it could be just as corrupt as anywhere else. In a way, the art world is more corrupt than, say, the business world, because at least people in the business world admit that they are motivated by self-interest. For me, this was a horrifying realization. I wanted to be an artist because I felt it was a grander, cleaner place to be. When I discovered that the art world was a tiny neighborhood full of power-plays and intrigues, I was brokenhearted. Eventually, I came to accept that the full range of human nature will play itself out in any arena. The art world may be small, but it is large enough to attract every type of human being.

There are some days when I think I'm going to die from an overdose of satisfaction.
SALVADOR DALÍ

The other thing I came to realize is that the art itself really is what I thought it was: clean and grand. One hour in the studio will remind you of this. Creating art is a search for truth, and viewing art can be a catalyst for profound understanding. Art will always be larger than any social group who claims it. If the thought of participating in the mainstream art world makes your flesh crawl, don't do it. Make your art for the rest of the world, skip the gallery system, and show your art on your own terms.

There really is enough to go around. There is an intelligence in the universe that favors life. This intelligence wants you to succeed. Many people in the art world carry an attitude of scarcity. *There aren't enough galleries; there aren't enough showing spaces; there aren't enough opportunities.* This attitude only creates more scarcity.

> *There is nothing fiercer than a failed artist. The energy remains, but, having no outlet, it implodes in a great black fart of rage which smokes up all the inner windows of the soul.*
>
> ERICA JONG

Reality will mold itself to fit your expectations. I know this is contrary to many people's beliefs, but I have seen the proof of it endless times in my classes. The artist who comes to the program with an attitude of adventure, a belief in the ability to succeed, and a willingness to do the work finds triumph after triumph. The artist who comes with the attitude that the work is too hard, that success is almost impossible, and that the competition is too steep will find those expectations realized as well. This artist will have successes, but only moderate ones, intermittently realized, which is exactly what was expected. The universe has given each artist a personally tailored version of success.

If you find it difficult to accept this idea, then I offer an experiment for you to try. For six months, do the work wholeheartedly, and if you can't actually believe that the universe wants you to succeed, pretend that you do. Whenever you start to feel that your task is impossible, remind yourself that, for right now, the task is easy and exciting. When people ask you how you are doing, say "Great! This isn't nearly as hard as I thought." Every letter you write, every action you take should carry that attitude of conviction. It won't be long before you'll find that you aren't pretending anymore. You will be too busy keeping up with your show commitments.

Attitude is everything. My life isn't always perfect, sometimes it seems to drag along forever with nothing good ever happening. Sometimes I buy into it and think, *Life is the pits, and it will never get any better*. This can go on for months, years, at a time. Then one morning I wake up and wonder, could I have been contributing to the creation of that reality just by reinforcing it with my thoughts? I change my attitude, and before long, my external experiences alter themselves to match. That doesn't mean you can avoid life's tragedies by wishing them away; it means you can add to life's bonuses by expecting them as well. It also doesn't mean that thoughts are the only thing that count; actions are important, too. You still have to work.

> *I have noted that, barring accidents, artists whose powers wear best and last longest are those who have trained themselves to work under adversity. Great artists treasure their time with a bitter and snarling miserliness.*
>
> CATHERINE DRINKER BOWEN

Don't be afraid to make mistakes. You'll make them no matter how carefully you plan anyway. Look at those little errors in judgment as part of the package and cut yourself some slack. Sometimes your mistakes will lead to a better place than the one you had in mind. Jim Pomeroy, a brilliant performance artist, used to say to his students, "To be an artist you have to make five hundred mistakes, so you might as well get started."

Oh yeah, and have fun!

> *I think I'm beginning to learn something about it.*
>
> AUGUSTE RENOIR
> [His last words about painting, at age seventy-eight]

Appendices

Organizations of Help to Artists

Americans for the Arts
New York office:
One East 53rd Street, 2nd Floor
New York, NY 10022
T 212.223.2787
F 212.980.4857
www.artsusa.org
Washington, DC, office:
1000 Vermont Avenue, NW, 6th Floor
Washington, DC 20005
T 202.371.2830
F 202.371.0424
www.artsusa.org
Offers multilayered programs in arts education
and arts policy; maintains clearinghouse on
arts policy. Sponsors and administers the
Visual Artists Hotline: 800.232.2789.

Art Dealers Association of America, Inc. (ADAA)
575 Madison Avenue
New York, NY 10022
T 212.940.8590
F 212.940.6484
www.artdealers.org
A nonprofit membership organization of fine arts
galleries. ADAA members deal primarily in
paintings, sculpture, prints, drawings, and
photographs from the Renaissance to the pre-
sent day.

Art Information Center
55 Mercer Street, 3rd Fl.
New York, NY 10013
T 212.966.3443
Provides information on galleries and the con-
temporary art scene in New York City,
Tues.–Fri., 10–6. Consultations available.

Artists Foundation
516 East Second Street, #49
Boston, MA 02127
T 617.464.3559
www.artistsfoundation.org
The organization's chief constituency is limited-
income working artists and members of the
public living in Massachusetts.

Artists Rights Society (ARS)
536 Broadway, 5th Floor
New York, NY 10012
T 212.420.9160
F 212.420.9286
www.arsny.com
Copyright, licensing, and monitoring organiza-
tion for visual artists in the United States. ARS
serves as a one-step clearinghouse for rights
and permissions to reputable publishers.

Asian American Arts Alliance
74 Varick Street, Suite 302
New York, NY 10013
T 212.941.9208
E-mail: info@aaartsalliance.org
www.aaartsalliance.org
Coordinates the a4 Online Directory, the most
extensive listing of Asian American arts and
cultural organizations, and member artists
based in New York City.

Asian American Artists Collective (AAAC)
3105 North Ashland, #293
Chicago, IL 60657
www.thecollectivechicago.org
Activist collaborative of diverse Asian American
artists.

Association of Independent Video and Film-
makers (AIVF)
304 Hudson Street, 6th Floor
New York, NY 10013
T 212.807.1400
F 212.463.8519
E-mail: info@aivf.org
www.aivf.org
Advocates for independent filmmaker's access to
public television and cable systems. Publishes
the *Independent Film and Video Monthly*.

En Foco
32 East Kingsbridge Road
Bronx, NY 10468
T 718.584.7718
E-mail: info@enfoco.org
www.enfoco.org
Presents work by photographers of African,
Asian, Latino, and Native American heritage.

Entitled Black Women Artists
www.entitled-bwartists.com
Network for women visual artists of African
descent in the Americas.

Guadalupe Cultural Arts Center
1300 Guadalupe Street
San Antonio, TX 78207
T 210.271.3151
E-mail: info@guadalupeculturalarts.org
www.guadalupeculturalarts.org
Promotes arts and culture of the Chicano,
Latino, and Native American peoples through
public and educational programming.

Guerrilla Girls
www.guerrillagirls.com
Activist women artists using subversion to trans-
form their audience.

National Assembly of State Arts Agencies
1029 Vermont Avenue, NW, 2nd Floor
Washington, DC 20005
T 202.347.6352

F 202.737.0526
TDD 202.347.5948
E-mail: nasaa@nasaa-arts.org
www.nasaa-arts.org
Membership organization that unites, represents, and serves the nation's state and jurisdictional arts agencies. Follow the Arts Over America link on the NASAA homepage for contact information on each state's arts agencies.

National Association of Latino Arts and Culture (NALAC)
1204 Buena Vista Street
San Antonio, TX 78207
T 210.432.3982
F 210.432.3934
E-mail: info@nalac.org
www.nalac.org
Supports the preservation, development, and promotion of the cultural and artistic expressions of the diverse Latino populations of the United States.

Side Street Projects
@ Armory Northwest
284 East Orange Grove Boulevard
Pasadena, CA 91104
T 626.577.7774
F 626.577.7747
E-mail: sidestreetprojects@earthlink.net
www.sidestreet.org
Artist-run organization offers support to emerging artists: fiscal receivership/grant-writing assistance, graphic design and new media production/consultation, digital projector rentals.

Women Environmental Artists Directory
www.weadartists.org
Free listings for women arts professionals concerned with environmental issues.

Women's Caucus for Art
PO Box 1498
Canal Street Station

New York, NY 10013
T 212.634.0007
E-mail: info@nationalwca.com
www.nationalwca.com
Supports expanding opportunities for the exhibition of women's art and art writing.

Digital Arts/New Media

Art Technology Boston
www.atboston.net
A consortium of small nonprofit organizations supporting new media.

National Alliance for Media Arts and Culture (NAMAC)
Ninth Street Media Arts Building
145 Ninth Street, Suite 250
San Francisco, CA 94103
T 415.431.1391
F 415.431.1392
E-mail: namac@namac.org
www.namac.org
Association of nonprofit organizations and individuals committed to furthering the media arts: film, video, audio, and digital.

Photo Alliance
PO Box 291010
San Francisco, CA 94129
T 415.781.8111
www.photoalliance.org
Connects the San Francisco Bay Area photographic community through public programs and education.

Visual Studies Workshop
31 Prince Street
Rochester, NY 14607
T 585.442. 8676
www.vsw.org
Center for media studies, including photography, visual books, digital imaging, film, and video. Publishes *Afterimage,* the journal of media arts and cultural criticism.

Grants/Internships/Residencies

Publications

Alliance of Artists' Communities. *Artists Communities: A Directory of Residencies in the United States Offering Time and Space for Creativity.* New York: Allworth Press, 1996.

Bowler, Gail Hellund. *Artists' and Writers' Colonies: Retreats, Residencies, and Respites for the Creative Mind.* Hillsboro, OR: Blue Heron Publishing, 1995.

Brunner, Helen M., Donald H. Russell, and Grant E. Samuelsen. *Money to Work II: Funding for Visual Artists.* Washington, DC: Art Resources International, 1992.

Foundation Center. *Foundation Grants to Individuals.* 14th ed. New York: Foundation Center, 2005.

Gullong, Jane, and Noreen Tomassi, eds. *Money for International Exchange in the Arts.* New York: American Council for the Arts, 1992.

Lefferts, Robert. *Getting a Grant: How to Write Successful Grant Proposals.* Englewood Cliffs, NJ: Prentice-Hall, 1978.

Oxenhorn, Douglas, ed. *Money for Visual Artists.* 2nd ed. New York: American Council for the Arts, 1993.

Grant-making Entities and Information

Arts International, Inc.
526 West 26th Street, Suite 516
New York, NY 10001
T 212.924.0771
F 212.924.0773
www.artsinternational.org
Focuses on development of global cultural interchange in the arts. Features descriptions of grant programs and partnerships, tools to facilitate international exchange, and a contacts and organizations database.

Creative Capital
65 Bleecker Street, 7th Floor
New York, NY 10012
T 212.598.9900
www.creative-capital.org
Provides grants for artists who pursue innovation in form and/or content in the performing and visual arts, film and video, and emerging fields.

Directory of Percent-for-Art and Art in Public Programs, compiled by Rosemary M. Cellini
Mailing List Labels Packages
PO Box 1233
Weston, CT 06883-1233
home.att.net/~mllpackage/package_information.htm
Lists public art programs sponsored by city, county, state, and federal agencies; private and not-for-profit organizations; colleges and universities; and sculpture gardens and parks.

Foundation Center
79 Fifth Avenue/16th Street
New York, NY 10003-3076
T 212.620.4230, 800.424.9836
F 212.807.3677
www.fdncenter.org
Low-fee monthly subscription to Foundation Grants to Individuals Online, which provides access to a database of more than 6,000 foundation and public charity programs that fund artists, students, and individuals.

New York Foundation for the Arts
155 Avenue of the Americas, 14th Floor
New York, NY 10013-1507
T 212.366.6900
F 212.366.1778
E-mail: NYFAweb@nyfa.org
www.nyfa.org
Provides grants, services, and fellowships annually to New York State originating artists.

Richard Florsheim Art Fund
4202 East Fowler Avenue
USF 30637
Tampa, FL 33620-30637
T 813.949.6886
E-mail: freundli@hotmail.com
www.florsheimartfund.org
Specific to senior American artists. Awards
grants to support the mounting of museum
exhibitions, publication of catalogs, and ac-
quisition of works by museums.

Internships
Southern Arts Federation
1800 Peachtree Street, NW, Suite 808
Atlanta, GA 30309
www.artsopportunities.org

National Network for Artist Placement
www.artistplacement.com
Publishes the *National Directory of Arts Internships.*

Artist Communities
Alliance of Artists Communities
255 South Main Street
Providence, RI 02903
T 401.351.4320
F 401.351.4507
E-mail: aac@artistcommunities.org
www.artistcommunities.org
Provides professional development opportuni-
ties via consultations and seminars. Publishes
*Artists Communities: A Directory of Residencies
in the United States That Offer Time and Space
for Creativity.*

Artist-in-Residence Programs
Alaska
Denali National Park and Preserve
Artist-in-Residence Program
PO Box 9
Denali Park, AK 99755
T 907.683.2294
E-mail: DENA_Info@nps.gov
Residency period: Mid-June through mid-
September.

Arizona
Grand Canyon National Park
Artist-in-Residence Program
PO Box 129, Community Building
Grand Canyon, AZ 86023
T 928.638.7739
Residency period: Last two weeks in September,
first week in October.

Arkansas
Buffalo National River
Artist-in-Residence Program
402 North Walnut, Suite 136
Harrison, AR 72601
T 870.741.5443
E-mail: buff_information@nps.gov
Residency period: March through November.

Hot Springs National Park
Artist-in-Residence Program
Attn: Volunteer Coordinator
PO Box 1860
Hot Springs, AR 71902
T 501.624.3383, ext. 652
E-mail: jeff_heitzman@nps.gov
Residency period: June through November.

California
Exploratorium
3601 Lyon Street
San Francisco, CA 94123
Pamela Winfrey 415.561.0309
E-mail: pamw@exploratorium.edu
Donna Wong 415.353.0482
E-mail: donnaw@exploratorium.edu
www.exploratorium.edu/about/air.html
Open: Year-round.

Headlands Center for the Arts
944 Fort Barry
Sausalito, CA 94965
T 415.331.2787
F 415.331.3857
www.headlands.org
Open: March through May; June through
August; September through November.

Joshua Tree National Park
Artist-in-Residence Program
74485 National Park Drive
Twenty-Nine Palms, CA 92277
T 760.367.5539
E-mail: artmojave@aol.com
Residency period: October through May.

Villa Montalvo
PO Box 158
Saratoga, CA 95071-0158
T 408.961.5800
F 408.961.5850
E-mail: kwallerstein@villamontalvo.org
www.villamontalvo.org/artistresidency.html
Open: By invitation only.

Yosemite Renaissance
Attn: AIR
PO Box 1430
Mariposa, CA 95338
T 209.966.4808
E-mail: yosemiteart@sti.net
www.yosemiteart.org
Residency period: Year-round.

Colorado
Rocky Mountain National Park
Artist-in-Residence Program
1000 Highway 36
Estes Park, CO 80517
T 970.586.1206
TTY/TDD 970.586.1319
E-mail: romo_information@nps.gov
www.rockymountainnp.com
Open: June through September.

Connecticut
Weir Farm Trust
735 Nod Hill Road
Wilton, CT 06897
T 203.761.9945
F 203.761.9116
E-mail: evanswft@optonline.net or
allenwft@optonline.net
www.nps.gov/wefa
Open: Year-round.

Delaware
Delaware Center for the Contemporary Arts
200 South Madison Street
Wilmington, DE 19801
T 302.656.6466
E-mail: hbennett@thedcca.org
www.thedcca.org
Open: Year-round.

Florida
Everglades National Park
Artist-in-Residence-in-Everglades
40001 State Road 9336
Homestead, FL 33034
T 305.242.7750
www.nps.gov/ever/current/airie.htm
Residency period: Year-round.

Georgia
Atlanta Contemporary Art Center
535 Means Street
Atlanta, GA 30318
T 404.688.1970
F 404.577.5856
www.thecontemporary.org
Residency period: Year-round.

Illinois
Ragdale Foundation
1260 North Green Bay Road
Lake Forest, IL 60045
T 847.234.1063
www.ragdale.org
Call for information on Ragdale Fellowships.

Indiana
Indiana Dunes National Lakeshore
Artist-in-Residence Program
1100 North Mineral Springs Road
Porter, IN 46304
T 219.926.7561, ext. 668
F 219.926.7561
www.nps.gov/indu/arp1.htm
Residency period: June through September.

Iowa

Herbert Hoover National Historical Site
Artist-in-Residence Program
110 Parkside Drive, PO Box 607
West Branch, IA 52358
T 319.643.2541
E-mail: dan_peterson@nps.gov
Residency period: May 1 through October 31.
Note: Housing may not be readily available for
upcoming resident artists.

Kentucky

Mammoth Cave National Park
Artist-in-Residence Program
Mammoth Cave, KY 42259
T 270.785.2254
E-mail: maryanne_davis@nps.gov
Residency period: Year-round (spring or fall
suggested).

Maine

Acadia National Park
Artist-in-Residence Program
PO Box 177, Eagle Lake Road
Bar Harbor, ME 04609
T 207.288.3338
E-mail: Acadia_Information@nps.gov
Residency period: May, early June, September,
October.

Carina House Artists' Residency Program
Farnsworth Art Museum
PO Box 466
Rockland, ME 04841
T 207.230.085
www.monhegan.com/marc
Residency period: June through August

Massachusetts

ICA Artists-in-Residence Program at Boston
National Historical Park
Institute of Contemporary Art
Artist-in-Residence Program
955 Boylston Street
Boston, MA 02115-3194
T 617.927.6615
E-mail: caroleanne@icaboston.org

Cape Cod National Seashore
This national park hosts two individual residency programs:
C-Scape Dune Shack:
Provincetown Community Compact, Inc.
PO Box 819
Provincetown, MA 02657
E-mail: tomboland@mediaone.net
Residency period: Year-round.
Margo-Gelb Shack:
Outer Cape Artists Residency Consortium
(OCARC)
22 Nelson Avenue
Provincetown, MA 02657
Residency period: Mid-May through mid-
October.

Michigan

The Alden B. Dow Creativity Center
Northwood University
4000 Whiting Drive
Midland, MI 48640-2398
T 989.837.4478
F 989.837.4468
E-mail: creativity@northwood.edu
www.northwood.edu/abd
Residency period: June through August.

Isle Royale National Park
800 East Lakeshore Drive
Houghton, MI 49931-1895
T 906.487.7152
F 906.487.7170
E-mail: greg_blust@nps.gov
www.nps.gov/isro
Residency period: Mid-June through early
September

Pictured Rocks National Lakeshore
Artist-in-Residence Program
PO Box 40
Munising, MI 49862
T 906.387.2607
E-mail: gregg_bruff@nps.gov
Residency period: September or October.

Sleeping Bear Dunes National Lakeshore
Artist-in-Residence Program
9922 Front Street
Empire, MI 49630
T 231.326.5134
E-mail: lisa_myers@nps.gov
Residency period: September through October.

Minnesota
Franconia Sculpture Park
29815 Unity Avenue
Shafer, MN 55074
T 651.465.3701
E-mail: info@franconia.org
www.franconia.org
Residency period: Summer.

Voyageurs National Park
Artist-in-Residence Program
3131 Highway 53
International Falls, MN 56649-8904
T 218.283.9821
E-mail: lynn_lufbery@nps.gov
Residency period: August.

Missouri
Grand Arts
1819 Grand Boulevard
Kansas City, MO 64108
T 816.421.6887
F 816.421.1561
www.grandarts.com
Residency period: Open.

Montana
Glacier National Park
Artist-in-Residence Program
PO Box 128
West Glacier, MT 59936
T 406.888.7942
F 406.888.7808
E-mail: matt_graves@nps.gov
Residency period: Summer.

Nebraska
Art Farm
1306 West 21 Road
Marquette, NE 68854-2112
T 402.854.3120
E-mail: artfarm@hamilton.net
www.artfarmnebraska.org
Residency period: June through November.

New Hampshire
MacDowell Colony
100 High Street
Peterborough, NH 03458
T 603.924.3886
F 603.924.9142
E-mail: admissions@macdowellcolony.org
www.macdowellcolony.org
Residency period: Year-round.

Saint Gaudens National Historic Site
Artist-in-Residence Program
RR 3, Box 73
Cornish, NH 03603
T 603.675.2175, ext. 107
E-mail: gregory_c_schwarz@nps.gov
Residency period: June through October.
 Sculptors only.

New Mexico
Helene Wurlitzer Foundation
PO Box 1891
Taos, NM 87571
T 505.758.2413
F 505.758.2559
E-mail: hwf@taosnet.com
Residency period: Year-round. Closed December
 15 to January 15.

Roswell Artist-in-Residence Program
PO Box 1
Roswell, NM 88202-0001
T 505.622.6037
F 505.623.5603
E-mail: stephen@rair.org
www.rair.org
Residency period: Year-round.

New York

Art Omi International Arts Center
55 Fifth Avenue
New York, NY 10003
T 212.206.6060
F 212.206.6114
E-mail: artomi55@aol.com
www.artomi.org
Residency period: July.

Blue Mountain Center
P.O. Box 109
Blue Mountain Lake, NY 12812-0109
T 518.352.7391
E-mail: bmc1@telenet.net
Residency period: June through October.

Bronx Council on the Arts
1738 Hone Avenue
Bronx, NY 10461-1486
T 718.931.9500
F 718.409.6445
E-mail:bronxart@bronxarts.org
www.bronxarts.org
Residency period: Year-round. Open to Bronx
 residents only.

International Studio and Curatorial Program
 (ISCP)
323 West 39th Street, Suite 806
New York, NY 10018
F 212.279.0773
E-mail: info@iscp-nyc.org
www.iscp-nyc.org
Residency period: Year-round.

Marie Walsh Sharpe Art Foundation
Space Program
830 North Tejon Street, Suite 120
Colorado Springs, CO 80903
T 719.635.3220
E-mail: sharpeartfdn@qwest.net
www.sharpeartfdn.org
Residency period: Year-round. Studios in
 Manhattan.

Millay Colony for the Arts
454 East Hill Road
PO Box 3
Austerlitz, NY 12017
T 518.392.3103, 518.392.4144
E-mail: apply@millaycolony.org
www.millaycolony.org
Residency period: April through November.

P.S.1 Contemporary Art Center
Attn: Clocktower/P.S.1 Projects
22–25 Jackson Avenue at 46th Avenue.
Long Island City, New York, NY 11101-5324
www.ps1.org
Residency period: April though November. Non-
 residential studio only.

William Flanagan Memorial Creative Persons
 Center
Edward F. Albee Foundation
14 Harrison Street
New York, NY 10013
T 212.226.2020
F 212 226.5551
www.pipeline.com/~jtnyc/albeefdtn.html
Residency period: June through October.

Women's Studio Workshop
PO Box 489
Rosendale, NY 12472
T 845.658.9133
F 845.658.9031
E-mail: info@wsworkshop.org
www.wsworkshop.org
Residency period: Open.

Yaddo
PO Box 395
Saratoga Springs, NY 12866-0395
www.yaddo.org

Ohio
Cuyahoga Valley National Park
CVEEC Artist-in-Residence Program
3675 Oak Hill Road

Peninsula, OH 44264
T 440.546.5995
E-mail: mary_pat_doorley@nps.gov
Residency period: (Spring) March through May;
 (Summer) June through September.

Wexner Center for the Arts
The Ohio State University
1871 North High Street
Columbus, OH 43210-1393
T 614.292.3535
F 614.292.3369
www.wexarts.org
Residency period: Open.

Pennsylvania
Mattress Factory
500 Sampsonia Way
Pittsburgh, PA 15212-4444
T 412.231.3169
F 412.322.2231
E-mail: info@mattress.org
www.mattress.org
Residency period: Open.

South Dakota
Badlands National Park
Artist-in-Residence Program
PO Box 6
Interior, SD 57750
T 605.433.5245
E-mail: badl_information@nps.gov
Residency period: (Fall) Mid-September through
 October; (Spring) March through mid-May.

Mount Rushmore National Memorial
Artist-in-Residence Program
13000 Highway 244, Building 31, Suite 1
Keystone, SD 57751
T 605.574.3195
E-mail: nichole_andler@nps.gov
Residency period: Late May through early Octo-
 ber. Open to traditional sculptors working in
 stone.

Texas
Amistad National Recreation Area
Artist-in-Residence Program
HCR 3, Box 5J,
Del Rio, TX 78840-9350
T 830.775.7491, ext. 211
E-mail: eric_finkelstein@nps.gov
Residency period: September or October.

Washington
Centrum
PO Box 1158
Port Townsend, WA 98368-0958
T 360.385.3102
F 360.385.2470
E-mail: info@centrum.org
www.centrum.org
Residency period: January through June; August
 through December.

Wisconsin
John Michael Kohler Arts Center
608 New York Avenue, PO Box 489
Sheboygan, WI 53082-0489
T 920.458.6144
F 920.458.4473
www.jmkac.org
Residency period: Open.

Wyoming
Ucross Foundation
30 Big Red Lane
Clearmont, WY 82835
T 307.737.2291
F 307.737.2322
E-mail: ucross@wyoming.com
www.ucrossfoundation.org
Residency period: February through June, and
 August through December.

Marketing and Publicity

Books

Abbott, Susan, and Barbara Webb. *Fine Art Publicity.* Stamford, CT.: Art Business News Library, 1991.

Birgus, Vladimir, and Lea Gryze, eds. *European Photography Guide 8.* Göttingen, Germany: European Photography, 2003.

Blakeslee, Carolyn, ed. *Getting Exposure: The Artist's Guide to Exhibiting the Work.* Upper Fairmount, MD: Art Calendar Publishing, 1995.

Blakeslee, Carolyn, and Drew Steis, eds. *Making a Living as an Artist.* Upper Fairmount, MD: Art Calendar Publishing, 1993.

Caplin, Lee Evan, ed. *The Business of Art.* Englewood Cliffs, NJ: Prentice-Hall, 1982.

Caputo, Kathryn. *How to Start Making Money with Your Crafts.* Cincinnati: Betterway Books, 1995.

Collins, Sheldan. *How to Photograph Works of Art.* Repr. ed. New York: Amphoto 1992.

Cox, Mary, and Lauren Mosko, eds. *Artist's and Graphic Designer's Market 2005.* Cincinnati: Writers Digest Books/ F&W Publications, 2004.

Crawford, Tad, and Susan Mellon. *The Artist-Gallery Partnership: A Practical Guide to Consigning Art,* Rev. ed. New York: Allworth Press, 1998.

DeVries, Henry, and Diane Gage. *Self-Marketing Secrets: Winning By Making Your Name Known.* San Diego: Pfeiffer and Company, 1991.

Fisher, Roger, and William Ury. *Getting to Yes: Negotiating Agreement Without Giving In.* New York: Penguin Books, 1991.

Grant, Daniel. *The Artist's Resource Handbook.* Rev. ed. New York: Allworth Press, 1996.

Hiraki, Osam, Maya Ishiwata, Takako Matsuda, and Osamu Hiraki, eds. *Japanese Photography Guide.* Tucson: Nazraeli Press, 1996.

Hoover, Deborah A. *Supporting Yourself as an Artist: A Practical Guide.* New York: Oxford University Press, 1985.

Jackson, Zella. *The Art of Selling Art.* New York: Consultant Press, 1988.

Jay, Bill, and Pat Evans, eds. *USA Photography Guide 3.* Tucson: Nazraeli Press, 1999.

Klayman, Toby Judith, and Cobbett Steinberg. *The Artist's Survival Manual: A Complete Guide to Marketing Your Work.* Updated ed. New York: Charles Scribner's Sons, 1987.

Kostabi, Mark. *Conversations with Kostabi.* Rutland, VT: Charles E. Tuttle Co., Journey Editions, 1996.

Marx, Kathryn. *Photography for the Art Market.* New York: Amphoto, 1988.

Merz, Blanchard. *Art Year.* Torino, Italy: Hopefulmonster Editore, 1996.

Michels, Carroll. *How to Survive and Prosper As an Artist.* New York: Henry Holt and Company, revised 2001.

Nordling, Lee. *Your Career in the Comics.* Kansas City, MO: Andrews and McMeel, 1995.

Phillips, Renee. *New York Contemporary Art Galleries.* 4th ed. New York: Manhattan Arts International, 2000.

Ray, Michael, and Rochelle Myers. *Creativity in Business.* New York: Doubleday, 1986.

Reid, Sheila. *Art without Rejection.* Vence, France: Rush Editions, 1993.

Rudd, Eric. *The Art World Dream: Alternative Strategies for Working Artists.* North Adams, MA: Cire Corporation, illustrated ed., 2001.

Smith, Constance. *Art Marketing 101: A Handbook for the Fine Artist.* 2nd ed. Penn Valley, CA: ArtNetwork, 1997.

Stich, Sidra. *art•SITES France: contemporary art + architecture handbook.* San Francisco: art•SITES, 1999.

——*art•SITES Britain and Ireland: contemporary art + architecture handbook.* San Francisco: art•SITES, 2000.

——*art•SITES Spain: contemporary art + architecture handbook.* San Francisco: art•SITES, 2001.

————art•SITES Paris: art-architecture-design. San Francisco: art•SITES, 2002.

Titus, William. *Photographing Works of Art.* New York: Watson-Guptill Publications, 1981.

Vickers, Marques. *Marketing and Buying Fine Art Online: A Right-Brained Guide to a Left-Brained Industry.* New York: Allworth Press, 2005.

Vitali, Julius. *The Fine Artist's Guide to Marketing and Self-Promotion.* New York: Watson-Guptill Publications, 1997.

Waddell, Heather. *London Art and Artists Guide,* 9th ed. London: London Art and Artists Guide, 2003.

Business Development

Business Committee for the Arts, Inc.
29–27 Queens Plaza North, Fourth Floor
Long Island City, NY 11101
T 718.482.9900
F 718.482.9911
E-mail: info@bcainc.org
www.bcainc.org
National not-for-profit organization that provides businesses of all sizes with resources to develop and advance partnerships with the arts that benefit business, the arts, and the community.

Calls for Art

Art Deadlines List
www.artdeadlineslist.com
Monthly listing of art contests, scholarships and grants, juried exhibitions, jobs and internships, calls for entries/proposals/papers, residencies, fellowships, festivals, funding opportunities, and more.

Corporate Art Collections

The International Directory of Corporate Art Collections, 2004–2005.
International Art Alliance
PO Box 1608
Largo, FL 33779
T 514.935.1228
F 514.935.1299
www.home.netcom.com/~the-iaa/corpart.html

Comprehensive reference for corporate art collecting around the world.

Digital Camera Reviews/Comparisons

www.digitalcamerainfo.com
www.photo.net
www.cnet.com
www.digitalcamera-hq.com

DVD, CD, and Slide Production

Image Innovations, Inc.
T 800.345.4118
www.slidescribe.com
Materials for digital, transparency, slide images, and archival labels.

Mediatechnics Services
20655 South Western Avenue, #100
Torrance, California 90501
T 310.781.1101
Duplication and replication services:
T 800.693.8347
F 310.781.1109
www.mediatechnics.com

Events Calendars

www.laughingsquid.com
Link database of local and regional art and culture; also maintains the Squid List, a daily art event announcements list and the Tentacle List, a place to post calls for artists and performers.

www.sfstation.com
Art event listings and calendar for posting announcements. San Francisco Bay Area focus.

www.flavorpill.com
Series of free weekly e-zines that cover cultural events, created locally in Chicago, Los Angeles, New York, and San Francisco.

Framing/Crating/Shipping

Duren, Lista. *Frame It: A Complete Do-It-Yourself Guide to Picture Framing.* Boston: Houghton Mifflin Company, 1976.

Horne, Stephen. *Way to Go! Crating Artwork for Travel*. Hamilton, NY: Gallery Association of New York State, 1985.

Oberrecht, Kenn. *Home Book of Picture Framing: Professional Secrets of Mounting Matting, Framing and Displaying Artworks, Photographs, Posters, Fabrics, Collectibles, Carvings and More*. 2nd ed. Mechanicsburg, PA: Stackpole Books, 1998.

Government Opportunities

Art in Embassies Program
www.aiep.state.gov
Exhibits original works of art by U.S. citizens in American diplomatic residences worldwide.

Art Bank Program
U.S. Department of State
2201 C Street, NW
Washington, DC 20520-0258
T 202.647.1435
Maintains collection of works on paper by twentieth-century American artists. Art is available to subscribing State Department offices who contribute to the purchase and framing of work in the collection. Limited yearly acquisitions.

Mailing Lists

American Society of Interior Designers
608 Massachusetts Avenue NE
Washington, DC 20002-6006
T 202.546.3480
www.asid.org
Rents membership lists of interior design professionals by city, state, region, or zip code.

Media Distribution Services

www.mdsconnect.com
Press kits, media database, fax blasts.

News Release Services

www.prnewswire.com
Read or post news releases.

www.home.businesswire.com
Business news releases in all fields.

www.pressreleasenetwork.com
Press release broadcast services.

www.gebbieinc.com
Sells media directories.

www.newsdirectory.com
International newspaper directory.

Online Auction Houses

www.auction.igavel.com
www.biddingtons.com
www.ebay.com
www.overstock.com

Packaging and Crating Supplies

Airfloat Systems
PO Box 229
Tupelo, MS 38802
T 800.445.2580
www.airfloatsys.com
Polyurethane-lined corrugated cardboard.

Chiswick Packaging Solutions
33 Union Avenue
Sudbury, MA 01776
T 800.225.8708
F 800.638.9899

Consolidated Plastics Co.
8181 Darrow Road
Twinsburg, OH 44087
T 800.362.1000
F 330.425.3900

Curatorial Assistance
113 East Union Street
Pasadena, CA 91103
T 626.577.9696
F 626.449.9603

Masterpak
145 East 57th Street, 5th Floor
New York, NY 10022
T 800.922.5522
F 212.586.6961

www.masterpak-usa.com
Crating and packing kits and supplies.

National Bag Co.
2233 Old Mill Road
Hudson, OH 44236
T 800.247.6000
F 330.425.9800
www.nationalbag.com

Packing and Crating Information Network
 (PACIN)
Artech Fine Art Services
2601 First Avenue
Seattle, WA 98121
T 206.728.8822
F 206.728.1521
E-mail: mikeh@artechseattle.com
www.pacin.org

Uline Shipping Supply Specialists
2105 South Lakeside Drive
Waukegan, IL 60085
T 800.958.5463
www.uline.com

Periodicals and E-zines

Art Business News
Pfingsten Publishing, LLC
6000 Lombardo Center Drive, Suite 420
Seven Hills, OH 44131
888.772.8926
T 216.328.8926
F 216.328.9452
www.artbusinessnews.com
Trade magazine for galleries and interior design
 retail markets, discussing art trends and art-
 related issues.

ArtBusiness.com
E-mail: artbusiness@artbusiness.com
www.artbusiness.com
Consults on marketing, promotion, public rela-
 tions, Web site construction, Internet selling,
 and career development.

Art-support.com
www.art-support.com
Tips on selling, exhibiting, promoting, and mar-
 keting your artworks. Publishes e-books and
 artist business forms. Many resource listings.

Fuel4arts.com
www.fuel4arts.com
Marketing and more. Australia based.

Postcard Printers

Image Media, Inc.
39346 US 19 North
Tarpon Springs, FL 34689
T 866.885.4468
F 727.937.8511
E-mail: cs@imiprint.com
www.imagemediaprint.com

48hourprint.com
T 617.269.5080, 800.844.0599
www.48hourprint.com

Modern Postcard
1675 Faraday Avenue
Carlsbad, CA 92008
T 800.959.8365
F 760.431.1939
www.modernpostcard.com

Clark Cards
PO Box 1155
Willmar, MN 56201
T 800.227.3658
E-mail: info@clarkcards.com
www.clarkcards.com

Printing for Less
211 East Geyser Street
Livingston, MT 59047
T 800.930.6040
E-mail: info@printingforless.com
www.printingforless.com/indexm.html

Press Releases

www.ereleases.com
Press release writing and distribution services.

www.prmadeeasy.com
Do-it-yourself public relations site.

www.publicityhound.com
Many tools plus links to good resources.

Services

A-1 Banner Packing and Crating
8231 West 3rd Street
Los Angeles, CA 90048
T 323.651.3241
F 323.651.4318
www.bannerpacking.com
Fine art shipping specialists.

American Worldwide Freight Services
5777 West Century Boulevard, Suite 945
Los Angeles International Airport
Los Angeles, CA 90045
T 800.922.2017
Fine art shipping specialists.

Art Handlers Ltd.
T 800.253.0158
Locations: California, Colorada, New Mexico,
 and Texas.

Art Moves Incorporated
4850 NW 17th Avenue
Miami, FL 33125
T 305.576.7576
F 305.576.9912

Artech, Inc.
2601 1st Avenue
Seattle, WA 98121
T 206.728.8822
F 206.728.1521
www.artechseattle.com

Atelier 4, Inc.
177 Water Street

Brooklyn, NY 11201-1111
T 718.875.5050
www.atelier4.com
Member of International Convention of Exhibi-
 tion and Fine Art Transporters (ICEFAT).

Atlantic Fine Art Services, Inc.
New York Office:
47–47 Van Dam Street
Long Island City, NY 11101
T 718.361.7358
Baltimore Office:
PO Box 933 Hanover Street
Baltimore, MD 21076
T 410.247.5112

Atthowe Fine Arts Services
3924 Market Street
Oakland, CA 94608
T 510.654.6816
F 510.654.2632
www.atthowe.com

Belk's Museum Services
2921 Como Avenue SE
Minneapolis, MN 55413
T 612.378.1189
F 612.378.0831
www.museumservices.org
Outdoor rigging, art transport, conservation.

Cooke's Crating and Fine Art
 Transportation, Inc.
3124 East 11th Street
Los Angeles, CA 90023
T 323.268.5101
F 323.262.2001
www.cookescrating.com

Crate 88
4091 Redwood Avenue
Los Angeles, CA 90066
T 310.821.8558
F 310.306.3572
www.crate88.com

Craters and Freighters
T 800.949.9931
F 303.399.9964
E-mail: info@cratersandfreighters.com
www.cratersandfreighters.com
Locations throughout the U.S.

Crozier Fine Arts
525 West 20th Street
New York, NY 10010
T 800.822.2787
F 212.243.5209
www.crozierfinearts.com

Curatorial Assistance/ArtSystems
113 East Union Street
Pasadena, CA 91103
T 213.681.2401
F 818.449.9603
www.curatorial.com

D.A.D. Trucking
855 Edgewater Road
Bronx, NY 10474
T 718.893.3044
F 718.893.3924

Elwell Trucking
1420 Carroll Avenue
San Francisco, CA 94124
T 415.822.5500

Enclosures International Corporation
PO Box 77326
San Francisco, CA 94107
T 415.826.3640
F 415.826.4499
E-mail: operations@enclosures-dls.com

Fine Art Shipping
404 North Oak Street
Inglewood, CA 90302
T 310.677.0011, 800.421.7464
F 310.677.0011
www.fineartship.com

Grosso Art Packers
1400 York Avenue
New York, NY 10021
T 212.734.8879
F 212.288.9009

ICON Group Inc.
423 North Spaulding Avenue
Chicago, IL 60624
T 773.533.1800
F 773.533.1900
www.icongroup.us

International Cargo Systems Inc.
Fine Art Division
PO Box 457
East Boston, MA 02128
T 617.561.1171
www.ics-worldwide.com

Judson Art Warehouse
49–20 Fifth Street
Long Island City, NY 11101
T 718.937.5500
F 718.937.5860

LA Packing & Crating
5722 West Jefferson Boulevard
Los Angeles, CA 90016
T 323.937.2667
F 323.937.9012

Lawrence Fine Arts
375 Oyster Point Boulevard, Unit 2
South San Francisco, CA 94080
T 650.624.9882
www.lawrencefinearts.com

Legacy
935 McLaughlin Avenue
San Jose, CA 95122
T 800.827.0990
www.legacypsi.com

Parma Movers Inc.
8686 Brookpark Road
Cleveland, OH 44129
T 216.741.4747

Racine Berkow Associates
New York Office:
18 West 23rd Street
New York, NY 10010
T 212.255.2011
F 212.255.2012
Washington, DC, Office:
616 North Washington Street
Alexandria, VA 22314
T 703.299.0660
F 703.299.1211
www.racineberkow.com

Ship/Art Denver
PO Box 16662
Denver, CO 80216
T 303.291.3906
F 303.291.3912

Ship/Art International
PO Box 1966
South San Francisco, CA 94083
T 650.952.0100, 800.938.0100
F 650.952.8958
www.shipart.com
Express shuttles, San Francisco–Los
 Angeles–New York, worldwide transporta-
 tion, insurance.

SurroundArt—New York
63 Flushing Avenue, Building #3
Brooklyn Navy Yard, Suite 1005
Brooklyn, NY 11205
T 718.852.4898
F 718.852.4966
www.surroundart.com

Tad Day Inc.
344 East 11th Street
New York, NY 10003
T 212.260.3834
F 212.529.8410

Transport Consultants International
New Jersey Office:
30 Union Avenue South
Cranford, NJ 07016
T 908.272.6500, 800.752.7002
F 908.272.6516
Florida Office:
1103 West Hibiscus Boulevard, Suite 302
Melbourne, FL 32901
T 321.722.0499
F 321.722.0599

West Coast Keating, Inc.
San Francisco Office:
11 Airport Boulevard, #108
South San Francisco, CA 94080
T 650.871.6069
Los Angeles Office:
11099 South La Cienega Boulevard, #278
Los Angeles, CA 90045
T 310.348.3950

United International Freight Systems, Inc.
635 Ramsey Avenue, Suite 106
Hillside, NJ 07205
T 908.851.0441
F 908.851.9370
International transport.

Slide Reproduction

Citizens Photo
709 SE 7th Avenue
Portland, OR 97214
T 503.232.8501, 800.221.3267
F 503.233.4037
www.citizensphoto.com
Good and inexpensive duplicates.

Holland Photo
1221 South Lamar Boulevard
Austin, TX 98704
T 512.442.4274, 800.477.4024
F 512.442.5898
www.hollandphoto.com

Modernage
1150 Avenue of the Americas
New York, NY 10036
T 212.997.1800, 800.997.2510
F 212.869.4796
E-mail: info@modernage.com.
www.modernage.com

Replichrome
89 Fifth Avenue, #903
New York, NY 10003
T 212.929.0409

Sunset Color Labs
PO Box 46145
Los Angeles, CA 90046
Mail order only.

Speakers Bureaus

www.speakerservices.com
Marketing for speakers.

www.roundtablegroup.com
Art speakers, training, and keynotes.

Art Periodicals and E-zines

Afterimage
31 Prince Street
Rochester, NY 14607
T 716.442.8676
F 585.442.1992
E-mail: afterimage@vsw.org
www.vsw.org/afterimage
Bimonthly magazine on photography, video, and film.

American Artist
770 Broadway
New York, NY 10003
T 646.654.5506, 800.562.2706
E-mail: mail@myamericanartist.com
www.myamericanartist.com
Monthly magazine for representational and figurative artists.

Aperture Foundation
PO Box 3000
Denville, NJ 07834
T 866.457.4603
International: 973.627.5162
F 212.475.8790
E-mail: custsvc_aperture@fulcoinc.com

www.aperture.org
Promotes fine art photography. Publishes quarterly magazine, offers educational programs, mounts exhibitions.

Art and Australia
11 Cecil Street
Paddington
NSW 2021 Australia
T 61 2 9331.4455
F 61 2 9331.4577
www.artaustralia.com
Auction, artist, and gallery coverage.

Art Calendar
PO Box 2675
Salisbury, MD 21802
T 410.749.9625
F 410.749.9626
E-mail: info@artcalendar.com
www.artcalendar.com
Monthly listings of exhibition opportunities, competitions, and grants.

Artforum
350 Seventh Avenue
New York, NY 10001
T 212.475.4000
F 212.529.1257
www.artforum.com
Visually exciting magazine (ten issues yearly) on
 New York and international art scene; articles
 often theoretical, avant-garde; for serious con-
 temporary artists, collectors, and curators.

Art in America
T 212.941.2806, 800.925.8059
www.artinamericamagazine.com
General purpose monthly focusing on U.S.
 scene; includes performing and visual arts.
 Annual Guide to Museums, Galleries and Artists
 published every August; accurate and infor-
 mative.

Artist's Magazine
4700 East Galbraith Road
Cincinnati, OH 45236
T 513. 531.2690, 800.283.0963
www.artistsmagazine.com
How-to magazine for working artists.

ArtNetwork
PO Box 1360
Nevada City, CA 95959
T 530.470.0862, 800.383.0677
F 530.470.0256
www.artmarketing.com
Books, artist directories, mailing lists, and an
 online gallery.

Art New England
425 Washington Street
Brighton, MA 02135
T 617.782.3008
F 617.782.4218
www.artnewengland.com
Bimonthly newspaper covering New England
 and New York.

ARTnews
48 West 38th Street
New York, NY 10018
T 212.398.1690
F 212.819.0394
E-mail: info@artnewsonline.com
www.artnewsonline.com
Monthly, covering U.S. art scene.

Art Now Inc.
97 Grayrock Road
PO Box 5541
Clinton, NJ 08809
T 908.638.5255
F 908.638.8737, 908.638.4151
E-mail: artnow@galleryguide.com
www.galleryguide.org
Publishes gallery guides: regional U.S., plus
 international editions.

Art Papers
PO Box 5748
Atlanta, GA 31107
T 404.588.1837
F 404.588.1836
E-mail: info@artpapers.org
www.artpapers.org
Theme-centered bimonthly on art world.

Artsy
e-mail: artsymag@yahoo.com
www.artsymag.com
Contemporary women's art magazine from a
 feminist perspective.

Artweek
PO Box 52100
Palo Alto, CA 94303
T 800.733.2916
F 262.495.8703
www.artweek.com
Monthly West Coast art magazine.

B&W Magazine
Box 700

Arroyo Grande, CA 93421
T 805.474.6633
F 805.489.3661
www.bandwmag.com
Magazine for collectors of fine photography.

Blind Spot Magazine
210 Eleventh Avenue
New York, NY 10001
T 212.633.1317
F 212.627.9364
www.blindspot.com
International source book of photography-based
 fine art.

C Magazine
PO Box 5, Station B
Toronto, ON M5T 2T2, Canada
T 416.539.9495, 800.745.6312
www.cmagazine.com
Covers Canadian art scene.

CameraArts
Magazine Subscriptions
PO Box 101417
Fort Lauderdale, FL 33310
T 800.697.7093 Option 4
E-mail: subscriptions@cameraarts.com
www.cameraarts.com
Bimonthly magazine focused on the medium-
 and small-format photographer.

Camerawork
1246 Folsom Street
San Francisco, CA 94103
T 415.863.1001
www.sfcamerawork.org
Published by Camerawork gallery.

Canadian Art
51 Front Street East, Suite 210
Toronto, ON M5E 1B3, Canada
T 416.368.8854
F 416.368.6135
www.canadianart.ca
Magazine on all types of Canadian visual art.

Drawing Society
PO Box 24
Gabriola Island, BC V0R1X0, Canada
www.drawingsociety.com
Articles and reviews focusing on drawing.

Fiberarts
201 East Fourth Street
Loveland, CO 80537
T 970.613.4679 (Editorial), 800.875.6208
 (Subscriptions)
www.fiberartsmagazine.com
Bimonthly covering textiles.

Flash Art International
68 Via Carlo Farini
20159 Milan, Italy
Subscriptions: European Publications,
799 Broadway, Room 237
New York, NY 10003
www.flashartonline.com
Coverage of European and U.S.
 contemporary art.

Marg
Marg Publications
Army & Navy Building
148 Mahatma Gandhi Road
Mumbai 400 001, India
E-mail: margpub@tata.com
www.marg-art.org
Quarterly magazine on Indian art of all types.
 Founded in 1946.

Mediamatic
PO Box 17490
1001 JL Amsterdam, The Netherlands
www.mediamatic.net
Journal in Dutch and English on electronic
 media, especially video; technical articles; and
 reviews.

NY Arts
473 Broadway, 7th Floor
New York, NY 10013
T 212.274.8993
F 212.226.3400
E-mail: info@nyartsmagazine.com
www.nyartsmagazine.com
Monthly publication on New York art scene.

Parkett
Parkett-Verlag AG
Quellenstrasse 27
CH-8031 Zurich, Switzerland
New York Office:
Parkett Publishers
155 Avenue of the Americas
New York, NY 10013
www.parkettart.com
Bilingual quarterly focusing on one artist; articles
 and essays.

Photograph
64 West 89th Street
New York, NY 10024
T 212.787.0401
F 212.799.3054
www.photography-guide.com
Bimonthly publication.

Public Art Review
2324 University Avenue West, Suite 102
St. Paul, MN 55114
T 651.641.1128
F 651.641.1983
E-mail: publicartreview@visi.com
www.publicartreview.org
Semiannual publication; examines the role of
 public art in contemporary society.

Resource Directory
Manhattan Arts International
200 East 72nd Street, #26L
New York, NY 10021
T 212. 472.1660
www.manhattanarts.com

Monthly newsletter: art and business articles,
 essays. Excellent resource for career develop-
 ment issues.

Sculpture Magazine
1529 18th Street, NW
Washington, DC 20036
T 202.234.0555
F 202.234.2663
www.sculpture.org
Magazine published by the International Sculp-
 ture Center.

Selling Your Art Online Sales Newsletter
Chris Mahler, publisher
Lambertville, MI
www.1x.com/advisor
E-newsletter.

Southwest Art
PO Box 420613
Palm Coast, FL 32142-0613
T 877.212.1938
International: 386.477.2398
www.southwestart.com
Nonspecialized magazine covering Southwest
 and California; interviews with artists.

Studio International
c/o Studio Trust
PO Box 1545
New York, NY 10021
Editor: PO Box 14718
St. Andrews, Scotland KY16 9RZ, UK
www.studio-international.co.uk
Quarterly covering well-known contemporary
 international artists; essays and reviews.

StudioNOTES
Box 502
Benicia, CA 94510
T 707.746.55516
www.studionotes.org
Online artist-to-artist journal and newsletter.

Books of Interest to Artists

Art Theory, History, and Gossip

Atkins, Robert, ed. *Art Speak: A Guide to Modern Ideas, Movements, and Buzzwords.* New York: Abbeville Press, 1990.

————. *Art Spoke: A Guide to Modern Ideas, Movements, and Buzzwords, 1848–1944.* New York: Abbeville Press, 1993.

Barnet, Sylvan. *A Short Guide to Writing About Art.* 8th ed. New York: Longman, 2005.

De Coppet, Laura, and Alan Jones. *The Art Dealers, Revised and Expanded: The Powers Behind the Scenes Tell How the Art World Really Works.* Lanham, MD: Cooper Square Press, 2002.

Haden-Guest, Anthony. *True Colors.* New York: Atlantic Monthly Press, 1996.

Hauser, Arnold. *The Social History of Art.* New York: Vintage Books, 1958; reissued 1985.

Hoving, Thomas. *Making the Mummies Dance.* New York: Simon and Schuster, 1993.

Rose, Barbara, ed. *Art as Art: The Selected Writings of Ad Reinhardt.* Berkeley and Los Angeles: University of California Press, 1991.

Weschler, Lawrence. *Shapinsky's Karma, Bogg's Bills, and Other True Life Tales.* New York: Penguin Books, 1988.

Wolfe, Tom. *The Painted Word.* New York: Bantam Books, 1975.

Creative Inspiration

Bayles, David, and Ted Orland. *Art and Fear: Observations on the Perils and Rewards of Artmaking.* Santa Barbara: Capra Press, 1993.

Barron, Frank, Alfonso Montuori, and Anthea Barron, eds. *Creators on Creating: Awakening and Cultivating the Imaginative Mind.* New York: Tarcher, 1997.

Becker, Carol, ed. *The Subversive Imagination: Artists, Society, and Social Responsibility.* New York: Routledge, 1994.

Cameron, Julia: *The Artist's Way: A Spiritual Path to Higher Creativity.* New York: Tarcher/Pedigree Books, 1992.

Edwards, Betty. *Drawing on the Right Side of the Brain.* Los Angeles: J. P. Tarcher, Inc., 1979.

————. *Drawing on the Artist Within.* New York: Simon and Schuster, 1987.

Flack, Audrey. *Art and Soul: Notes on Creating.* New York: Penguin Books, 1991.

Goldberg, Natalie. *Writing Down the Bones.* Boston: Shambhala Publications, 1986.

Lamott, Anne. *Bird by Bird: Some Instructions on Writing and Life.* New York: Anchor Books, 1994.

Maisel, Eric. *Affirmations for Artists.* New York: G. P. Putnam and Sons, 1996.

Sternberg, Robert, and Todd Lubart. *Defying the Crowd: Cultivating Creativity in a Culture of Conformity.* New York: The Free Press/Simon & Schuster, 1995.

Artist Lifestyle

Career

ArtJob
1743 Wazee Street, Suite 300
Denver, CO 80202
T 303.629.1166, 888.562.7232
F 303.629.9717
www.artjob.org
Lists professional opportunities and career information in all areas of the arts.

SEASOURCE
www.seasource.org
Online resources for self-employment in the arts.

Health and Benefits

Janecek, Lenore. *Health Insurance: A Guide for Artists, Consultants, Entrepreneurs and Other Self-Employed.* New York: Americans for the Arts, 1993.

McCann, Michael. *Health Hazards Manual for Artists.* New York: Lyons and Burford, 1994.

Rempel, Siegfried, and Wolfgang Rempel. *Health Hazards for Photographers.* New York: Lyons and Burford, 1992.

Rossol, Monona. *The Artist's Complete Health and Safety Guide,* rev. ed. New York: Allworth Press, 2001.

Shaw, Susan D., and Monona Rossol. *Overexposure: Health Hazards in Photography.* 2nd ed. New York: Allworth Press, 1991.

Artists' Health Insurance Resource Center
The Actors' Fund of America
729 Seventh Avenue, 10th Floor
New York, NY 10019
T 212.221.7300
F 212.764.0238
www.actorsfund.org/ahirc
A health insurance resource for artists and people in the entertainment industry.

Studio Space

Kartes, Cheryl. *Creating Space: A Guide to Real Estate Development for Artists.* New York: American Council for the Arts, 1993.

Rudd, Eric. *The Art Studio/Loft Manual: For Ambitious Artists and Creators.* North Adams, MA: Cire Corporation; illustrated ed., 2001.

ArtHouse
1360 Mission Street, Suite 200
San Francisco, CA 94103
T 415.552.2183
F 415.552.2615
E-mail: josie@arthouseca.org
www.arthouseca.org
A project of California Lawyers for the Arts: clearinghouse for information about artists' studio and live/work space and cultural facilities in the San Francisco Bay Area.

ArtSpace Projects, Inc.
250 3rd Avenue North
Suite 500
Minneapolis, MN 55401
T 612.333.9012
F 612.333.9089
www.artspaceusa.org
Supports creation and preservation of affordable space for artists and arts organizations through development projects, asset management activities, and consulting services.

Supplies

Archivart
7 Caesar Place
Moonachie, NJ 07074
T 800.804.8428
www.archivart.com
Archival materials.

Art & Frame of Sarasota
www.in2art.com

Art Supplies Online
www.artsuppliesonline.com

CKS Canvases and Panels
1111 North La Brea Avenue
Inglewood, CA 90302
T 310.677.3775

Cheap Joe's Art Stuff
www.cheapjoes.com

Daniel Smith Artists' Materials
4150 First Avenue South
Seattle, WA 98124-5568
T 800.426.6740
F 800.238.406
www.danielsmith.com
General art supplies.

Dick Blick Art Materials
www.dickblick.com

Exposures
1 Memory Lane
Oshkosh, WI 54903-3615
T 800.222.4947
www.exposuresonline.com
Frames and storage systems.

Fine Art Stretcher Bars
1746-A Berkeley Street
Santa Monica, CA 90404
T 310. 586.9222

FLAX
1699 Market Street
San Francisco, CA 94103-1295
T 800.FLAXART
www.flaxart.com
General art supplies.

Gibson Displays
256 Little Farm Road
Statesvillle, NC 28625
T 888.873.8121
www.gibsondisplays.com
Print bins.

Guerrilla Painter
www.pochade.com
Pochade boxes and plein-air supplies.

John Annseley Company
259 Brandt Road
PO Box 181
Healdsburg, CA 95448
T 888.471.4448
F 707.433.1831
E-mail: annesley@sonic.net
www.johnannesley.com
Stretcher bars.

Light Impressions
T 800.828.6216
F 800.828.5539
www.lightimpressiondirect.com
Archival materials, portfolios, slide sheets.

Metropolitan Picture Framing
6959 Washington Avenue South
Minneapolis, MN 55439
T 800.626.3139
F 612.941.6733
E-mail: info@metroframes.com
www.metroframe.com

Sinopia: Pigments and Materials
3385 22nd Street
San Francisco, CA 94110
T 415.824.3180
F 415.824.3280
www.sinopia.com
Supplies for making custom paints and brushes.

Twin Brook Professional Stretchers
RR 1, Box 5444
Lincolnville, ME 04849
T 800.856.1567
F 207.763.4271

Utrecht Art Supply
Main Office, 33–35th Street
Brooklyn, NY 11232
T 800.223.9132
(also in Berkeley, Boston, Chicago, Detroit, Los
 Angeles, New York, Philadelphia, San Fran-
 cisco, and Washington DC)
www.utrechtart.com

Utility
PO Box 217
Gardiner, NY 12525
T 800.680.9290
F 914.255.9293
www.utilitycanvas.com
Canvas.

Williamsburg Art Materials
1711 Monkey Run Road
East Meredith, NY 13757
T 800.293.9399
F 607.278.6254
www.williamsburgoilpaint.com
Handmade paints and pigments.

Legal Resources

Publications

Conner, Floyd. *The Artist's Friendly Legal Guide.* Cincinnati: North Light Books, 1988.

Crawford, Tad. *Legal Guide for the Visual Artist: The Professional's Handbook.* New York: Madison Square Press, 1986.

Hanson, Jo. *Artist's Taxes, the Hands-on Guide: An Alternative to Hobby Taxes.* San Francisco: Vortex Press, 1987.

Register of Copyrights. *Copyright Information Kit #115.* Washington DC: Library of Congress, 202.707.9100. (Copyright information kit for visual artists; can be ordered by phone.)

Victoroff, Gregory. *The Visual Artist's Business and Legal Guide.* Englewood Cliffs, NJ: Prentice-Hall, 1995.

Organizations

American Arbitration Association
335 Madison Avenue, Floor 10
New York, NY 10017-4605
T 212.716.5800, 800.778.7879
F 212.716.5905
E-mail: websitemail@adr.org
www.adr.org
Dispute resolution services worldwide.

Volunteer Lawyers for the Arts
www.starvingartistslaw.com/help/volunteer%20 lawyers.htm
Self-help legal resource site. Pro bono legal services for artists listed by state.

California

California Lawyers for the Arts, Inc.
San Francisco Office:
Fort Mason Center, C-255
San Francisco, CA 94123
T 415.775.7200
F 415.775.1143

E-mail: cla@calawyersforthearts.org
www.calawyersforthearts.org
Also has offices in Oakland, Sacramento, and Santa Monica.

San Diego Lawyers for the Arts
Attn: Craddock Stropes, Lawyers for the Arts
625 Broadway, Suite 735
San Diego, CA 92101
E-mail: cstropes@sdpal.com
www.sandiegoperforms.com/volunteer/lawyer_a rts.html
Assists arts organizations, not individuals.

Colorado

Colorado Lawyers for the Arts
PO Box 48148
Denver, CO 80203
T 303.722.7994
F 303.778.0203
www.coloradoartslawyers.org

Connecticut

Connecticut Volunteer Lawyers for the Arts/CT Commission on Culture & Tourism
Arts Division
One Financial Plaza
755 Main Street
Hartford, CT 06103
T 860.256.2736
E-mail: artsvla@ctarts.org
www.ctarts.org/vla.htm

District of Columbia

Washington Area Lawyers for the Arts (WALA)
901 New York Avenue, NW, Suite P-1
Washington, DC 20001-4413
T 202.289.4440
F 202.289.4985
E-mail: legalservices@thewala.org
www.thewala.org

Florida

Volunteer Lawyers for the Arts of Pinellas County
14700 Terminal Boulevard, Suite 229
Clearwater, FL 33762
T 727.453.7860
F 727.453.7862
E-mail: bkotchey@co.pinellas.fl.us
www.pinellasarts.org/smart_law.htm

Florida Volunteer Lawyers for the Arts
1350 East Sunrise Boulevard.
Fort Lauderdale, FL 33304
T 954.462.9191, ext. 324
F 954.462.9182
E-mail: vla@artserve.org
www.artserve.org

Georgia

Georgia Volunteer Lawyers for the Arts
T 404.873.3911
E-mail: gla@glarts.org
www.glarts.org

Illinois

Lawyers for the Creative Arts
213 West Institute Place, Suite 403
Chicago, IL 60610
T 312.649.4111
F 312.944.2195
www.law-arts.org/

Kansas

Mid-America Arts Resources
c/o Susan J. Whitfield-Lungren
PO Box 363
Lindsborg, KS 67456
T 913.227.2321
E-mail: swhitfield@ks-usa.net

Louisiana

Louisiana Volunteer Lawyers for the Arts
c/o Arts Council of New Orleans
225 Baronne Street, Suite 1712
New Orleans, LA 70112
T 504.523.1465

F 504.529 2430
www.artscouncilofneworleans.org

Maine

Maine Volunteer Lawyers for the Arts
Contact: Terry Cloutier, Esq.
T 207.871.7033
E-mail: tcloutier@lambertcoffin.com

Maine Lawyer Referral and Information Service
Maine State Bar Association
T 207.622.1460, 800.860.1460
www.mainebar.org/lawyer_need.asp

Massachusetts

Volunteer Lawyers for the Arts of
 Massachusetts, Inc.
249 A Street, Studio 14
Boston, MA 02110
T 617.350.7600
TTY 617.350.7600
F 617.350.7610
E-mail: mail@vlama.org
www.vlama.org

Michigan

ArtServe Michigan
Volunteer Lawyers for the Arts & Culture
17515 West Nine Mile Road, Suite 1025
Southfield, MI 48075-4426
T 248.557.8288, ext. 14
F 248.557.8581
kdabbs@artservemichigan.org
www.artservemichigan.org/docs/services_sub/
 art_law.html

Minnesota

Springboard for the Arts
Resources and Counseling for the Arts
308 Prince Street, Suite 270
St. Paul, MN 55101
T 651.292.4381
F 651.292.4315
E-mail: info@RC4Arts.org
www.springboardforthearts.org

Missouri

St. Louis Volunteer Lawyers and Accountants for
 the Arts
6128 Delmar
St. Louis, MO 63112
T 314.863.6930
F 314.863.6932
www.vlaa.org

Montana

Montana Arts Council
316 North Park Avenue, Suite 252
Helena, MT 59620
T 406.444.6430
F 406.444.6548
E-mail: mac@state.mt.us

New Hampshire

Lawyers for the Arts/New Hampshire
One Granite Place
Concord, NH 03301
T 603.224.8300
F 603.226.2963
E-mail: arts@nhbca.com
www.nhbca.com/lawyersforarts.php

New York

Albany/Schenectady League of Arts, Inc.
161 Washington Avenue
Albany, NY 12207
T 518.449.5380

Huntington Arts Council
213 Main Street
Huntington, NY 11743
T 631.271.8423
www.huntingtonarts.com

Volunteer Lawyers for the Arts
1 East 53rd Street, 6th Floor
New York, NY 10022-4201
T 212.319.2787, ext. 1
F 212.752.6575
www.vlany.org

North Carolina

North Carolina Volunteer Lawyers for the Arts
 (NCVLA)
PO Box 26513
Raleigh, NC 27611-6513
T 775.255 5286
F 775.255 5286
E-mail: info@ncvla.org
www.ncvla.org

Ohio

Volunteer Lawyers and Accountants for the
 Arts–Cleveland
c/o The Cleveland Bar Association
113 St. Clair Avenue, Suite 100
Cleveland, OH 44114
T 216.696.3525 (lawyer referral service)

Volunteer Lawyers and Accountants for the
 Arts—Toledo
c/o Arnold Gottlieb, Esq.
608 Madison, Suite 1523
Toledo, OH 43604
T 419.255.3344
F 419.255.1329

Oklahoma

Oklahoma Accountants and Lawyers for the Arts
c/o Eric King, Gable & Gotwals
One Leadership Square, 15th Floor
211 North Robinson
Oklahoma City, OK 73102
T 405.235.5500
F 405.235.2875
E-mail: eking@gablelaw.com

Oregon

Oregon Lawyers for the Arts/Northwest Lawyers
 for the Arts
c/o Kohel Haver, Haver & Associates
621 SW Morrison Street, Suite 1417
Portland, OR 97205
T 503.295 2787
E-mail: artcop@aol.com

Pennsylvania

Philadelphia Volunteer Lawyers for the Arts
251 South 18th Street
Philadelphia, PA 19103
T 215.545.3385
F 215.545.4839
E-mail: info@pvla.org
www.pvla.org

ProArts—Pittsburgh Volunteer Lawyers for
 the Arts
425 Sixth Avenue, Suite 1220
Pittsburgh, PA 15219-1835
T 412.391.2060
F 412.394.4280
E-mail: proarts@proarts-pittsburgh.org
www.proarts-pittsburgh.org/vla.htm

Rhode Island

Ocean State Lawyers for the Arts
PO Box 19
Saunderstown, RI 02874
T 401.789.5686
E-mail: dspatt@artslaw.org
www.artslaw.org

Texas

Texas Accountants & Lawyers for the Arts
1540 Sul Ross
Houston, TX 77006
T 713.526.4876, ext. 201; 800.526.8252
F 713.526.1299
E-mail: info@talarts.org
www.talarts.org

Utah

Utah Lawyers for the Arts
PO Box 652
Salt Lake City, UT 84110
T 801.482.5373

Virginia

Virginia Lawyers for the Arts
Contact: Susan Jennings
T 888.223.4674
E-mail: adeiss@joneswaldo.com

Washington

Washington Lawyers for the Arts
819 North 49th, #207
Seattle, WA 98103
T 206.328.7053
F 206.545.4866
E-mail: director@wa-artlaw.org
www.wa-artlaw.org

International Legal Resources

Australia

Arts Law Centre of Australia
The Gunnery, 43–51 Cowper Wharf Road
Woolloomooloo, Sydney NSW 2011
T 61 2 9356.2566, 800.221.457 (toll-free from
 Australia)
F 61 2 9358.6475
E-mail: artslaw@artslaw.com.au
www.artslaw.com.au/

Canada

CARFAC—Canadian Artists' Representation
2 Daly Avenue, Suite 250
Ottawa, ON K1N 6E2
E-mail: carfac@carfac.ca
www.carfac.ca/
www.carfac.ca/english/eng_regions.html (list of
 regional CARFAC contacts and affiliates)

Copyright Issues

United States Copyright Office
www.loc.gov/copyright
Downloadable forms for registering artwork
 with the Library Of Congress.

Unites States Patent and Trademark Office
www.uspto.gov

Online Galleries

Brick and Mortar Galleries

Mixed Greens
www.mixedgreens.com

Mary Boone Gallery
www.maryboonegallery.com

Alona Kagan
www.alonakagangallery.com

Noho Gallery
www.nohogallery.com

Virtual Galleries

Artspan
www.artspan.com

MesArt
www.mesart.com

FolioLink
www.foliolink.com

Juried Virtual Galleries

Projekt30
www.projekt30.com

Artists Register
www.artistsregister.com

The Guild
www.guild.com

Community-based Virtual Galleries

Chicago Artist's Coalition
www.caconline.org

International Sculpture Center
www.sculpture.org

Photographic Society of America
www.psa-phot.org

The Varo Registry of Women Artists
www.varoregistry.com

Web Site Management

www.linkpopularitycheck.com
www.marketleap.com
Web site ranking.

www.samspade.org
Assists in identifying any Web site's ISP host to trace copyright infringement or image theft.

www.evite.com
Electronic event invitations.

www.geektools.com
Traces spammers.

www.artspan.com
Web site design for artists.

www.cyber-robotics.com
Internet marketing software.

www.links4trade.com
Links management system.

www.verisign.com
On-line payment processing.

www.paypal.com
On-line payment processing.

www.bidpay.com
On-line payment service for auction sales.

Appendix X

Artists and Experts Who Helped with This Book

Ben Blackwell
www.benblackwell.com

Jan Camp
www.jcampstudio.com

Chris Eckert
www.chriseckert.com

Carrie Lederer
www.carrielederer.com

Susan Martin
www.susan-martin.com

Rachel Powers
www.rachelpowersart.com

Alma Robinson
www.calawyersforthearts.org

Tracy Rocca
www.tracyrocca.com

Frank Yamrus
www.frankyamrus.com

The following sample was provided by California Lawyers for the Arts.
Before using this or any contract form, you should consult an attorney.

CALIFORNIA LAWYERS FOR THE ARTS
ARTIST-GALLERY AGREEMENT

This Agreement is made the _____ day of _____, _____ [year] by and between:

NAME: _____ ("Artist")

ADDRESS: _____

PHONE: _____

and

NAME: _____ ("Gallery")

ADDRESS: _____

PHONE: _____

which is organized as a _____

The parties agree as follows:

1. AGENCY. Artist appoints Gallery as his/her (exclusive/non-exclusive) agent for the purpose of exhibition and sale of the consigned works of art in the following geographical areas:

2. CONSIGNMENT. Artist shall consign to Gallery and Gallery shall accept consignment of the following works of art during the term of this Agreement:

 • __ All new works created by Artist [in the following media: _____
 _____]

 • __ All works which Gallery shall select. Gallery shall have the first choice of all new works created by Artist [in the following media: _____
 _____]

 • __ Not less than _____ new works per year [in the following media: _____
 _____]

 • __ All new works created by Artist excluding works reserved by Artist for studio sales and commission sales made directly by Artist.

 • __ The works described in the Consignment Sheet (Schedule A of this Agreement) and such additional works as shall be mutually agreed and described in a similar Consignment Sheet.

 Artist shall not exhibit or sell any consigned work independently from Gallery without the prior written approval of Gallery. Artist shall be free to exhibit and sell any work not consigned to Gallery under this Agreement.

3. DELIVERY. _____ shall be responsible for delivery of the consigned works to Gallery. All costs of delivery (including transportation and insurance) shall be paid as follows:

 (a) _____% by Artist; (b) _____% by Gallery.

Specify legal organization of gallery (e.g., corporation).

Specify exclusive or non-exclusive agency and geographical area (e.g., San Francisco).

Include one of the following applicable statements, specifying particular media when appropriate.

Specify Artist or Gallery.

4. TITLE & RECEIPT. Artist warrants that he/she created and possesses unencumbered title to all works of art consigned to Gallery under this Agreement. Title to the consigned work shall remain in Artist's possession until he/she is paid in full. Gallery acknowledges receipt of the works described in the Consignment Sheet (Schedule A of this Agreement) and shall give Artist a similar Consignment Sheet to acknowledge receipt of all additional works consigned to Gallery under this Agreement.

Specify promotional efforts (e.g., exhibitions, openings).

5. PROMOTION. Gallery shall make reasonable and good faith efforts to promote Artist and to sell the consigned works as follows: _____

_____.

Specify discount percentage (if any).

6. SALES PRICE. Gallery shall sell the consigned works at the retail price mutually agreed upon by both parties and specified in writing in the attached Consignment Sheet. Gallery shall have discretion to vary the agreed retail price by _____% in the case of discount sales only.

Specify each art medium separately.

7. SALES COMMISSION. Gallery shall receive the following sales commission:
(a) _____% of the agreed retail price for selling works in the following medium: _____.
(b) _____% of the agreed retail price for selling works in the following medium: _____.
(c) _____% of the amount paid for studio sales or commission sales made directly by Artist.

The remainder of the retail price shall be paid to Artist. In the case of discount sales, the amount of the discount shall be deducted from the Gallery's sales commission.

Optional.

8. PAYMENT.
(a) On outright sales, Gallery shall pay Artist's share within thirty (30) days after the date of sale.
(b) On deferred payment sales, Gallery shall pay Artist's share within thirty (30) days after the transfer of possession of artwork or receipt of sales proceeds, whichever comes first.
(c) Installment sales must be approved in advance by the Artist and may not extend for a period of longer than six (6) months unless otherwise approved by the Artist. On installment sales, Gallery shall first apply all proceeds from sale of the work to pay Artist's share. Payment shall be made within thirty (30) days after Gallery's receipt of each installment.

As provided by law, California Civil Code Section 1738.6 (d), Gallery shall hold the proceeds from the sale of consigned works in trust for the benefit of Artist. Gallery agrees to guarantee the credit of its customers, and to bear all losses due to the failure of the customer's credit.

9. APPROVAL SALES. Gallery shall not permit any consigned work to remain in the possession of a customer for the purpose of sale on approval for a period exceeding fourteen (14) days.

10. RENTALS. Gallery may not rent any consigned work without the prior written consent of Artist. The rental period may not exceed _____ weeks, unless a longer period is approved by Artist. Gallery shall receive _____% of the rental fees, and the remainder shall be paid to Artist within thirty (30) days after Gallery's receipt of each rental fee.

11. EXHIBITIONS. Gallery shall arrange, install, and publicize at least _____ [number] solo exhibitions of Artist's work on the main premises of Gallery of not less than _____ weeks duration each and within the initial term of this agreement. Gallery shall make reasonable efforts to arrange other solo and group exhibitions thereafter. Artist's work may not be included in any group exhibition without his/her prior written approval. Gallery shall be responsible for costs of exhibitions and other promotional efforts, including:

Consider costs of preparation, promotions, reception, framing, installation hardware, etc., when assigning responsibility for costs.

12. LOSS OR DAMAGE. As provided by law, California Civil Code Section 1738.6(c), Gallery shall be responsible for loss of or damage to the consigned work from the date of delivery to Gallery until the date of delivery to the purchaser or repossession by Artist. Gallery shall insure the consigned works for the benefit of Artist for _____% of the agreed retail price. In the event of damage to artwork, no restoration efforts shall be undertaken without the express advance consent of Artist, who shall have first right to perform restoration.

13. STATEMENTS OF ACCOUNT. Gallery shall give Artist a Statement of Account (Schedule B of this Agreement) within fifteen (15) days after the end of each quarter of the calendar year, beginning with _____ [month] _____[year]. The Statement of Account shall include the following information:
(a) the work(s) sold or rented;
(b) the date, price, and terms of sale or rental;
(c) the commission due to Gallery;
(d) the name and address of each purchaser or renter;
(e) the amount due to Artist;
(f) the location of all unsold works (if not on Gallery's premises).

Gallery warrants that the Statement of Account shall be accurate and complete in all respects. With reasonable notice given, Artist and Gallery (or their

authorized representatives) shall have the mutual right to inspect the financial records of the other party pertaining to any transaction involving Artist's work.

14. CONTRACT FOR SALE. Gallery shall use Artist's own contract for sale in any sale of the consigned works.

15. COPYRIGHT. Artist reserves the common-law copyright to all works consigned to Gallery, including all reproduction rights and the right to claim statutory copyright. No work may be reproduced by Gallery without the prior written approval of Artist. All approved reproductions in catalogs, brochures, advertisements, and other promotional literature shall carry the following notice: © _____[year of publication] by _____ [name of Artist].

16. SECURITY. As provided by law, California Civil Code Section 1738.6(b), the consigned works shall be held in trust for the benefit of Artist, and shall not be subject to claim by a creditor of Gallery. In the event of any default by Gallery, Artist shall have all the rights of a secured party under the Uniform Commercial Code.

17. TERM OF AGREEMENT. This Agreement shall commence upon the date of signing and shall continue in effect until the _____ day of _____, _____. Thereafter, either party may terminate the Agreement by giving thirty (30) days prior written notice, except that the Agreement may not be terminated for ninety (90) days following a solo exhibition of Artist's work in Gallery. Artist has the right to terminate this agreement in the event of a Gallery close, move, or bankruptcy.

Specify Artist or Gallery.

18. RETURN OF WORKS. _____ shall be responsible for return of all works not sold upon termination of the Agreement. All costs of return (including transportation and insurance) shall be paid as follows: (a) _____% by Artist; (b) _____% by Gallery.

If Artist fails to accept return of the works within _____ days after written request by Gallery, Artist shall pay reasonable storage costs.

19. NON-ASSIGNABILITY. The Agreement may not be assigned by Gallery to another person or gallery without the prior written approval of Artist. Gallery shall notify Artist in advance of any change in personnel in charge of Gallery or of any change in ownership of Gallery.

20. DISPUTE RESOLUTION. All disputes arising out of this agreement shall be submitted to mediation in accordance with the rules of Arts Arbitration and Mediation Services, a program of California Lawyers for the Arts. If such

services are not available, the dispute shall be submitted to arbitration in accordance with the laws of the State of California. The arbitrator's award shall be final, and judgment may be entered upon it by any court having jurisdiction thereof.

21. ENTIRE AGREEMENT. This Agreement represents the entire agreement between Artist and Gallery and supersedes all prior negotiations, representations, and agreements, whether oral or written. This Agreement may only be amended by written instrument signed by both parties.

22. GOVERNING LAW. This Agreement shall be governed by the laws of the State of California.

IN WITNESS WHEREOF the parties hereto have executed this Agreement on the day and year first written above.

_____ _____
Artist For Gallery

CONSIGNMENT SHEET (SCHEDULE A)

Received From: _____ Date: _____

The following works of art:

TITLE: MEDIUM: SIZE: RETAIL PRICE: RENTAL PRICE:

1. _____
2. _____
3. _____
4. _____
5. _____
6. _____
7. _____
8. _____
9. _____
10. _____

SIGNED BY:

_____ _____

Artist For Gallery

STATEMENT OF ACCOUNT (SCHEDULE B)

Artist: _____ Date: _____

Address: _____ Quarter: _____

TITLE: RETAIL PRICE: SALES COMMISSION: DUE TO ARTIST:

1. _____
2. _____
3. _____
4. _____
5. _____
6. _____
7. _____
8. _____
9. _____
10. _____

NET AMOUNT DUE TO ARTIST: $_____

For Gallery

Index

preventing misunderstandings with, 104–5
relationship with, 94
sending slides to, 24–25
specializing in local artists, 77–78
status of representation by, 6
targeting appropriate, 24, 64, 86
in a taxicab, 20
today's system of, 4
traditional system of, 2–4
types of, 8–13
university, 12
visiting, 150–58
Web sites for, 80, 83
GIF, 166
Goals, defining, 64–69
Google, 166, 178
Government opportunities, 222
Grants, 213–14
Green, Vanalyne, 33, 35
Gruen, John, 20
Guerrilla Girls, 18–19, 211

H
Hanson, Jo, 125
Haring, Keith, 20–21
Health, 232
Herbert, Jeanne, 33, 34
Hits, 166
Horne, Stephen, 121
HTML, 166

I
Images. *See also* CDs/DVDs; Slides
choosing, 43–44, 186
in e-mail, 182, 183
essential characteristics of, 46
formats for, 166, 167
importance of quality of, 43, 45–46
photographing, 46–55
scanning, 56–57
theft of, 187–88
transferring, to computers, 56–57
on Web sites, 174, 181, 182
working with, on computers, 58
Installation, 91, 131, 140–44

Internet. *See also* E-mail; Web sites
definition of, 166
impact of, 5–6, 164
resources on, 80, 83
terms on, 166–67
theft on, 187–88
Internships, 214
Interpolation, 57–58
Inventory List, 111–13
Invoicing, 119, 120
IRS, 125–26
ISPs, 166, 188

J
Jeanne-Claude, 21
Johns, Jasper, 4
Jones, Katherine Huffaker, 95
JPEG, 166
Juried shows, 71–75

K
Keywords, 167, 179
Knecht, Gary, 199

L
Lawyers for the Arts, 95
Lederer, Carrie, 38, 40
Legal issues, 234–37. *See also* Contracts;
 Copyright; Rights
Lichtenstein, Roy, 4
Lighting, 143
Links, 167, 181–84
Local artists, 77–78
Los Angeles, status of, 84

M
Mailing lists
adding names to, 145, 158
developing and maintaining, 123–24
for exhibitions, 92
for press releases, 135
renting, 222
software for, 108, 123
Web sites and, 174
Mallonee, Tom, 30, 32
Martin, Susan, 38, 41